BENEATH THE PAVING STONES

SITUATIONISTS AND THE BEACH, MAY 1968

TEXTS COLLECTED BY DARK STAR

British Library Cataloguing in Publication Data
A catalogue record for this book is available from the
British Library

ISBN 1902593383

AK Press Europe
PO Box 12766
Edinburgh
EH89YE
ak@akedin.demon.co.uk
http://www.akuk.com

AK Press USA
PO Box 40682
San Francisco
CA 94140-0682
USA
ak@akpress.org
http://www.akpress.org

Design by Billy Hunt

Sous les pavés, la plage

This book is dedicated to the memory of Fredy Perlman (1934 - 1985)

"Having little, being much."

CONTENTS

Foreword

This anthology brings together the three most widely translated, distributed and influential pamphlets of the Situationist International available in the sixties. We have also included an eyewitness account of the May Events by a member of Solidarity published in June 1968. (Dark Star would like to point out that although Solidarity does not possess the current 'kudos' or media/cultural interest possessed by the Situationists, politically they are deserving of more recognition and research).

To briefly sketch in some historical context, both *The Poverty of Student Life* (also known as *Ten Days That Shook The University*), and *Paris: May 1968* were conceived as pamphlets. *The Totality for Kids* and *The Decline And Fall of The Spectacular Commodity Economy* were translated from articles in the Situationist International Journal. *The Totality for Kids,* written by Raoul Vaneigem, originally appeared in two parts in Issue No 7 (April 1962) and Issue No 8 (January 1963). *The Decline and Fall of The Spectacular Commodity Economy,* written by Guy Debord, originally appeared in Issue No 10 (March 1966). *The Poverty of Student Life*, probably the most famous or infamous of these pamphlets, was originally distributed by AFGES students on 22 November 1966. It was reissued in March 1967

and in May 1967 it was widely distributed around the Nanterre campus by Anarchists. November of that year saw the publication of Debord's *Society of the Spectacle* and December the publication of Vaneigem's *Revolution of Everyday Life.*

What we hope this Anthology will offer the reader is not only a concise introduction to the ideas of the Situationists but also an insight into what Situationist material was readily available in the late sixties. For the non-French speaking person with an interest in radical politics the chances are that their encounter with and knowledge of the Situationists would be derived from these three pamphlets. It is worth emphasising that although we recall seeing a duplicated translation of *Society of the Spectacle* it was not until Black & Red published their translation in 1970 that the book became generally available. Likewise, although an edition of *Revolution Of Everyday Life* was translated by John Fullerton and Paul Sieveking and published by Practical Paradise in 1972 (in an edition whose unique selling point - to utilise a commercial phrase - seemed to be the book's ability to fall to pieces in pamphlet-size chunks!), it was not until Donald Nicholson-Smith's translation published by Rebel Press in 1983 that the title became widely available. If we recall that Chris

Gray's seminal *Anthology* was not published until 1974 the significance of these three pamphlets in arousing interest in the Situationist project at the time cannot be emphasised enough.

Whether by intelligent analysis or chance, the pamphlets also allow the reader to acquire some knowledge of the two principal theoreticians of the Paris-based Situationists, Debord and Vaneigem, before moving on to their main texts; whilst *The Poverty of Student Life*, with its provocative and at times humourous writing, serves as a reminder that the Situationist International was a group project.

For a substantial period of time these three pamphlets constituted the main knowledge of the Situationist project. With the translation of more and more texts it has become easier to analyse the influences and events that shaped the Situationist International, its transition from Lettrism, the influence of Dada and Surrealism etc, and even to contemplate Situationist Exhibitions. However we have no doubt that these three pamphlets have both an historical and contemporary significance.

In the *Second Manifesto Of Surrealism* (1930), Andre Breton wrote:

"There are still today, in the lycees,even in the workshops, in the street, the seminaries and military barracks, pure young people who refuse to knuckle down. It is to them and them alone that I address myself, it is for them alone that I am trying to defend Surrealism against the accusation that it is, after all, no more than an intellectual pastime like any other".

In a similar spirit we offer this anthology to young people of all ages who refuse to knuckle down.

Dark Star, London 2001

MOINS DE 21ANS
voici votre
bulletin de
VOTE

On the poverty of student life

Considered in its economic, political, psychological, sexual, and particularly intellectual aspects, and a modest proposal for its remedy

First published in 1966 at the University of Strasbourg by students of the university and members of the Internationale Situationniste.

A few students elected to the student union printed 10,000 copies with university funds. The copies were distributed at the official ceremony marking the beginning of the academic year. The student union was promptly closed by court order. In his summation the judge concluded:

"The accused have never denied the charge of misusing the funds of the student union. Indeed, they openly admit to having made the union pay some £1500 for the printing and distribution of 10,000 pamphlets, not to mention the cost of other literature inspired by "Internationale Situationniste". These publications express ideas and aspirations which, to put it mildly, have nothing to do with the aims of a student union. One has only to read what the accused have written, for it is obvious that these five students, scarcely more than adolescents, lacking all experience of real life, their minds confused by ill-digested philosophical, social, political and economic theories, and perplexed by the drab monotony of their everyday life, make the empty, arrogant, and pathetic claim to pass definitive judgments, sinking to outright abuse, on their fellow-students, their teachers, God, religion, the clergy, the governments and political systems of the whole world. Rejecting all morality and restraint, these cynics do not hesitate to commend theft, the destruction of scholarship, the abolition of work, total subversion, and a world-wide proletarian revolution with "unlicensed pleasure" as its only goal.

In view of their basically anarchist character, these theories and propaganda are eminently noxious. Their wide diffusion in both student circles and among the general public, by the local, national and foreign press, are a threat to the morality, the studies, the reputation and thus the very future of the students of the University of Strasbourg."

To make shame more shameful by giving it publicity

We might very well say, and no one would disagree with us, that the student is the most universally despised creature in France, apart from the priest and the policeman. Naturally he is usually attacked from the wrong point of view, with specious reasons derived from the ruling ideology. He may be worth the contempt of a true revolutionary, yet a revolutionary critique of the student situation is currently taboo on the official Left. The licensed and impotent opponents of capitalism repress the obvious - that what is wrong with the students is also what is wrong with them. They convert their unconscious contempt into a blind enthusiasm. The radical intelligentsia (from *Les Temps Modernes* to *L'Express*) prostrates itself before the so-called rise of the student and the declining bureaucracies of the Left (from the Communist party to the Stalinist National Union of Students) bids noisily for his moral and material support.

There are reasons for this sudden enthusiasm, but they are all provided by the present form of capitalism, in its overdeveloped state. We shall use this pamphlet for denunciation. We shall expose these reasons one by one, on the principle that the end of alienation is only reached by the straight and narrow path of alienation itself.

Up to now, studies of student life have ignored the essential issue. The surveys and analyses have all been psychological or sociological or economic: in other words, academic exercises, content with the false categories of one specialisation or another. None of them can

achieve what is most needed - a view of modern society as a whole. Fourier denounced their error long ago as the attempt to apply scientific laws to the basic assumptions of the science ("porter régulièrement sur les questions primordiales"). Everything is said about our society except what it is, and the nature of its two basic principles - the commodity and the spectacle. The fetishism of facts masks the essential category, and the details consign the totality to oblivion.

Modern capitalism and its spectacle allot everyone a specific role in a general passivity. The student is no exception to the rule. He has a provisional part to play, a rehearsal for his final role as an element in market society as conservative as the rest. Being a student is a form of initiation. An initiation which echoes the rites of more primitive societies with bizarre precision. It goes on outside of history, cut off from social reality. The student leads a double life, poised between his present status and his future role. The two are absolutely separate, and the journey from one to the other is a mechanical event "in the future." Meanwhile, he basks in a schizophrenic consciousness, withdrawing into his initiation group to hide from that future. Protected from history, the present is a mystic trance.

At least in consciousness, the student can exist apart from the official truths of "economic life." But for very simple reasons: looked at economically, student life is a hard one. In our society of abundance, he is still a pauper. 80% of students come from income groups well above the working class, yet 90% have less money than the meanest labourer. Student poverty is an anachronism, a throw-back from an earlier age of capitalism; it does not share in the new poverties of the spectacular societies; it has yet to attain the new poverty of the new proletariat. Nowadays the teenager shuffles off the moral prejudices and authority of the family to become part of the market even before he is adolescent: at fifteen he has all the delights of being directly exploited. In contrast the student covets his protracted infancy as an irresponsible and docile paradise. Adolescence and its crises may bring occasional brushes with his family, but in essence he is not troublesome: he agrees to be treated as a baby by the institutions which provide his education. (If ever they stop screwing his arse off, it's only to come round and kick him in the balls.)

"There is no student problem." Student passivity is only the most obvious symptom of a general state of affairs, for each sector of social life has been subdued by a similar imperialism. Our social thinkers have a bad conscience about the student problem, but only because the real problem is the poverty and servitude of all. But we have different reasons to despise the student and all his works. What is unforgivable is not so much his actual misery but his complaicence in the face of the misery of others. For him there is only one real alienation: his own. He is a full-time and happy consumer of that commodity, hoping to arouse at least our pity, since he cannot claim our interest. By the logic of modern capitalism, most students can only become mere petits cadres (with the same function in neo-capitalism as the skilled worker had in the nineteenth-century economy). The student really knows how miserable will be that golden future which is supposed to make up for the shameful poverty of the present. In the face of that knowledge, he prefers to dote on the present and invent an imaginary prestige for himself. After all, there will be no magical compensation for present drabness: tomorrow will be like yesterday, lighting these fools the way to dusty death. Not unnaturally he takes refuge in an unreal present.

The student is a stoic slave: the more chains authority heaps upon him, the freer he is in phantasy. He shares with his new family, the University, a belief in a curious kind of autonomy. Real independence, apparently, lies in a direct subservience to the two most powerful systems of social control: the family and the State. He is their well-behaved and grateful child, and like the submissive child he is overeager to please. He celebrates all the values and mystifications of the system, devouring them with all the anxiety of the infant at the breast. Once, the old illusions had to be imposed on an aristocracy of labour; the petits cadres-to-be ingest them willingly under the guise of culture.

There are various forms of compensation for poverty. The total poverty of ancient societies

produced the grandiose compensation of religion. The student's poverty by contrast is a marginal phenomenon, and he casts around for compensations among the most down-at-heel images of the ruling class. He is a bore who repairs the old jokes of an alienated culture. Even as an ideologist, he is always out of date. One and all, his latest enthusiasms were ridiculous thirty years ago.

Once upon a time the universities were respected; the student persists in the belief that he is lucky to be there. But he arrived too late. The bygone excellence of bourgeois culture (By this we mean the culture of a Hegel or of the encyclopédistes, rather than the Sorbonne and the Ecole Normale Supérieure) has vanished. A mechanically produced specialist is now the goal of the "educational system." A modern economic system demands mass production of students who are not educated and have been rendered incapable of thinking. Hence the decline of the universities and the automatic nullity of the student once he enters its portals. The university has become a society for the propagation of ignorance; "high culture" has taken on the rhythm of the production line; without exception, university teachers are cretins, men who would get the bird from any audience of schoolboys. But all this hardly matters: the important thing is to go on listening respectfully. In time, if critical thinking is repressed with enough conscientiousness, the student will come to partake of the wafer of knowledge, the professor will tell him the final truths of the world. Till then - a menopause of the spirit. As a matter of course the future revolutionary society will condemn the doings of lecture theatre and faculty as mere noise - socially undesirable. The student is already a very bad joke.

The student is blind to the obvious - that even his closed world is changing. The "crisis of the university" - that detail of a more general crisis of modern capitalism - is the latest fodder for the deaf-mute dialogue of the specialists. This "crisis" is simple to understand: the difficulties of a specialised sector which is adjusting (too late) to a general change in the relations of production.

There was once a vision - if an ideological one - of a liberal bourgeois university. But as its social base disappeared, the vision became banality. In the age of free-trade capitalism, when the "liberal" state left it its marginal freedoms, the university could still think of itself as an independent power. Of course it was a pure and narrow product of that society's needs - particularly the need to give the privileged minority an adequate general culture before they rejoined the ruling class (not that going up to university was straying very far from class confines). But the bitterness of the nostalgic don (No one dares any longer to speak in the name of nineteenth century liberalism; so they reminisce about the "free" and "popular" universities of the middle ages - that democracy of "liberal") is understandable: better, after all, to be the bloodhound of the haute bourgeoisie than sheepdog to the world's white-collars. Better to stand guard on privilege than harry the flock into their allotted factories and bureaux, according to the whims of the "planned economy". The university is becoming, fairly smoothly, the honest broker of technocracy and its spectacle. In the process, the purists of the academic Right become a pitiful sideshow, purveying their "universal" cultural goods to a bewildered audience of specialists.

More serious, and thus more dangerous, are the modernists of the Left and the Students' Union, with their talk of a "reform of University structure" and a "reinsertion of the University into social and economic life", i.e. its adaptation to the needs of modern capitalism. The one-time suppliers of general culture to the ruling classes, though still guarding their old prestige, must be converted into the forcing-house of a new labour aristocracy. Far from contesting the historical process which subordinates one of the last relatively autonomous social groups to the demands of the market, the progressives complain of delays and inefficiency in its completion. They are the standard-bearers of the cybernetic university of the future (which has already reared its ugly head in some unlikely quarters). And they are the enemy: the fight against the market, which is starting again in earnest, means the fight against its latest lackeys.

As for the student, this struggle is fought out entirely over his head, somewhere in the heavenly realm of his masters. The whole of his

life is beyond his control, and for all he sees of the world he might as well be on another planet. His acute economic poverty condemns him to a paltry form of survival. But, being a complacent creature, he parades his very ordinary indigence as if it were an original lifestyle: self-indulgently, he affects to be a Bohemian. The Bohemian solution is hardly viable at the best of times, and the notion that it could be achieved without a complete and final break with the university milieu is quite ludicrous. But the student Bohemian (and every student likes to pretend that he is a Bohemian at heart) clings to his false and degraded version of individual revolt. He is so "eccentric" that he continues - thirty years after Reich's excellent lessons - to entertain the most traditional forms of erotic behaviour, reproducing at this level the general relations of class society. Where sex is concerned, we have learnt better tricks from elderly provincial ladies. His rent-a-crowd militancy for the latest good cause is an aspect of his real impotence.

The student's old-fashioned poverty, however, does put him at a potential advantage - if only he could see it. He does have marginal freedoms, a small area of liberty which as yet escapes the totalitarian control of the spectacle. His flexible working-hours permit him adventure and experiment. But he is a sucker for punishment and freedom scares him to death: he feels safer in the straight-jacketed space-time of lecture hall and weekly essay . He is quite happy with this open prison organised for his "benefit", and, though not constrained, as are most people, to separate work and leisure, he does so of his own accord - hypocritically proclaiming all the while his contempt for assiduity and grey men. He embraces every available contradiction and then mutters darkly about the "difficulties of communication" from the uterine warmth of his religious, artistic or political clique.

Driven by his freely-chosen depression, he submits himself to the subsidiary police force of psychiatrists set up by the avant-garde of repression. The university mental health clinics are run by the student mutual organisation, which sees this institution as a grand victory for student unionism and social progress. Like the Aztecs who ran to greet Cortes's sharpshooters, and then wondered what made the thunder and

why men fell down, the students flock to the psycho-police stations with their "problems".

The real poverty of his everyday life finds its immediate, phantastic compensation in the opium of cultural commodities. In the cultural spectacle he is allotted his habitual role of the dutiful disciple. Although he is close to the production-point, access to the Sanctuary of Thought is forbidden, and he is obliged to discover "modern culture" as an admiring spectator. Art is dead, but the student is necrophiliac. He peeks at the corpse in cine-clubs and theatres, buys its fish-fingers from the cultural supermarket. Consuming unreservedly, he is in his element: he is the living proof of all the platitudes of American market research: a conspicuous consumer, complete with induced irrational preference for Brand X (Camus, for example), and irrational prejudice against Brand Y (Sartre, perhaps).

Impervious to real passions, he seeks titillation in the battles between his anaemic gods, the stars of a vacuous heaven: Althusser - Garaudy-Barthes - Picard - Lefebvre - Levi Strauss - Halliday-deChardin - Brassens... and between their rival theologies, designed like all theologies to mask the real problems by creating false ones: humanism - existentialism - scientism - structuralism - cyberneticism - new criticism - dialectics-of-naturism - metaphilosophism...

He thinks he is avant-garde if he has seen the latest happening. He discovers "modernity" as fast as the market can produce its ersatz version of long outmoded (though once important) ideas; for him, every rehash is a cultural revolution. His principal concern is status, and he eagerly snaps up all the paperback editions of important and "difficult" texts with which mass culture has filled the bookstores. (If he had an atom of self-respect or lucidity, he would knock them off. But no: conspicuous consumers always pay!). Unfortunately, he cannot read, so he devours them with his gaze, and enjoys them vicariously through the gaze of his friends. He is an other-directed voyeur.

His favourite reading matter is the kitsch press, whose task it is to orchestrate the consumption of cultural nothing-boxes. Docile as ever, the student accepts its commercial ukases

and makes them the only measuring-rod of his tastes. Typically, he is a compulsive reader of weeklies like *Le Nouvel Observateur* and *L'Express* (whose nearest English equivalents are the posh Sundays and *New Society*). He generally feels that *Le Monde* - whose style he finds somewhat difficult - is a truly objective newspaper. And it is with such guides that he hopes to gain an understanding of the modern world and become a political initiate!

In France more than anywhere else, the student is passively content to be politicised. In this sphere too, he readily accepts the same alienated, spectacular participation. Seizing upon all the tattered remnants of a Left which was annihilated more than forty years ago by "socialist" reformism and Stalinist counter-revolution, he is once more guilty of an amazing ignorance. The Right is well aware of the defeat of the workers' movement, and so are the workers themselves, though more confusedly. But the students continue blithely to organise demonstrations which mobilise students and students only. This is political false consciousness in its virgin state, a fact which naturally makes the universities a happy hunting ground for the manipulators of the declining bureaucratic organisations. For them, it is child's play to program the student's political options. Occasionally there are deviationary tendencies and cries of "Independence!" but after a period of token resistance the dissidents are reincorporated into a status quo which they have never really radically opposed. The "Jeunesses Communistes Révolutionnaires," whose title is a case of ideological falsification gone mad (they are neither young, nor communist, nor revolutionary), have with much brio and accompanying publicity defied the iron hand of the Party... but only to rally cheerily to the pontifical battle-cry, "Peace in Vietnam!"

The student prides himself on his opposition to the "archaic" Gaullist régime. But he justifies his criticism by appealing - without realising it - to older and far worse crimes. His radicalism prolongs the life of the different currents of edulcorated Stalinism: Togliatti's, Garaudy's, Krushchev's, Mao's, etc. His youth is synonymous with appaling naiveté; and his attitudes are in reality far more archaic than the régime's - the Gaullists do after all understand modern society well enough to administer it.

But the student, sad to say, is not deterred by the odd anachronism. He feels obliged to have general ideas on everything, to unearth a coherent world-view capable of lending meaning to his need for activism and asexual promiscuity. As a result, he falls prey to the last doddering missionary efforts of the churches. He rushes with atavistic ardor to adore the putrescent carcass of God, and cherishes all the stinking detritus of prehistoric religions in the tender belief that they enrich him and his time. Along with their sexual rivals, those elderly provincial ladies, the students form the social category with the highest percentage of admitted adherents to these archaic cults. Everywhere else, the priests have been either beaten off or devoured, but university clerics shamelessly continue to bugger thousands of students in their spiritual shithouses.

We must add in all fairness that there do exist students of a tolerable intellectual level, who without difficulty dominate the controls designed to check the mediocre capacity demanded from the others. They do so for the simple reason that they have understood the system, and so despise it and know themselves to be its enemies. They are in the system for what they can get out of it - particularly grants. Exploiting the contradiction which, for the moment at least, ensures the maintenance of a small sector - "research" - still governed by a liberal-academic rather than a technocratic rationality, they calmly carry the germs of sedition to the highest level: their open contempt for the organisation is the counterpart of a lucidity which enables them to outdo the system's lackeys, intellectually and otherwise. Such students cannot fail to become theorists of the coming revolutionary movement. For the moment, they make no secret of the fact that what they take so easily from the system shall be used for its overthrow.

The student, if he rebels at all, must first rebel against his studies, though the necessity of this initial move is felt less spontaneously by him than by the worker, who intuitively identifies his work with his total condition. At the same time, since the student is a product of modern society just like Godard or Coca-Cola, his

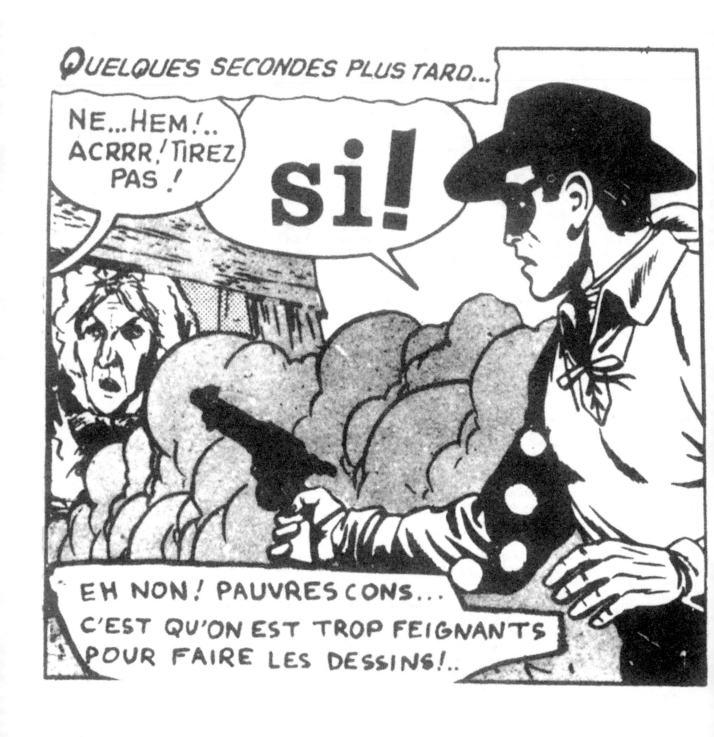

extreme alienation can only be fought through the struggle against this whole society. It is clear that the university can in no circumstances become the battlefield; the student, insofar as he defines himself as such, manufactures a pseudo-value which must become an obstacle to any clear consciousness of the reality of his dispossession. The best criticism of student life is the behaviour of the rest of youth, who have already started to revolt. Their rebellion has become one of the signs of a fresh struggle against modern society.

It is not enough for thought to seek its realisation in practice: practice must seek its theory

After years of slumber and permanent counter-revolution, there are signs of a new period of struggle, with youth as the new carriers of revolutionary infection. But the society of the spectacle paints its own picture of itself and its enemies, imposes its own ideological categories on the world and its history. Fear is the very last response. For everything that happens is reassuringly part of the natural order of things. Real historical changes, which show that this society can be superseded, are reduced to the status of novelties, processed for mere consumption. The revolt of youth against an imposed and "given" way of life is the first sign of a total subversion. It is the prelude to a period of revolt - the revolt of those who can no longer live in our society. Faced with a danger, ideology and its daily machinery perform the usual inversion of reality. An historical process becomes a pseudo-category of some socio-natural science: the Idea of Youth.

Youth is in revolt, but this is only the eternal revolt of youth; every generation espouses "good causes," only to forget them when "the young man begins the serious business of production and is given concrete and real social aims," After the social scientists come the journalists with their verbal inflation. The revolt is contained by overexposure: we are given it to contemplate so that we shall forget to participate. In the spectacle, a revolution becomes a social aberration - in other words a social safety valve - which has its part to play in the smooth working of the system. It reassures because it remains a marginal phenomenon, in the apartheid of the temporary problems of a healthy pluralism (compare and contrast the "woman question" and the "problem of racialism"). In reality, if there is a problem of youth in modern capitalism it is part of the total crisis of that society. It is just that youth feels the crisis most acutely.

Youth and its mock freedoms are the purest products of modern society. Their modernity consists in the choice they are offered and are already making: total integration to neo-capitalism, or the most radical refusal. What is surprising is not that youth is in revolt but that its elders are so soporific. But the reason is history, not biology - the previous generation lived through the defeats and were sold the lies of the long, shameful disintegration of the revolutionary movement.

In itself Youth is a publicity myth, and as part of the new "social dynamism" it is the potential ally of the capitalist mode of production. The illusory primacy of youth began with the economic recovery after the second world war. Capital was able to strike a new bargain with labour: in return for the mass production of a new class of manipulable consumers, the worker was offered a role which gave him full membership of the spectacular society. This at least was the ideal social model, though as usual it bore little relation to socio-economic reality (which lagged behind the consumer ideology). The revolt of youth was the first burst of anger at the persistent realities of the new world - the boredom of everyday existence, the dead life which is still the essential product of modern capitalism, in spite of all its modernisations. A small section of youth is able to refuse that society and its products, but without any idea that this society can be superseded. They opt for a nihilist present. Yet the destruction of capitalism is once again a real issue, an event in history, a process which has already begun. Dissident youth must achieve the coherence of a critical theory, and the practical organisation of that coherence.

At the most primitive level, the "delinquents" (blousons noirs) of the world use violence to express their rejection of society and its

sterile options, But their refusal is an abstract one: it gives them no chance of actually escaping the contradictions of the system. They are its products - negative, spontaneous, but none the less exploitable, All the experiments of the new social order produce them: they are the first side-effects of the new urbanism; of the disintegration of all values; of the extension of an increasingly boring consumer leisure; of the growing control of every aspect of everyday life by the psycho-humanist police force; and of the economic survival of a family unit which has lost all significance.

The "young thug" despises work but accepts the goods. He wants what the spectacle offers him - but now, with no down payment. This is the essential contradiction of the delinquent's existence. He may try for a real freedom in the use of his time, in an individual assertiveness, even in the construction of a kind of community. But the contradiction remains, and kills. (On the fringe of society, where poverty reigns, the gang develops its own hierarchy, which can only fulfil itself in a war with other gangs, isolating each group and each individual within the group.) In the end the contradiction proves unbearable. Either the lure of the product world proves too strong, and the hooligan decides to do his honest day's work: to this end a whole sector of production is devoted specifically to his recuperation. Clothes, records, guitars, scooters, transistors, purple hearts beckon him to the land of the consumer. Or else he is forced to attack the laws of the market itself - either in the primary sense, by stealing, or by a move towards a conscious revolutionary critique of commodity society. For the delinquent only two futures are possible: revolutionary consciousness, or blind obedience on the shop floor.

The Provos are the first organisation of delinquency - they have given the delinquent experience its first political form. They are an alliance of two distinct elements: a handful of careerists from the degenerate world of 'art,' and a mass of beatniks looking for a new activity. The artists contributed the idea of the game, though still dressed up in various threadbare ideological garments. The delinquents had nothing to offer but the violence of their rebellion. From the start the two tendencies hardly mixed:

the pre-ideological mass found itself under the Bolshevik "guidance" of the artistic ruling class, who justified and maintained their power by an ideology of provo-democracy. At the moment when the sheer violence of the delinquent had become an idea - an attempt to destroy art and go beyond it - the violence was channelled into the crassest neo-artistic reformism. The Provos are an aspect of the last reformism produced by modern capitalism: the reformism of everyday life. Like Bernstein, with his vision of socialism built by tinkering with capitalism, the Provo hierarchy think they can change everyday life by a few well-chosen improvements. What they fail to realise is that the banality of everyday life is not incidental, but the central mechanism and product of modern capitalism. To destroy it, nothing less is needed than all-out revolution. The Provos choose the fragmentary and end by accepting the totality.

To give themselves a base, the leaders have concocted the paltry ideology of the provotariat (a politico-artistic salad knocked up from the leftovers of a feast they had never known). The new provotariat is supposed to oppose the passive and "bourgeois" proletariat, still worshipped in obscure Leftist shrines. Because they despair of the fight for a total change in society, they despair of the only forces which can bring about that change. The proletariat is the motor of capitalist society, and thus its mortal enemy: everything is designed for its suppression (parties; trade union bureaucracies; the police; the colonisation of all aspects of everyday life) because it is the only really menacing force. The Provos hardly try to understand any of this; and without a critique of the system of production, they remain its servants. In the end an anti-union workers demonstration sparked off the real conflict. The Provo base went back to direct violence, leaving their bewildered leaders to denounce "excesses" and appeal to pacifist sentiments. The Provos, who had talked of provoking authority to reveal its repressive character, finished by complaining that they had been provoked by the police. So much for their pallid anarchism.

It is true that the Provo base became revolutionary in practice. But to invent a revolutionary consciousness their first task is to destroy their

leaders, to rally the objective revolutionary forces of the proletariat, and to drop the Constants and deVries of this world (one the favourite artist of the Dutch royal family, the other a failed M.P. and admirer of the English police). There is a modern revolution, and one of its bases could be the Provos - but only without their leaders and ideology. If they want to change the world, they must get rid of these who are content to paint it white.

Idle reader, your cry of "What about Berkeley?" escapes us not. True, American society needs its students; and by revolting against their studies they have automatically called that society in question. From the start they have seen their revolt against the university hierarchy as a revolt against the whole hierarchical system, the dictatorship of the economy and the State. Their refusal to become an integrated part of the commodity economy, to put their specialised studies to their obvious and inevitable use, is a revolutionary gesture. It puts in doubt that whole system of production which alienates activity and its products from their creators. For all its confusion and hesitancy, the American student movement has discovered one truth of the new refusal: that a coherent revolutionary alternative can and must be found within the "affluent society." The movement is still fixated on two relatively accidental aspects of the American crisis - the Negroes and Vietnam - and the mini-groups of the New Left suffer from the fact.

There is an authentic whiff of democracy in their chaotic organisation, but what they lack is a genuine subversive content. Without it they continually fall into dangerous contradictions. They may be hostile to the traditional politics of the old parties; but the hostility is futile, and will be recuperated, so long as it is based on ignorance of the political system and naive illusions about the world situation. Abstract opposition to their own society produces facile sympathy with its apparent enemies - the so-called Socialist bureaucracies of China and Cuba. A group like Resurgence Youth Movement can in the same breath condemn the State and praise the "Cultural Revolution" - that pseudo-revolt directed by the most elephantine bureaucracy of modern times. At the same time, these organisa-tions, with their blend of libertarian, political and religious tendencies, are always liable to the obsession with "group dynamics" which leads to the closed world of the sect. The mass consumption of drugs is the expression of a real poverty and a protest against it; but it remains a false search for "freedom" within a world dedicated to repression, a religious critique of a world that has no need for religion, least of all a new one.

The beatniks - that right wing of the youth revolt - are the main purveyors of an ideological 'refusal' combined with an acceptance of the most fantastic superstitions (Zen, spiritualism, 'New Church' mysticism, and the stale porridge of Ghandi-ism and humanism). Worse still, in their search for a revolutionary program the American students fall into the same bad faith as the Provos, and proclaim themselves 'the most exploited class in our society.' They must understand one thing: there are no 'special' student interests in revolution. Revolution will be made by all the victims of encroaching repression and the tyranny of the market.

And for the East, bureaucratic totalitarianism is beginning to produce its own forces of negation. Nowhere is the revolt of youth more violent and more savagely repressed - the rising tide of press denunciation and the new police measures against "hooliganism" are proof enough. A section of youth, so the right-minded 'socialist' functionaries tell us, have no respect for moral and family order (which still flourishes there in its most detestable bourgeois forms). They prefer "debauchery," despise work and even disobey the party police. The USSR has set up a special ministry to fight the new delinquency.

Alongside this diffuse revolt a more specific opposition is emerging. Groups and clandestine reviews rise and fall with the barometer of police repression. So far the most important has been the publication of the "open letter to the Polish Workers Party" by the young Poles Kuron and Modzelewski, which affirmed the necessity of "abolishing the present system of production and social relations" and that to do this "revolution is unavoidable." The Eastern intellectuals have one great task - to make conscious the concrete critical action of the workers of East

Berlin, Warsaw and Budapest: the proletarian critique of the dictatorship of the bureaucracy. In the East the problem is not to define the aims of revolution, but to learn how to fight for them. In the West struggle may be easy, but the goals are left obscure or ideological; in the Eastern bureaucracies there are no illusions about what is being fought for: hence the bitterness of the struggle. What is difficult is to devise the forms revolution must take in the immediate future.

In Britain, the revolt of youth found its first expression in the peace movement. It was never a whole-hearted struggle, with the misty non-violence of the Committee of 100 as its most daring program, At its strongest the Committee could call 300,000 demonstrators on to the streets, It had its finest hour in Spring 1963 with the "Spies for Peace" scandal. But it had already entered on a definitive decline: for want of a theory the unilateralists fell among the traditional Left or were recuperated by the Pacifist conscience.

What is left is the enduring (quintessentially English) archaisms in the control of everyday life, and the accelerating decomposition of the old secular values. These could still produce a total critique of the new life; but the revolt of youth needs allies. The British working class remains one of the most militant in the world. Its struggles - the shop stewards movement and the growing tempo and bitterness of wildcat strikes - will be a permanent sore on an equally permanent capitalism until it regains its revolutionary perspective, and seeks common cause with the new opposition. The débâcle of Labourism makes that alliance all the more possible and all the more necessary. If it came about, the explosion could destroy the old society - the Amsterdam riots would be child's play in comparison. Without it, both sides of the revolution can only be stillborn: practical needs will find no genuine revolutionary form, and rebellious discharge will ignore the only forces that drive and can therefore destroy modern capitalism. Japan is the only industrialised country where this fusion of student youth and working class militants has already taken place.

Zengakuren, the organisation of revolutionary students, and the League of Young Marxist Workers joined to form the backbone of the Communist Revolutionary League. The movement is already setting and solving the new problems of revolutionary organisation. Without illusions, it fights both western capitalism and the bureaucracies of the so-called socialist states. Without hierarchies, it groups together several thousand students and workers on a democratic basis, and aims at the participation of every member in all the activities of the organisation.

They are the first to carry the struggle on to the streets, holding fast to a real revolutionary program, and with a mass participation. Thousands of workers and students have waged a violent struggle with the Japanese police. In many ways the C.R.L. lacks a complete and concrete theory of the two systems it fights with such ferocity. It has not yet defined the precise nature of bureaucratic exploitation, and it has hardly formulated the character of modern capitalism, the critique of everyday life and the critique of the spectacle. The Communist Revolutionary League is still fundamentally an avant-garde political organisation, the heir of the best features of the classic proletarian movement. But it is at present the most important group in the world - and should henceforth be one of the poles of discussion and a rallying point for the new proletarian critique.

To create at long last a situation which goes beyond the point of no return

"To be avant-garde means to keep abreast of reality" (*Internationale Situationniste 8*). A radical critique of the modern world must have the totality as its object and objective. Its searchlight must reveal the world's real past, its present existence and the prospects for its transformation as an indivisible whole. If we are to reach the whole truth about the modern world - and a fortiori if we are to formulate the project of its total subversion - we must be able to expose its hidden history; in concrete terms this means subjecting the history of the international revolutionary movement, as set in motion over a century ago by the western proletariat, to a demystified and critical scrutiny.

"This movement against the total organisa-

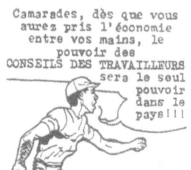

Camarades, dès que vous aurez pris l'économie entre vos mains, le pouvoir des CONSEILS DES TRAVAILLEURS sera le seul pouvoir dans le pays !!!

tion of the old world came to a stop long ago" (*Internationale Situationniste 1*). It failed. Its last historical appearance was in the Spanish social revolution, crushed in the Barcelona 'May Days' of 1937. Yet its so-called "victories" and "defeats," if judged in the light of their historical consequences, tend to confirm Liebknecht's remark, the day before his assassination, that "some defeats are really victories, while some victories are more shameful than any defeat." Thus the first great 'failure' of workers' power, the Paris Commune, is in fact its first great success, whereby the primitive proletariat proclaimed its historical capacity to organise all aspects of social life freely. And the Bolshevik revolution, hailed as the proletariat's first great triumph, turns out in the last analysis to be its most disastrous defeat.

The installation of the Bolshevik order coincides with the crushing of the Spartakists by the German "Social-Democrats." The joint victory of Bolshevism and reformism constitutes a unity masked by an apparent incompatibility, for the Bolshevik order too, as it transpired, was to be a variation on the old theme. The effects of the Russian counter-revolution were, internally, the institution and development of a new mode of exploitation, bureaucratic state capitalism, and externally, the growth of the 'Communist' International, whose spreading branches served the unique purpose of defending and reproducing the rotten trunk. Capitalism, under its bourgeois and bureaucratic guises, won a new lease of life - over the dead bodies of the sailors of Kronstadt, the Ukrainian peasants, and the workers of Berlin, Kiel, Turin, Shanghai, and Barcelona.

The Third International, apparently created by the Bolsheviks to combat the degenerate reformism of its predecessor, and to unite the avant-garde of the proletariat in "revolutionary communist parties," was too closely linked to the interests of its founders ever to serve an authentic socialist revolution. Despite all its polemics, the third International was a chip off the old block. The Russian model was rapidly imposed on the Western workers' organisations, and the evolution of both was thenceforward one and the same thing. The totalitarian dictatorship of the bureaucratic class over the Russian proletariat found its echo in the subjection of the great mass of workers in other countries to castes of trade union and political functionaries, with their own private interests in repression. While the Stalinist monster haunted the working-class consciousness, old-fashioned capitalism was becoming bureaucratised and overdeveloped, resolving its famous internal contradictions and proudly claiming this victory to be decisive, Today, though the unity is obscured by apparent variations and oppositions, a single social form is coming to dominate the world - this modern world which it proposes to govern with the principles of a world long dead and gone. The tradition of the dead generations still weighs like a nightmare on the minds of the living.

Opposition to the world offered from within - and in its own terms - by supposedly revolutionary organisations, can only be spurious. Such opposition, depending on the worst mystifications and calling on more or less reified ideologies, helps consolidate the social order. Trade unions and political parties created by the working class as tools of its emancipation are now no more than the 'checks and balances' of the system. Their leaders have made these organisations their private property; their stepping stone to a role within the ruling class. The party program or the trade union statute may contain vestiges of revolutionary phraseology, but their practice is everywhere reformist - and doubly so now that official capitalist ideology mouths the same reformist slogans. Where the unions have seized power - in countries more backward than Russia in 1917 - the Stalinist model of counterrevolutionary totalitarianism has been faithfully reproduced. Elsewhere, they have become a static complement to the self-regulation of managerial capitalism. The official organisations have become the best guarantee of repression - without this 'opposition' the humanist-democratic facade of the system would collapse and its essential violence would be laid bare.

In the struggle with the militant proletariat, these organisations are the unfailing defenders of the bureaucratic counter-revolution, and the docile creatures of its foreign policy. They are the bearers of the most blatant falsehood in a

world of lies, working diligently for the perennial and universal dictatorship of the State and the Economy. As the situationists put it, "a universally dominant social system, tending toward totalitarian self-regulation, is apparently being resisted - but only apparently - by false forms of opposition which remain trapped on the battlefield ordained by the system itself. Such illusory resistance can only serve to reinforce what it pretends to attack. Bureaucratic pseudo-socialism is only the most grandiose of these guises of the old world of hierarchy and alienated labour."

As for student unionism, it is nothing but the travesty of a travesty, the useless burlesque of a trade unionism itself long totally degenerate.

The principal platitude of all future revolutionary organisation must be the theoretical and practical denunciation of Stalinism in all its forms. In France at least, where economic backwardness has slowed down the consciousness of crisis, the only possible road is over the ruins of Stalinism. It must become the delenda est Carthago of the last revolution of prehistory.

Revolution must break with its past, and derive all its poetry from the future. little groups of 'militants' who claim to represent the authentic Bolshevik heritage are voices from beyond the grave. These angels come to avenge the "betrayal" of the October Revolution will always support the defence of the USSR - if only "in the last instance." The 'under-developed' nations are their promised land. They can scarcely sustain their illusions outside this context, where their objective role is to buttress theoretical underdevelopment. They struggle for the dead body of 'Trotsky,' invent a thousand variations on the same ideological theme, and end up with the same brand of practical and theoretical impotence. Forty years of counter-revolution separate these groups from the Revolution; since this is not 1920 they can only be wrong (and they were already wrong in 1920).

Consider the fate of an ultra-Leftist group like Socialisme ou Barbarie, where after the departure of a 'traditional Marxist' faction (the impotent *Pouvoir Ouvrier*) a core of revolutionary 'modernists' under Cardan disintegrated and disappeared within 18 months. While the old categories are no longer revolutionary, a rejection of Marxism à la Cardan is no substitute for the reinvention of a total critique. The Scylla and Charybdis of present revolutionary action are the museum of revolutionary prehistory and the modernism of the system itself.

As for the various anarchist groups, they possess nothing beyond a pathetic and ideological faith in this label. They justify every kind of self-contradiction in liberal terms: freedom of speech, of opinion, and other such bric-a-brac. Since they tolerate each other, they would tolerate anything.

The predominant social system, which flatters itself on its modernisation and its permanence, must now be confronted with a worthy enemy: the equally modern negative forces which it produces. Let the dead bury their dead, The advance of history has a practical demystifying effect - it helps exorcise the ghosts which haunt the revolutionary consciousness, Thus the revolution of everyday life comes face to face with the enormity of its task. The revolutionary project must be reinvented, as much as the life it announces. If the project is still essentially the abolition of class society, it is because the material conditions upon which revolution was based are still with us. But revolution must be conceived with a new coherence and a new radicalism, starting with a clear grasp of the failure of those who first began it. Otherwise its fragmentary realisation will bring about only a new division of society.

The fight between the powers-that-be and the new proletariat can only be in terms of the totality. And for this reason the future revolutionary movement must be purged of any tendency to reproduce within itself the alienation produced by the commodity system; it must be the living critique of that system and the negation of it, carrying all the elements essential for its transcendence. As Lukacs correctly showed, revolutionary organisation is this necessary mediation between theory and practice, between men and history, between the Dams of workers and the proletariat constituted as a class (Lukacs' mistake was to believe that the Bolsheviks fulfilled this role). If they are to be realised in practice, "theoretical" tendencies or differences must be translated into organisational problems, It is by its present organisation that a new revolutionary movement will stand or

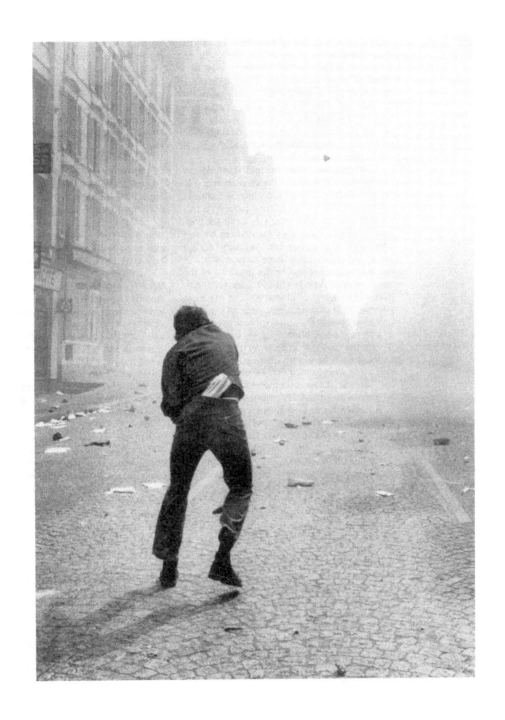

fall. The final criterion of its coherence will be the compatibility of its actual form with its essential project - the international and absolute power of Workers' Councils as foreshadowed by the proletarian revolutions of the last hundred years. There can be no compromise with the foundations of existing society - the system of commodity production; ideology in all its guises; the State; and the imposed division of labour from leisure.

The rock on which the old revolutionary movement foundered was the separation of theory and practice. Only at the supreme moments of struggle did the proletariat supersede this division and attain their truth. As a rule the principle seems to have been *hic Rhodus hic non salta*. Ideology, however 'revolutionary,' always serves the ruling class; false consciousness is the alarm signal revealing the presence of the enemy fifth column. The lie is the essential produce of the world of alienation, and the most effective killer of revolutions: once an organisation which claims the social truth adopts the lie as a tactic, its revolutionary career is finished.

All the positive aspects of the Workers' Councils must be already there in an organisation which aims at their realisation. All relics of the Leninist theory of organisation must be fought and destroyed. The spontaneous creation of Soviets by the Russian workers in 1905 was in itself a practical critique of that baneful theory, yet the Bolsheviks continued to claim that working-class spontaneity could not go beyond "trade union consciousness" and would be unable to grasp the "totality." This was no less than a decapitation of the proletariat so that the Party could place itself "at the head" of the Revolution. If once you dispute the proletariat's capacity to emancipate itself, as Lenin did so ruthlessly, then you deny its capacity to organise all aspects of a post-revolutionary society. In such a context, the slogan "All Power to the Soviets" meant nothing more then the subjection of the Soviets to the Party, and the installation of the Party State in place of the temporary 'State' of the armed masses.

"All Power to the Soviets" is still the slogan, but this time without the Bolshevik afterthoughts. The proletariat can only play the game of revolution if the stakes are the whole world, for the only possible form of workers' power - generalised and complete autogestion - can be shared with nobody. Workers' control is the abolition of all authority: it can abide no limitation, geographical or otherwise: any compromise amounts to surrender, "Workers' control must be the means and the end of the struggle: it is at once the goal of that struggle end its adequate form."

A total critique of the world is the guarantee of the realism and reality of a revolutionary organisation. To tolerate the existence of an oppressive social system in one place or another, simply because it is packaged and sold as revolutionary, is to condone universal oppression. To accept alienation as inevitable in any one domain of social life is to resign oneself to reification in all its forms. It is not enough to favour Workers' Councils in the abstract; in concrete terms they mean the abolition of commodities and therefore of the proletariat. Despite their superficial disparities, all existing societies are governed by the logic of commodities - and the commodity is the basis of their dreams of self-regulation. This famous fetishism is still the essential obstacle to a total emancipation, to the free construction of social life. In the world of commodities, external and invisible forces direct men's actions; autonomous action directed towards clearly perceived goals is impossible. The strength of economic laws lies in their ability to take on the appearance of natural ones, but it is also their weakness, for their effectiveness thus depends only on "the lack of consciousness of those who help create them."

The market has one central principle - the loss of self in the aimless and unconscious creation of a world beyond the control of its creators. The revolutionary core of autogestion is the attack on this principle. Autogestion is conscious direction by all of their whole existence, It is not some vision of a workers' control of the market, which is merely to choose one's own alienation, to program one's own survival (squaring the capitalist circle). The task of the Workers' Councils will not be the autogestion of the world which exists, but its continual qualitative transformation. The commodity and its laws (that vast detour in the history of man's production of himself) will be superseded by a new

social form.

With autogestion ends one of the fundamental splits in modern society - between a labour which becomes increasingly reified end a "leisure" consumed in passivity. The death of the commodity naturally means the suppression of work and its replacement by a new type of free activity. Without this firm intention, socialist groups like *Socialisme ou Barbarie* or *Pouvoir Ouvrier* fell back on a reformism of labour couched in demands for its 'humanisation.' But it is work itself which must be called into question. Far from being a 'Utopia,' its suppression is the first condition for a break with the market. The everyday division between 'free time' and 'working hours,' those complementary sectors of alienated life, is an expression of the internal contradiction between the use-value and exchange-value of the commodity. It has become the strongest point of the commodity ideology, the one contradiction which intensifies with the rise of the consumer. To destroy it, no strategy short of the abolition of work will do. It is only beyond the contradiction of use-value and exchange-value that history begins, that men make their activity an object of their will and their consciousness, and see themselves in the world they have created. The democracy of Workers' Councils is the resolution of all previous contradictions. It makes "everything which exists, apart from individuals, impossible."

What is the revolutionary project? The conscious domination of history by the men who make it. Modern history, like all past history, is the product of social praxis, the unconscious result of human action. In the epoch of totalitarian control, capitalism has produced its own religion: the spectacle. In the spectacle, ideology becomes flesh of our flesh, is realised here on earth. The world itself walks upside down. And like the 'critique of religion' in Marx's day, the critique of the spectacle is now the essential precondition of any critique.

The problem of revolution is once again a concrete issue. On one side the grandiose structures of technology and material production; on the other a dissatisfaction which can only grow more profound. The bourgeoisie end its Eastern heirs, the bureaucracy; cannot devise the means to use their own overdevelopment, which will be the basis of the poetry of the future, simply because they both depend on the preservation of the old order. At most they harness overdevelopment to invent new repressions. For they know only one trick, the accumulation of Capital and hence the proletariat - a proletarian being a man with no power over the use of his life, and who knows it. The new proletariat inherits the riches of the bourgeois world and this gives it its historical chance. Its task is to transform and destroy these riches, to constitute them as part of a human project: the total appropriation of nature and of human nature by man.

A realised human nature can only mean the infinite multiplication of real desires and their gratification. These real desires are the underlife of present society, crammed by the spectacle into the darkest corners of the revolutionary unconscious, realised by the spectacle only in the dreamlike delirium of its own publicity. We must destroy the spectacle itself, the whole apparatus of commodity society, if we are to realise human needs. We must abolish those pseudo-needs and false desires which the system manufactures daily in order to preserve its power.

The liberation of modern history, and the free use of its hoarded acquisition, can come only from the forces it represses. In the nineteenth century the proletariat was already the inheritor of philosophy; now it inherits modern art and the first conscious critique of everyday life, with the self-destruction of the working class art, and philosophy shall be realised. To transform the world and to change the structure of life are one and the same thing for the proletariat - they are the passwords to its destruction as a class, its dissolution of the present reign of necessity, and its accession to the realm of liberty. As its maximum program it has the radical critique and free reconstruction of all the values and patterns of behaviour imposed by an alienated reality. The only poetry it can acknowledge is the creativity released in the making of history, the free invention of each moment and each event: Lautréamont's poésie faite par tous - the beginning of the revolutionary celebration. For proletarian revolt is a festival or it is nothing; in revolution the road of excess leads once and for all to the palace of wisdom. A palace which

23

knows only one rationality: the game. The rules are simple: to live instead of devising a lingering death, and to indulge untrammelled desire.

Postscript: if you make a social revolution, do it for fun

If the above text needed confirmation, it was amply provided by the reactions to its publication. In Strasbourg itself, a very respectable and somewhat olde-worlde city, the traditional reflex of outraged horror was still accessible - witness Judge Llabador's naive admission that our ideas are subversive (see our introduction). At this level too, the press seized on the passing encouragements to stealing and hedonism (interpreted, inevitably, in a narrow erotic sense). The union cellars had become the most infamous dive in Strasbourg. The offices had been turned into a pigsty, with students daubing the walls and relieving themselves in the corridors. They had come with inflatable mattresses to sleep on the premises "with women and children"! Minors had been perverted...

The amoral popular press was of course at wit's end to find adequate labels: the Provos, the Beatniks, and a "weird group of anarchists"were variously reported to have seized power in the city. Under the direction of situationist beatniks, the University restaurant was in the red, and the union's Morsiglia holiday camp had been used free, gratis and for nothing by these gentlemen.

Some tried their hand at analysis, but only communicated the incomprehension of a man suddenly caught in quicksands: "The San Francisco and London beatniks, the mods and rockers of the English beaches, the hooligans behind the Iron Curtain, all have been largely superseded by this wave of new-style nihilism. Today it is no longer a matter of outrageous hair and clothes, of dancing hysterically to induce a state of ecstacy, no longer even a matter of entering the artificial paradise of drugs. From now on, the international of young people who are 'against it' is no longer satisfied with provoking society, but intent on destroying it - on destroying the very foundations of a society 'made for the old and rich' and acceding to a state of 'freedom without any kind of restriction whatsoever' ".

It was the Rector of the University who led the chorus of modernist repression: "These students have insulted their professors", he declared. "They should be dealt with by psychiatrists. I don't want to take any legal measures against them - they should be in a lunatic asylum. As to their incitement to illegal acts, the Minister of the Interior is looking into that". ("I stand for freedom", he added.) Later, besieged by the press, he reiterated that, "We need sociologists and psychologists to explain such phenomena to us". An Italian journalist replied that some of his most brilliant social science students were in fact responsible for the whole affair. The situationists had an even better reply to such appeals to the psychiatric cops: through the agency of the student mutual organisation, they officially closed the local student psychiatric clinic. It is to be hoped that one day such institutions will be physically destroyed rather than tolerated, but in the meantime this 'administrative' decision has such an exemplary value that it is worth quoting:

"The administrative committee of the Strasbourg section of the Mutuelle Nationale des Etudiants de France considering that the University Psychological Aid Bureaux (BAPU) represents the introduction of a para-police control of students, in the form of a repressive psychiatry whose clear function everywhere - somewhere between outright judicial oppression and the degrading lies of the mass spectacle - is to help maintain the apathy of all the exploited victims of modern capitalism; considering that this type of modernist repression... was evoked as soon as the Committee of the General Federal Association of the Strasbourg Students made known its adhesion to situationist theses by publishing the pamphlet On Student Poverty... and that Rector Bayen was quite ready to denounce those responsible to the press as, "fit cases for the psychiatrists"; considering that the existence of a BAPU is a scandal and a menace to all those students of the University who are determined to think for themselves, hereby decides that from the twelfth of January 1967 the BAPU of Strasbourg shall be closed down."

Another development which must have been predictable to any studious reader of the pamphlet was the attempt to explain away the

CEDER un PEU C'EST CAPITULER BEAUCOUP

Strasbourg affair in terms of a "crisis in the universities". *Le Monde*, the most 'serious' French paper, and a platform for technocratic liberalism, kept its head while all around were losing theirs. After a long silence to get its breath back, it published an article which shackled situationist activity in Alsace to the "present student malaise" (another symptom: fascist violence in Paris University), for which the only cure is to give "real responsibility" to the students (read: let them direct their own alienation). This type of reasoning refuses a priori to see the obvious that so-called student malaise is a symptom of a far more general disease.

Much was made of the unrepresentative character of the union committee, although it had been quite legally elected. It is quite true, however, that our friends got power thanks to the apathy of the vast majority. The action had no mass base whatsoever. What it achieved was to expose the emptiness of student politics and indicate the minimum requirements for any conceivable movement of revolutionary students. At the general assembly of the National Union of French Students in January, the Strasbourg group proposed a detailed motion calling for the dissolution of the organisation, and obtained the implicit support of a large number of honest but confused delegates, disgusted by the corridor politics and phoney revolutionary pretensions of the union. Such disgust, though perhaps a beginning, is not enough: a revolutionary consciousness among students would be the very opposite of student consciousness. Until students realise that their interests coincide with those of all who are exploited by modern capitalism, there is little or nothing to be hoped for from the universities. Meanwhile, the exemplary gestures of avant-garde minorities are the only form of radical activity available.

This holds good not only in the universities but almost everywhere. In the absence of a widespread revolutionary consciousness, a quasi-terroristic denunciation of the official world is the only possible planned public action on the part of a revolutionary group. The importance of Strasbourg lies in this: it offers one possible model of such action. A situation was created in which society was forced to finance, publicise and broadcast a revolutionary critique of

itself, and furthermore to confirm this critique through its reactions to it. It was essentially a lesson in turning the tables on contemporary society. The official world was played with by a group that understood its nature better than the official world itself. The exploiters were elegantly exploited. But despite the virtuosity of the operation, it should be seen as no more than an initial and, in view of what is to come, very modest attempt to create the praxis by which the crisis of this society as a whole can be precipitated; as such. it raises far wider problems of revolutionary organisation and tactics. As the mysterious M.K. remarked to a journalist, Strasbourg itself was no more than "a little experiment".

The concept of 'subversion' (detournement), originally used by the situationists in a purely cultural context, can well be used to describe the type of activity at present available to us on many fronts. An early definition: "the redeployment of pre-existing artistic elements within a new ensemble... Its two basic principles are the loss of importance of each originally independent element (which may even lose its first sense completely), and the organisation of a new significant whole which confers a fresh meaning on each element" (*cf. Internationale Situationniste 3, pp 10-11*). The historical significance of this technique or game derives from its ability to both devalue and 'reinvest' the heritage of a dead cultural past, so that "subversion negates the value of previous forms of expression... but at the same time expresses the search for a broader form, at a higher level - for a new creative currency". Subversion counters the manoeuvre of modern society, which seeks to recuperate and fossilise the relics of past creativity within its spectacle. It is clear that this struggle on the cultural terrain is no different in structure from the more general revolutionary struggle; subversion can therefore also be conceived as the creation of a new use value for political and social debris: a student union, for example, recuperated long ago and turned into a paltry agency of repression, can become a beacon of sedition and revolt. Subversion is a form of action transcending the separation between art and politics: it is the art of revolution.

Strasbourg marks the beginning of a new period of situationist activity. The social position

of situationist thought has been determined up to now by the following contradiction: the most highly developed critique of modern life has been made in one of the least highly developed modern countries - in a country which has not yet reached the point where the complete disintegration of all values becomes patently obvious and engenders the corresponding forces of radical rejection. In the French context, situationist theory has anticipated the social forces by which it will be realised.

In the more highly developed countries, the opposite has happened: the forces of revolt exist, but without a revolutionary perspective. The Committee of 100 or the Berkeley rebellion of 1964, for example, were spontaneous mass movements which collapsed because they proved incapable of grasping more than the incidental aspects of alienation (the Bomb, Free Speech...), because they failed to understand that these were merely specific manifestations of everyone's exclusion from the whole of his experience, on every level of individual and social life. Without a critique of this fundamental alienation, these movements could never articulate the real dissatisfaction which created them - dissatisfaction with the nature of everyday life - while as specialised 'causes' they could only become integrated or dissolve. As a shrewd Italian journalist wrote in L'Europeo, situationist theory is the 'missing link' in the development of the new forces of revolt - the revolutionary perspective of total transformation still absent from the immense discontent of contemporary youth, as from the industrial struggle which continues in all its violence at shop-floor level. The time will come - and our job is to hasten it - when these two currents join forces. Louise Crowley has indicated the reactionary role to which the old workers' movement is now doomed: the maintenance of work made potentially unnecessary by the progress of automation. Whatever Solidarity may think, outright opposition to forced labour is going to become a rallying-point of revolutionary activity in the most advanced areas of the world.

Already, in the highly industrialised countries, the decomposition of modern society is becoming obvious at a mass level. All previous ideological explanations of the world have collapsed, and left the misery and chaos of everyday life without any coherent dissimulation at all. Politics, morality and culture are all in ruins - and have now reached the point of being marketed as such, as their own parody, the spectacle of decadence being the last desperate attempt to stabilise the decadence of the spectacle. Less and less masks the reduction of the whole of life to the production and consumption of commodities; less and less masks the relationship between the isolation, emptiness and anguish of everyday life and this dictatorship of the commodity; less and less masks the increasing waste of the forces of production, and the richness of lived experience now possible if these forces were only used to fulfil human desires instead of to repress them.

If England is the temporary capital of the spectacular world, it is because no other country could take its demoralisation so seriously. The island, having recovered from its fit of satirical giggles, has flipped out. The consumption of hysteria has become a principle of social production, but one where the real banality of the goods keeps breaking the surface, and letting loose a necessary violence - the violence of a man who has been given everything, but finds that everything is phoney. Fashion accelerates because revolution is treading on its tail.

With the end of the first phase of pop, the spectacle is beginning to pitch its convulsive tent in the theatre and the art gallery. Degenerate bourgeois entertainment is dying of self-consciousness and impotent dislike of its audience: rather than mount improvised 'political' tear-jerkers, it should learn to destroy itself. Now is the time for a Christopher Fry revival.

Fake culture, fake politics. If we pass over student unionism in Anglo-America, it is out of simple contempt. There is a sharpening of the pseudo-struggle (Reagan versus the Regents, LSE versus Addams), but its only interest is in guessing which side is financed by the CIA. The triumph of Wilsonism is more important, since its harsh mediocrity reveals the logic of modern capitalism: the stronger the Labour Movement, with its bone-hard hierarchies and its school-teacher notions of technology and social justice, the greater the guarantee of total repression. The militant proletariat, whose opposition to the

capitalist system is unabated, will remain revolutionary chickenfeed till the myth of the Labour Movement has been finally laid.

With the decline of the spectacular antagonisms (Tory/Labour, East/West, High Culture/Low Culture), the official Left is looking around for new mock battles to fight. It has always had a masochistic urge to embrace the toughminded alternative. The orthodox 'communist' party owed its popularity among the lumpenintelligentsia to an assertion that it was too practical to have time for theory - a claim amply confirmed by its own blend of flaccid intellectual nullity and permanent political impotence. Those who counsel "working within the Labour Movement" play on the same secret craving to rush around with buckets of water trying to light a fire. The latest enthusiasm of the Left is Mao's "cultural revolution", that farce produced by courtesy of the Chinese bureaucracy (complete with blue jokes about red panties). To repeat an old adage, there is no revolution without the arming of the working-class. A revolution of unarmed schoolchildren, which even then has to be neutered by the "support" of the army, is a pseudo-revolution serving some obscure need for readjustment within the bureaucracy. As a tactic for bureaucratic reorganisation it is familiar - after the hysterical and ineffective purge of the Right comes the appeal to "discipline", the call "to purify our ranks and eliminate individualism" (People's Daily, 21st Feb 1967), and finally the essential purge of the Left. Far from marking an attack on 'socialist' bureaucracy, the GPCR marks the bureaucracy's first adjustment to the techniques of neo-capitalist repression, its colonisation of everyday life. It is the beginning of the Great Leap Forward to Kruschov's Russia and Kennedy's America.

The real revolution begins at home: in the desperation of consumer production, in the continuing struggle of the unofficial working class. As yet this unofficial revolt has an official ideology. The notion that modern capitalism is producing new revolutionary forces, new poverties of a new proletariat, is still suppressed. Instead there is an a priori fascination with the 'conversion' or the 'subversion' of the old union movement. The militants are recuperating themselves (and their intellectual 'advisers' urge on the process). The only real subversion is in a new consciousness and a new alliance - the location of the struggle in the banalities of everyday life, in the supermarket and the beatclub as well as on the shopfloor. The enemy is entrism, cultural or political. Art and the Labour Movement are dead! Long live the Situationist International!

Members of the Internationale Situationniste and Students of Strasbourg

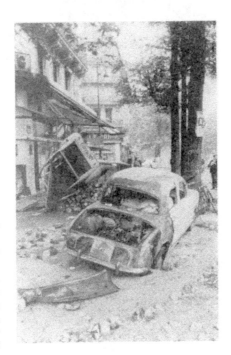

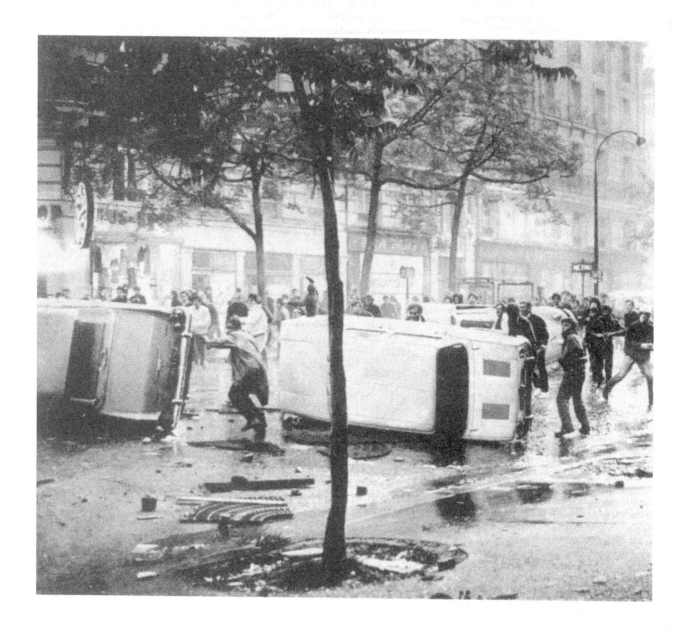

Our Goals & Methods in the Strasbourg Scandal

The various expressions of stupor and indignation in response to the situationist pamphlet *On the Poverty of Student Life*, which was published at the expense of the Strasbourg chapter of the French National Student Union (UNEF), although having the salutary effect of causing the theses in the pamphlet itself to be rather widely read, have inevitably given rise to numerous misconceptions in the reportage and commentaries on the SI's role in the affair. In response to all kinds of illusions fostered by the press, by university officials and even by a certain number of unthinking students, we are now going to specify exactly what the conditions of our intervention were and recount the goals we were pursuing with the methods that we considered consistent with them.

Even more erroneous than the exaggerations of the press or of certain opposing lawyers concerning the amount of money the SI supposedly took the opportunity of pillaging from the treasury of the pitiful student union is the absurd notion, often expressed in the journalistic accounts, according to which the SI sunk so low as to campaign among the Strasbourg students in order to persuade them of the validity of our perspectives and to get a bureau elected on such a program. We neither did this nor attempted the slightest infiltration of the UNEF by secretly slipping SI partisans into it. One has only to read us to realise that we have no interest in such goals and do not use such methods. The fact is that a few Strasbourg students came to us in the summer of 1966 and informed us that six of their friends - and not they themselves - had just been elected as officers of the Bureau of the local Students Association (AFGES), without any program whatsoever and in spite of their being widely known in the UNEF as extremists in complete disagreement with all the variants of that decomposing body, and even

determined to destroy it. The fact that they were elected (quite legally) clearly showed the complete apathy of the mass of students and the complete impotence of the Association's remaining bureaucrats. These latter no doubt figured that the "extremist" Bureau would be incapable of finding any adequate way to express its negative intentions. Conversely, this was the fear of the students who came to see us; and it was mainly for this reason that they had felt they themselves shouldn't take part in this 'Bureau': for only a coup of some scope, and not some merely humorous exploitation of their position, could save its members from the air of compromise that such a pitiful role immediately entails. To add to the complexity of the problem, while the students who spoke with us were familiar with the SI's positions and declared themselves in general agreement with them, those who were in the Bureau were for the most part ignorant of them, and counted mainly on the students we were seeing to determine the activity that would best correspond to their subversive intentions.

At this stage we limited ourselves to suggesting that all of them write and publish a general critique of the student movement and of the society, such a project having at least the advantage of forcing them to clarify in common what was still unclear to them. In addition, we stressed that their legal access to money and credit was the most useful aspect of the ridiculous authority that had so imprudently been allowed to them, and that a nonconformist use of these resources would certainly have the advantage of shocking many people and thus drawing attention to the nonconformist aspects of the content of their text.

These comrades agreed with our recommendations. In the development of this project they remained in contact with the SI, particular-

ly through Mustapha Khayati. The discussion and the first drafts undertaken collectively by those we had met with and the members of the AFGES Bureau - who had all resolved to see the matter through - brought about an important modification of the plan. Everyone agreed on the basis of the critique to be made, and specifically on the main points as Khayati had outlined them, but they found they were incapable of effecting a satisfactory formulation, especially in the short time remaining before the beginning of the term. This inability should not be seen as the result of any serious lack of talent or experience, but was simply the consequence of the extreme heterogeneity of the group, both within and outside the Bureau. Their initial coming together on the most vague bases prepared them very poorly to collectively articulate a theory they had not really appropriated together. In addition, personal antagonisms and mistrust arose among them as the project progressed; the common concern that the coup attain the most far-reaching and incisive effect was all that still held them together. In such circumstances, Khayati ended up drafting the greater part of the text, which was periodically discussed and approved among the group of students at Strasbourg and by the situationists in Paris - the only (few) significant changes being made by the latter.

Various preliminary actions announced the appearance of the pamphlet. On 26 October the cybernetician Moles, having finally attained a professorial chair in social psychology in order to devote himself to the programming of young cadres, was driven from it in the opening minutes of his opening lecture by tomatoes hurled at him by a dozen students. (Moles was given the same treatment in March at the Musee des Arts Decoratifs in Paris, where this certified robot was to lecture on the control of the masses by means of urbanism; this latter refutation was carried out by some thirty young anarchists belonging to groups that want to bring revolutionary criticism to bear on all modern issues.) Shortly after this inaugural class - which was at least as unprecedented in the annals of the university as Moles himself - the AFGES began publicising the pamphlet by pasting up Andre Bertrand's comic strip, The Return of the Durruti

Column, a document that had the merit of stating in no uncertain terms what his comrades were planning on doing with their positions: "The general crisis of the old union apparatuses and leftist bureaucracies was felt everywhere, especially among the students, where activism, for a long time. had no other outlet than the most sordid self sacrifice to stale ideologies and the most unrealistic ambitions. The last squad of professionals who elected our heroes didn't even have the excuse of mystification. They placed their hopes for a new lease of life in a group that didn't hide its intentions of scuttling this archaic militantism once and for all."

The pamphlet was distributed point-blank to the notables at the official opening ceremony of the university; simultaneously, the AFGES Bureau made it known that its only 'student' program was the immediate dissolution of that Association, and convoked a special general assembly to vote on that question. This perspective immediately horrified many people. "This may be the first concrete manifestation of a revolt aiming quite openly at the destruction of society," wrote a local newspaper (*Dernieres Nouvelles*, 4 December 1966). And *L'Aurore* of 26 November: "The Situationist International, an organisation with a handful of members in the chief capitals of Europe, anarchists playing at revolution, talk of 'seizing power' - not in order to keep it, but to sow disorder and destroy even their own authority." And even in Turin the *Gazetta del Popolo* of the same date expressed excessive concern: "It must be considered, however, whether repressive measures... might not risk provoking disturbances... In Paris and other university cities in France the Situationist International, galvanized by the triumph of its adherents in Strasbourg, is preparing to launch a major offensive to take control of the student organisations." At this point we had to take into consideration a new decisive factor: the situationists had to defend themselves from being *recuperated* as a 'news item' or an intellectual fad. The pamphlet had ended up being transformed into an SI text: we had not felt that we could refuse to aid these comrades in their desire to strike a blow against the system, and it was unfortunately *not possible for this aid to have been less than it was*. This involvement of

the SI gave us, for the duration of the project, a function of de facto leadership which we in no case wanted to prolong beyond this limited joint action: as anyone can well imagine, the pitiful *student milieu* is of no interest to us. Here as in any other situation, we simply had to act in such a way as to make the new social critique that is presently taking shape reappear by means of the practice without concessions that is its exclusive basis. It was the unorganised character of the group of Strasbourg students which had created the necessity for the direct situationist intervention and at the same time prevented even the carrying out of an orderly dialogue, which alone could have ensured a minimal equality in decision-making. The debate that normally characterises a joint action undertaken by independent groups had scarcely any reality in this agglomeration of individuals who showed more and more that they were united in their approval of the SI and separated in every other regard.

It goes without saying that such a deficiency in no way constituted for us a recommendation for the ensemble of this group of students, who seemed more or less interested in joining the SI as a sort of easy way of avoiding having to express themselves autonomously. Their lack of homogeneity was also revealed, to a degree we had not been able to foresee, on an unexpected issue: at the last minute several of them hesitated before the forthright distribution of the text at the university's opening ceremony. Khayati had to show these people that one must not try to make scandals half way, nor hope, in the midst of such an act in which one has already implicated oneself, that one will become less implicated by toning down the repercussions of the coup; that on the contrary, the success of a scandal is the only relative safeguard for those who have deliberately triggered it. Even more unacceptable than this last-minute hesitation on such a basic tactical point was the possibility that some of these individuals, who had so little confidence even in each other, would at some point come to make statements in our name. Khayati was thus charged by the SI to have the AFGES Bureau declare that none of them was a situationist. This they did in their communique of 29 November: "None of the members of our Bureau belongs to the Situationist International, a movement which for some time has published a journal of the same name, but we declare ourselves in complete solidarity with its analyses and perspectives." On the basis of this declared autonomy, the SI then addressed a letter to Andre Schneider, president of the AFGES, and Vayr-Piova, vice-president, to affirm its total solidarity with what they had done. The SI's solidarity with them has been maintained ever since, both by our refusal to dialogue with those who tried to approach us while manifesting a certain envious hostility toward the Bureau members (some even having the stupidity to denounce their action to the SI as being "spectacular"!) and by our financial assistance and public support during the subsequent repression (see the declaration signed by 79 Strasbourg students at the beginning of April in solidarity with Vayr-Piova, who had been expelled from the university; a penalty that was rescinded a few months later). Schneider and Vayr-Piova stood firm in the face of penalties and threats; this firmness, however, was not maintained to the same degree in their attitude toward the SI.

The judicial repression immediately initiated in Strasbourg - and which has since been followed by a series of proceedings in the same vein that are still going on - concentrated on the supposed illegality of the AFGES Bureau, which was, upon the publication of the situationist pamphlet, suddenly considered as a mere 'de facto Bureau' usurping the union representation of the students. This repression was all the more necessary since the holy alliance of the bourgeois, the Stalinists and the priests, formed in opposition to the AFGES, enjoyed an 'authority' even smaller than that of the Bureau among the city's 18,000 students. It began with the court order of 13 December, which sequestered the Association's offices and administration and prohibited the general assembly that the Bureau had convoked for the 16th for the purpose of voting on the dissolution of the AFGES. This ruling (resulting from the mistaken belief that a majority of the students were likely to support the Bureau's position if they had the opportunity to vote on it), by freezing the development of events, meant that our comrades - whose only

perspective was to destroy their own position of leadership without delay - were obliged to continue their resistance until the end of January. The Bureau's best practice until then had been their treatment of the mass of journalists who were flocking to get interviews: they refused most of them and insultingly boycotted those who represented the worst institutions (French Television, Planete); thus one segment of the press was induced to give a more exact account of the scandal and to reproduce the AFGES communiques less inaccurately. Since the fight was now taking place on the terrain of administrative measures and since the legal AFGES Bureau was still in control of the local section of the National Student Mutual, the Bureau struck back by deciding on 11 January, and by implementing this decision the next day, to close the 'University Psychological Aid Centre' (BAPU), which depended financially on the Mutual, "considering that the BAPUs are the manifestation in the student milieu of a repressive psychiatry's para-police control, whose clear function is to maintain... the passivity of all exploited sectors..., considering that the existence of a BAPU in Strasbourg is a disgrace and a threat to all the students of this university who are determined to think freely." At the national level, the UNEF was forced by the revolt of its Strasbourg chapter - which had previously been held up as a model - to recognise its own general bankruptcy. Although it obviously did not go so far as to defend the old illusions of unionist liberty that were so blatantly denied its opponents by the authorities, the UNEF nevertheless could not sanction the judicial expulsion of the Strasbourg Bureau. A Strasbourg delegation was thus present at the general assembly of the UNEF held in Paris on 14 January, and at the opening of the meeting demanded a preliminary vote on its motion to *dissolve the entire UNEF*, "considering that the UNEF declared itself a union uniting the vanguard of youth (Charter of Grenoble, 1946) at a time when workers' unionism had long since been defeated and turned into a tool for the self-regulation of modern capitalism, working to integrate the working class into the commodity system... considering that the vanguardist pretension of the UNEF is constantly belied by its subreformist slogans and practice... considering

that student unionism is a pure and simple farce and that it is urgent to put an end to it." This motion concluded by calling on "all revolutionary students of the world... to prepare along with all the exploited people of their countries a relentless struggle against all aspects of the old world, with the aim of contributing toward the advent of the international power of the workers councils." Only two associations, those of Nantes and of the convalescent-home students, voted with Strasbourg to deal with this preliminary motion before hearing the report of the national leadership (it should be noted, however, that in the preceding weeks the young UNEF bureaucrats had succeeded in deposing two other Association bureaux that had been spontaneously in favour of the AFGES position, those of Bordeaux and Clermont-Ferrand). The Strasbourg delegation consequently walked out on a debate where it had nothing more to say.

The final exit of the AFGES Bureau was not to be so noble, however. At this time three situationists (the 'Garnautins') had just been excluded for having jointly perpetrated - and been forced to admit before the SI - several slanderous lies directed against Khayati, whom they had hoped would himself be excluded as a result of this clever scheme (see the 22 January tract *Warning! Three Provocateurs*). Their exclusion had no relation with the Strasbourg scandal - in it as in everything else they had ostensibly agreed with the conclusions reached in SI discussions - but two of them happened to be from the Strasbourg region. In addition, as we mentioned above, certain of the Strasbourg students had begun to be irritated by the fact that the SI had not rewarded them for their shortcomings by recruiting them. The excluded liars sought out an uncritical public among them and counted on covering up their previous lies and their admission of them by piling new lies on top of them. Thus all those who had been rejected joined forces in the mystical pretension of going beyond the practice that had condemned them. They began to believe the newspapers and even to expand on them. They saw themselves as masses who had really 'seized power' in a sort of Strasbourg Commune. They told themselves that they hadn't been treated the way a revolutionary proletariat deserves to be treated. They

ON VOUS INTOXIQUE!

assured themselves that their historic action had superseded all previous theories: forgetting that the only discernable 'action' in an affair of this sort was, at most, the *drafting of a text*, they collectively compensated for this deficiency by inflating their illusions. This amounted to nothing more ambitious than dreaming together for a few weeks while continually upping the dose of constantly reiterated falsifications. The dozen Strasbourg students who had effectively supported the scandal split into two equal parts. This supplementary problem thus acted as a touchstone. We naturally made *no promises* to those who remained "partisans of the SI" and we clearly stated that we would not make any: it was simply up to them to be, unconditionally, partisans of the truth. Vayr-Piova and some others became partisans of falsehood with the excluded "Garnautins" (although certainly without knowledge of several excessive blunders in Frey's and Garnault's recent fabrications, but nevertheless being aware of quite a few of them). Andre Schneider, whose support the liars hoped to obtain since he held the title of AFGES president, was overwhelmed with false tales from all of them, and was weak enough to believe them without further investigation and to countersign one of their declarations. But after only a few days, independently becoming aware of a number of indisputable lies that these people thought it natural to tell their initiates in order to save their miserable cause, Schneider immediately decided that he should publicly acknowledge the mistake of his first course: with his tract *Memories from the House of the Dead* he denounced those who had deceived him and led him to share the responsibility for a false accusation against the SI. The return of Schneider, whose character the liars had underestimated and who had thus been privileged to witness the full extent of their collective manipulation of embarrassing facts, struck a definitive blow in Strasbourg itself against the excluded and their accomplices, who had already been discredited everywhere else. In their spite these wretches, who the week before had gone to so much trouble to win over Schneider in order to add to the credibility of their venture, proclaimed him a notoriously feeble-minded person who had simply succumbed to "the prestige of the SI." (More and more often, recently, in the most diverse discussions, liars end up in this way unwittingly identifying "the prestige of the SI" with *the simple fact of telling the truth* - an amalgam that certainly does us honour.) Before three months had gone by, the association of Frey and consorts with Vayr-Piova and all those who were willing to maintain a keenly solicited adhesion (at one time there were as many as eight or nine of them) was to reveal its sad reality: based on infantile lies by individuals who considered each other to be clumsy liars, it was the very picture, involuntarily parodic, of a type of 'collective action' that should never be engaged in; and with the type of people who should never be associated with! They went so far as to conduct a ludicrous *electoral campaign* before the students of Strasbourg. Dozens of pages of pedantic scraps of misremembered situationist ideas and phrases were, with a total unawareness of the absurdity, run off with the sole aim of *keeping the 'power' of the Strasbourg chapter of the MNEF*, microbureaucratic fiefdom of Vayr-Piova, who was eligible for re-election 13 April. As successful in this venture as in their previous maneuvres, they were defeated by people as stupid as they were - Stalinists and Christians who were more naturally partial to electoralism, and who also enjoyed the bonus of being able to denounce their deplorable rivals as "false situationists." In the tract *The SI Told You So*, put out the next day, Andre Schneider and his comrades were easily able to show how this unsuccessful attempt to exploit the remains of the scandal of five months before for promotional purposes revealed itself as the complete renunciation of the spirit and the declared perspectives of that scandal. Finally Vayr-Piova, in a communique distributed 20 April, stated: "I find it amusing to be at last denounced as a 'nonsituationist' - something I have openly proclaimed since the SI set itself up as an official power." This is a representative sample of a vast and already forgotten literature. That the SI has become *an official power* - this is one of those theses typical of Vayr-Piova or Frey, which can be examined by those who are interested in the question; and after doing this they will know what to think of the intelligence of such theoreticians. But this

aside, the fact that Vayr-Piova proclaims - "openly," or even perhaps "secretly" in a "proclamation" reserved for the most discreet accomplices in his lies, for example? - that he has not belonged to the SI since whenever was the date of our transformation into an "official power" - this is a *boldfaced lie*. Everyone who knows him knows that Vayr-Piova has never had the opportunity to claim to be anything but a "nonsituationist" (see what we wrote above concerning the AFGES communique of 29 November).

The most favourable results of this whole affair naturally go beyond this new and opportunely much-publicised example of our refusal to enlist anything that a neomilitantism in search of glorious subordination might throw our way. No less negligible is that aspect of the result that forced the official recognition of the irreparable decomposition of the UNEF, a decomposition that was even more advanced than its pitiful appearance suggested: the coup de grace was still echoing in July at its 56th Congress in Lyon, in the course of which the sad president Vandenburie had to confess: "The unity of the UNEF has long since ended. Each association lives (*SI note: this term is pretentiously inaccurate*) autonomously, without paying any attention to the directives of the National Committee. The growing gap between the base and the governing bodies has reached a state of serious degradation. The history of the proceedings of the UNEF has been nothing but a series of crises... Reorganisation and a revival of action have not been possible." Equally comical were some side-effects stirred up among the academics who felt that this was another current issue to petition about. As can be well imagined, we considered the position published by the forty professors and assistants of the Faculty of Arts at Strasbourg, which denounced the *false students* behind this "tempest in a teacup" about false problems "without the shadow of a solution," to be more logical and socially rational (as was, for that matter, Judge Llabador's summing up) than that wheedling attempt at approval circulated in February by a few decrepit modernist-institutionalists gnawing their meagre bones at the professorial chairs of 'Social Sciences' at Nanterre (impudent Touraine, loyal Lefebvre, pro-Chinese Baudrillart, cunning

Lourau).

In fact, we want ideas to become *dangerous* again. We cannot be accepted with the spinelessness of a false eclectic interest, as if we were Sartres, Althussers, Aragons or Godards. Let us note the wise words of a certain Professor Lhuillier, reported in the 21 December *Nouvel Observateur*: "I am for freedom of thought. But if there are any Situationists in the room, I want them to get out right now." While not entirely denying the effect that the dissemination of a few basic truths may have had in slightly accelerating the movement that is impelling the lagging French youth toward an awakening awareness of an impending more general crisis in the society, we think that the distribution of *On the Poverty of Student Life* has been a much more significant factor of clarification in some other countries where such a process is already much more clearly under way. In the afterword of their edition of Khayati's text, the English situationists wrote: "The most highly developed critique of modern life has been made in one of the least highly developed modern countries - in a country which has not yet reached the point where the complete disintegration of all values becomes patently obvious and engenders the corresponding forces of radical rejection. In the French context, situationist theory has anticipated the social forces by which it will be realised." The theses of *On the Poverty of Student Life* have been much more truly understood in the United States and England (the strike at the London School of Economics in March caused a certain stir, the Times commentator unhappily seeing in it a return of the class struggle he had thought was over with). To a lesser degree this is also the case in Holland - where the SI's critique, reinforcing a much harsher critique by events themselves, was not without effect on the recent dissolution of the 'Provo' movement - and in the Scandinavian countries. The struggles of the West Berlin students this year have picked up something of the critique, though in a still very confused way.

But revolutionary youth naturally has no other course than to join with the mass of workers who, starting from the experience of the new conditions of exploitation, are going to take up once again the struggle for the domination of

their world, for the suppression of work. When young people begin to know the current theoretical form of this real movement that is everywhere spontaneously bursting forth from the soil of modern society, this is only a *moment* of the progression by which this unified theoretical critique, which identifies itself with an adequate *practical unification*, strives to break the silence and the general organisation of separation. It is only in this sense that we find the result satisfactory. We obviously exclude from these young people that alienated semiprivileged fraction molded by the university: this sector is the natural base for an admiring consumption of a fantasised situationist theory considered as the latest spectacular fashion. We will continue to disappoint and refute this kind of approbation. Sooner or later it will be understood that the SI must be judged not on the superficially scandalous aspects of certain manifestations through which it appears, but on its *essentially scandalous* central truth.

Situationist International 11, October 1967

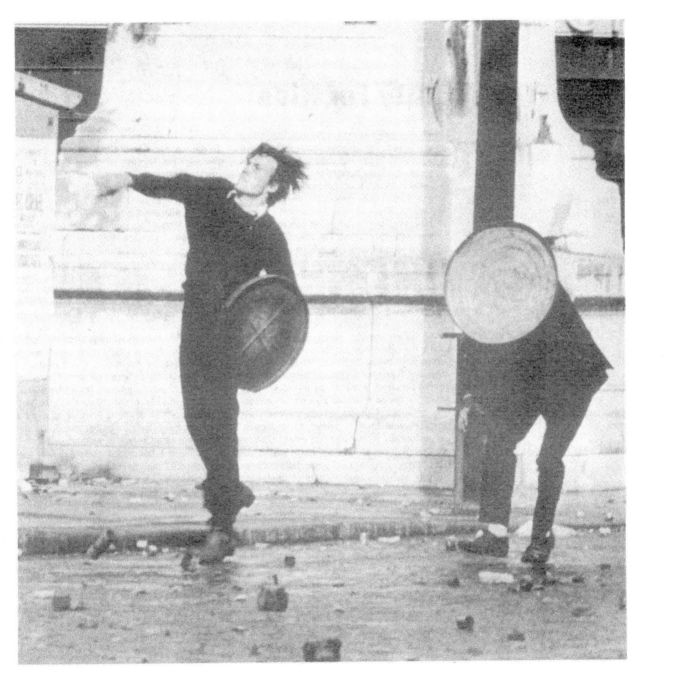

The Totality For Kids

Almost everyone has always been excluded from life and forced to devote the whole of their energy to survival. Today, the welfare state imposes the elements of this survival in the form of technological comforts (cars, frozen foods, Welwyn Garden City, Shakespeare televised for the masses).

Moreover, the organisation controlling the material equipment of our everyday lives is such that what in itself would enable us to construct them richly, plunges us instead into a luxury of impoverishment, making alienation even more intolerable as each element of comfort appears to be a liberation and turns out to be a servitude. We are condemned to the slavery of working for freedom.

To be understood, this problem must be seen in the light of hierarchical power. Perhaps it isn't enough to say that hierarchical power has preserved humanity for thousands of years as alcohol preserves a foetus, by arresting either growth or decay. It should also be made clear that hierarchical power represents the most highly evolved form of private appropriation, and historically is its alpha and omega. Private appropriation itself can be defined as appropriation of things by means of appropriation of people, the struggle against natural alienation engendering social alienation.

Private appropriation entails an organisation of appearances by which its radical contradictions can be dissimulated. The executives must see themselves as degraded reflections of the master, thus strengthening, through the looking-glass of an illusory liberty, all that produces their submission and their passivity. The master must be identified with the mythical and perfect servant of a god or a transcendence, whose substance is no more than a sacred and abstract representation of the totality of people and things over which the master exercises a power which can only become even stronger as everyone accepts the purity of his renunciation. To the real sacrifice of the worker corresponds the mythical sacrifice of the organiser, each negates himself in the other, the strange becomes familiar and the familiar strange, each is realised in an inverted perspective. From this common alienation a harmony is born, a negative harmony whose fundamental unity lies in the notion of sacrifice. This objective (and perverted) harmony is sustained by myth; this term having been used to characterise the organisation of appearances in unitary societies, that is to say, in societies where power over slaves, over a tribe, or over serfs is officially consecrated by divine authority where the sacred allows power to seize the totality.

The harmony based initially on the 'gift of oneself' contains a relationship which was to develop, become autonomous, and destroy it. This relationship is based on partial exchange (commodity, money, product, labour force...) the exchange of a part of oneself on which the bourgeois conception of liberty is based. It arises as commerce and technology become preponderant within agrarian-type economies.

When the bourgeoisie seized power they destroyed its unity. Sacred private appropriation became liacised in capitalistic mechanisms. The totality was freed from its seizure by power and became concrete and immediate once more. The era of fragmentation has been a succession of attempts to recapture an inaccessible unity, to shelter power behind a substitute for the sacred.

A revolutionary movement is when 'all that reality presents' finds its immediate representation. For the rest of the time hierarchical power, always more distant from its magical and mystical regalia, endeavours to make everyone forget that the totality (no more than reality!) exposes its imposture.

1 Bureaucratic capitalism has found its legitimation in Marx. I am not referring here to orthodox Marxism's dubious merit of having reinforced the neocapitalist structures whose present reorganisation is an implicit homage to Soviet totalitarianism; I am emphasising the extent to which Marx's most profound analyses of alienation have been vulgarised in the most commonplace facts, which, stripped of their magical veil and materialised in each gesture, have become the sole substance, day after day, of the lives of an increasing number of people. In a word, bureaucratic capitalism contains the palpable reality of alienation; it has brought it home to everybody far more successfully than Marx could ever have hoped to do, it has banalised it as the diminishing of material poverty has been accompanied by a spreading mediocrity of existence. As poverty has been reduced in terms of mere material survival, it has become more profound in terms of our way of life - this is at least one widespread feeling that exonerates Marx from all the interpretations a degenerate Bolshevism has derived from him. The "theory" of peaceful coexistence has accelerated such an awareness and revealed, to those who were still confused, that exploiters can get along quite well with each other despite their spectacular divergences.

2 "Any act," writes Mircea Eliade, "can become a religious act. Human existence is realised simultaneously on two parallel planes, that of temporality, becoming, illusion, and that of eternity, substance, reality." In the nineteenth century the brutal divorce of these two planes demonstrated that power would have done better to have maintained reality in a mist of divine transcendence. But we must give reformism credit for succeeding where Bonaparte had failed, in dissolving becoming in eternity and reality in illusion; this union may not be as solid as the sacraments of religious marriage, but it is lasting, which is the most the managers of coexistence and social peace can ask of it. This is also what leads us to define ourselves - in the illusory but inescapable perspective of duration - as the end of abstract temporality, as the end of the reified time of our acts; to define ourselves - does it have to be spelled

out? - at the positive pole of alienation as the end of social alienation, as the end of humanity's term of social alienation.

3 The socialisation of primitive human groups reveals a will to struggle more effectively against the mysterious and terrifying forces of nature. But struggling in the natural environment, at once with it and against it, submitting to its most inhuman laws in order to wrest from it an increased chance of survival - doing this could only engender a more evolved form of aggressive defence, a more complex and less primitive attitude, manifesting on a higher level the contradictions that the uncontrolled and yet influenceable forces of nature never ceased to impose. In becoming socialised, the struggle against the blind domination of nature triumphed inasmuch as it gradually assimilated primitive, natural alienation, but in another form. Alienation became social in the fight against natural alienation. Is it by chance that a technological civilisation has developed to such a point that social alienation has been revealed by its conflict with the last areas of natural resistance that technological power hadn't managed (and for good reasons) to subjugate? Today the technocrats propose to put an end to primitive alienation: with a stirring humanitarianism they exhort us to perfect the technical means that "in themselves" would enable us to conquer death, suffering, discomfort and boredom. But to get rid of death would be less of a miracle than to get rid of suicide and the desire to die. There are ways of abolishing the death penalty than can make one miss it. Until now the specific use of technology - or more generally the socioeconomic context in which human activity is confined - while quantitatively reducing the number of occasions of pain and death, has allowed death itself to eat like a cancer into the heart of each person's life.

4 The prehistoric food-gathering age was succeeded by the hunting age during which clans formed and strove to increase their chances of survival. Hunting grounds and reserves were staked out from which outsiders were absolutely excluded since the welfare of the whole clan depended on its maintaining its

territory. As a result, the freedom gained by settling down more comfortably in the natural environment, and by more effective protection against its rigors, engendered its own negation outside the boundaries laid down by the clan and forced the group to moderate its customary rules in organising its relations with excluded and threatening groups. From the moment it appeared, socially constituted economic survival implied the existence of boundaries, restrictions, conflicting rights. It should never be forgotten that until now both history and our own nature have developed in accordance with the movement of privative appropriation: the seizing of control by a class, group, caste or individual of a general power over socioeconomic survival whose form remains complex - from ownership of land, territory, factories or capital, all the way to the "pure" exercise of power over people (hierarchy). Beyond the struggle against regimes whose vision of paradise is a cybernetic welfare state lies the necessity of a still greater struggle against a fundamental and initially natural state of things, in the development of which capitalism plays only an incidental, transitory role; a state of things which will only disappear when the last traces of hierarchical power disappear - along with the "swine of humanity;' of course.

5 To be an owner is to arrogate a good from whose enjoyment one excludes other people - while at the same time recognising everyone's abstract right to possession. By excluding people from the real right of ownership, the owner extends his dominion over those he has excluded (absolutely over non-owners, relatively over other owners), without whom he is nothing. The non-owners have no choice in the matter. The owner appropriates and alienates them as producers of his own power, while the necessity of ensuring their own physical existence forces them in spite of themselves to collaborate in producing their own exclusion and to survive without ever being able to live. Excluded, they participate in possession through the mediation of the owner, a mystical participation characterising from the outset all the clan and social relationships that gradually replaced the principle of obligatory cohesion in which each member was an integral part of the group ("organic interdependence"). Their guarantee of survival depends on their activity within the framework of privative appropriation. They reinforce a right to property from which they are excluded. Due to this ambiguity each of them sees himself as participating in ownership, as a living fragment of the right to possess, and this belief in turn reinforces his condition as excluded and possessed. (Extreme cases of this alienation: the faithful slave, the cop, the bodyguard, the centurion - creatures who, through a sort of union with their own death, confer on death a power equal to the forces of life and identify in a destructive energy the negative and positive poles of alienation, the absolutely submissive slave and the absolute master.) It is of vital importance to the exploiter that this appearance is maintained and made more sophisticated; not because he is especially machiavellian, but simply because he wants to stay alive. The organisation of appearance is bound to the survival of his privileges and to the physical survival of the non-owner, who can thus remain alive while being exploited and excluded from being a person. Privative appropriation and domination are thus originally imposed and felt as a positive right, but in the form of a negative universality. Valid for everyone, justified in everyone's eyes by divine or natural law, the right of privative appropriation is objectified in a general illusion, in a universal transcendence, in an essential law under which everyone individually manages to tolerate the more or less narrow limits assigned to his right to live and to the conditions of life in general.

6 In this social context the function of alienation must be understood as a condition of survival. The labour of the non-owners is subject to the same contradictions as the right of privative appropriation. It transforms them into possessed beings, into producers of their own expropriation and exclusion, but it represents the only chance of survival for slaves, for serfs, for workers - so much so that the activity that allows their existence to continue by emptying it of all content ends up, through a natural and sinister reversal of perspective, by taking on a positive sense. Not only has value been attributed

to work (in its form of sacrifice in the ancien régime, in its brutalising aspects in bourgeois ideology and in the so-called People's Democracies), but very early on to work for a master, to alienate oneself willingly, became the honourable and scarcely questioned price of survival. The satisfaction of basic needs remains the best safeguard of alienation; it is best dissimulated by being justified on the grounds of undeniable necessities. Alienation multiplies needs because it can satisfy none of them; nowadays lack of satisfaction is measured in the number of cars, refrigerators, TVs: the alienating objects have lost the ruse and mystery of transcendence, they are there in their concrete poverty. To be rich today is to possess the greatest number of poor objects.

Up to now surviving has prevented us from living. This is why much is to be expected of the increasingly evident impossibility of survival, an impossibility which will become all the more evident as the glut of conveniences and elements of survival reduces life to a single choice: suicide or revolution.

7 The sacred presides even over the struggle against alienation. As soon as the relations of exploitation and the violence that underlies them are no longer concealed by the mystical veil, there is a breakthrough, a moment of clarity, the struggle against alienation is suddenly revealed as a ruthless hand-to-hand fight with naked power, power exposed in its brute force and its weakness, a vulnerable giant whose slightest wound confers on the attacker the infamous notoriety of an Erostratus. Since power survives, the event remains ambiguous. Praxis of destruction, sublime moment when the complexity of the world becomes tangible, transparent, within everyone's grasp; inexpiable revolts - those of the slaves, the Jacques, the iconoclasts, the Enrages, the Communards, Kronstadt, the Asturias, and - promises of things to come - the hooligans of Stockholm and the wildcat strikes... only the destruction of all hierarchical power will allow us to forget these. We aim to make sure it does.
The deterioration of mythical structures and their slowness in regenerating themselves, which make possible the awakening of con-

sciousness and the critical penetration of insurrection, are also responsible for the fact that once the "excesses" of revolution are past, the struggle against alienation is grasped on a theoretical plane, subjected to an "analysis" that is a carryover from the demystification preparatory to revolt. It is at this point that the truest and most authentic aspects of a revolt are re-examined and repudiated by the "we didn't really mean to do that" of the theoreticians charged with explaining the meaning of an insurrection to those who made it - to those who aim to demystify by acts, not just by words.
All acts contesting power call for analysis and tactical development. Much can be expected of:
a) the new proletariat, which is discovering its destitution amidst consumer abundance (see the development of the workers' struggles presently beginning in England, and the attitudes of rebellious youth in all the modern countries);
b) countries that have had enough of their partial, sham revolutions and are consigning their past and present theorists to the museums (see the role of the intelligentsia in the Eastern bloc);
c) the Third World, whose mistrust of technological myths has been kept alive by the colonial cops and mercenaries, the last, over-zealous militants of a transcendence against which they are the best possible vaccination;
d) the force of the SI ("our ideas are in everyone's mind"), capable of forestalling remote-controlled revolts, "crystal nights" and sheepish resistance.

8 Privative appropriation is bound to the dialectic of particular and general. In the mystical realm where the contradictions of the slave and feudal systems are resolved, the non-owner, excluded as a particular individual from the right of possession, strives to ensure his survival through his labour: the more he identifies with the interests of the master, the more successful he is. He knows the other non-owners only through their common plight: the compulsory surrender of their labour power (Christianity recommended voluntary surrender: once the slave "willingly" offered his labour

power, he ceased to be a slave), the search for the optimum conditions of survival, and mystical identification. Struggle, though born of a universal will to survive, takes place on the level of appearance where it brings into play identification with the desires of the master and thus introduces a certain individual rivalry that reflects the rivalry between the masters. Competition develops on this plane as long as the relations of exploitation remain dissimulated behind a mystical opacity and as long as the conditions producing this opacity continue to exist; as long as the degree of slavery determines the slave's consciousness of the degree of lived reality. (We are still at the stage of calling "objective consciousness" what is in reality the consciousness of being an object.) The owner, for his part, depends on the general acknowledgment of a right from which he alone is not excluded, but which is seen on the plane of appearance as a right accessible to each of the excluded taken individually. His privileged position depends on such a belief, and this belief is also the basis for the strength that is essential if he is to hold his own among the other owners; it is his strength. If, in his turn, he seems to renounce exclusive appropriation of everything and everybody, if he poses less as a master than as a servant of public good and defender of collective security, then his power is crowned with glory and to his other privileges he adds that of denying, on the level of appearance (which is the only level of reference in unilateral communication), the very notion of personal appropriation; he denies that anyone has this right, he repudiates the other owners. In the feudal perspective the owner is not integrated into appearance in the same way as the non-owners, slaves, soldiers, functionaries, servants of all kinds. The lives of the latter are so squalid that the majority can live only as a caricature of the Master (the feudal lord, the prince, the major-domo, the taskmaster, the high priest, God, Satan...). But the master himself is also forced to play one of these caricatural roles. He can do so without much effort since his pretension to total life is already so caricatural, isolated as he is among those who can only survive. He is already one of our own kind (with the added grandeur of a past epoch, which adds an exquisite savour to his

sadness); he, like each of us, was anxiously seeking the adventure where he could find himself on the road to his total perdition. Could the master, at the very moment he alienates the others, see that he reduces them to dispossessed and excluded beings, and thus realise that he is only an exploiter, a purely negative being? Such an awareness is unlikely and would be dangerous. By extending his dominion over the greatest possible number of subjects, isn't he enabling them to survive, giving them their only chance of salvation? ("Whatever would happen to the workers if the capitalists weren't kind enough to employ them?" the high-minded souls of the nineteenth century liked to ask.) In fact, the owner officially excludes himself from all claim to privative appropriation. To the sacrifice of the non- owner, who through his labour exchanges his real life for an apparent one (thus avoiding immediate death by allowing the master to determine his variety of living death), the owner replies by appearing to sacrifice his nature as owner and exploiter; he excludes himself mythically, he puts himself at the service of everyone and of myth (at the service of God and his people, for example). With an additional gesture, with an act whose gratuitousness bathes him in an otherworldly radiance, he gives renunciation its pure form of mythical reality, renouncing common life, he is the poor man amidst illusory wealth, he who sacrifices himself for everyone while all the other people only sacrifice themselves for their own sake, for the sake of their survival. He turns his predicament into prestige. The more powerful he is the greater his sacrifice. He becomes the living reference point of the whole illusory life, the highest attainable point in the scale of mythical values. "Voluntarily" withdrawn from common mortals, he is drawn toward the world of the gods, and his more or less established participation in divinity, on the level of appearance (the only generally acknowledged frame of reference), consecrates his rank in the hierarchy of the other owners. In the organisation of transcendence the feudal lord - and, through osmosis, the owners of some power or production materials, in varying degrees - is led to play the principal role, the role that he really does play in the economic organisation of the group's survival. As a result,

LA BEAUTÉ

EST DANS LA RUE

the existence of the group is bound on every level to the existence of the owners as such, to those who, owning everything because they own everybody, also force everyone to renounce their lives on the pretext of the owners' unique, absolute and divine renunciation. (From the god Prometheus punished by the gods to the god Christ punished by men, the sacrifice of the Owner becomes vulgarised, it loses its sacred aura, is humanised.) Myth thus unites owner and non-owner, it envelops them in a common form in which the necessity of survival, whether merely physical or as a privileged being, forces them to live on the level of appearance and of the inversion of real life, the inversion of the life of everyday praxis. We are still there waiting to live a life less than or beyond a mystique against which our every gesture protests while submitting to it.

9 Myth, the unitary absolute in which the contradictions of the world find an illusory resolution, the harmonious and constantly harmonised vision that reflects and reinforces order - this is the sphere of the sacred, the extra-human zone where an abundance of revelations are manifested but where the revelation of the process of privative appropriation is carefully suppressed. Nietzsche saw this when he wrote, "All becoming is a criminal revolt from eternal being and its price is death." When the bourgeoisie claimed to replace the pure Being of feudalism with Becoming, all it really did was to desacralise Being and resacralise Becoming to its own profit; it elevated its own Becoming to the status of Being, no longer that of absolute ownership but rather that of relative appropriation: a petty democratic and mechanical Becoming, with its notions of progress, merit and causal succession. The owner's life hides him from himself; bound to myth by a life and death pact, he cannot see himself in the positive and exclusive enjoyment of any good except through the lived experience of his own exclusion. (And isn't it through this mythical exclusion that the non-owners will come to grasp the reality of their own exclusion?) He bears the responsibility for a group, he takes on the burden of a god. Submitting himself to its benediction and its retribution, he swathes himself in

austerity and wastes away. Model of gods and heroes, the master, the owner, is the true reality of Prometheus, of Christ, of all those whose spectacular sacrifice has made it possible for "the vast majority of people" to continue to sacrifice themselves to the extreme minority, to the masters. (Analysis of the owner's sacrifice should be worked out more subtly: isn't the case of Christ really the sacrifice of the owner's son? If the owner can never sacrifice himself except on the level of appearance, then Christ stands for the real immolation of the owner's son when circumstances leave no other alternative. As a son he is only an owner at a very early stage of development, an embryo, little more than a dream of future ownership. In this mythic dimension belongs Barrès' well-known remark in 1914 when war had arrived and made his dreams come true at last: "Our youth, as is proper, has gone to shed torrents of our blood.") This rather distasteful little game, before it became transformed into a symbolic rite, knew a heroic period when kings and tribal chiefs were ritually put to death according to their "will." Historians assure us that these august martyrs were soon replaced by prisoners, slaves or criminals. They may not get hurt any more, but they've kept the halo.

10 The concept of a common fate is based on the sacrifice of the owner and the non-owner. Put another way, the notion of a human condition is based on an ideal and tormented image whose function is to resolve the irresolvable opposition between the mythical sacrifice of the minority and the really sacrificed life of everyone else. The function of myth is to unify and eternalise, in a succession of static moments, the dialectic of "will-to-live" and its opposite. This universally dominant factitious unity attains its most tangible and concrete representation in communication, particularly in language. Ambiguity is most manifest at this level, it leads to an absence of real communication, it puts the analyst at the mercy of ridiculous phantoms, at the mercy of words - eternal and changing instants - whose content varies according to who pronounces them, as does the notion of sacrifice. When language is put to the test, it can no longer dissimulate the misrepre-

sentation and thus it provokes the crisis of participation. In the language of an era one can follow the traces of total revolution, unfulfilled but always imminent. They are the exalting and terrifying signs of the upheavals they foreshadow, but who takes them seriously? The discredit striking language is as deeply rooted and instinctive as the suspicion with which myths are viewed by people who at the same time remain firmly attached to them. How can key words be defined by other words? How can phrases be used to point out the signs that refute the phraseological organisation of appearance? The best texts still await their justification. When a poem by Mallarmé becomes the sole explanation for an act of revolt, then poetry and revolution will have overcome their ambiguity. To await and prepare for this moment is to manipulate information not as the last shock wave whose significance escapes everyone, but as the first repercussion of an act still to come.

11 Born of man's will to survive the uncontrollable forces of nature, myth is a public welfare policy that has outlived its necessity. It has consolidated its tyrannical force by reducing life to the sole dimension of survival, by negating it as movement and totality.
When contested, myth homogenises the diverse attacks on it; sooner or later it engulfs and assimilates them. Nothing can withstand it, no image or concept that attempts to destroy the dominant spiritual structures. It reigns over the expression of facts and lived experience, on which it imposes its own interpretive structure (dramatisation). Private consciousness is the consciousness of lived experience that finds its expression on the level of organised appearance.

Myth is sustained by rewarded sacrifice. Since every individual life is based on its own renunciation, lived experience must be defined as sacrifice and recompense. As a reward for his asceticism, the initiate (the promoted worker, the specialist, the manager - new martyrs canonised democratically) is granted a niche in the organisation of appearance; he is made to feel at home in alienation. But collective shelters disappeared with unitary societies, all that's left is their later concrete embodiments for the ben-

efit of the public: temples, churches, palaces... memories of a universal protection. Shelters are private nowadays, and even if their protection is far from certain there can be no mistaking their price.

12 "Private" life is defined primarily in a formal context. It is, to be sure, born out of the social relations created by privative appropriation, but its essential form is determined by the expression of those relations. Universal, incontestable but constantly contested, this form makes appropriation a right belonging to everyone and from which everyone is excluded, a right one can obtain only by renouncing it. As long as it fails to break free of the context imprisoning it (a break that is called revolution), the most authentic experience can be grasped, expressed and communicated only by way of an inversion through which its fundamental contradiction is dissimulated. In other words, if a positive project fails to sustain a praxis of radically overthrowing the conditions of life - which are nothing other than the conditions of privative appropriation - it does not have the slightest chance of escaping being taken over by the negativity that reigns over the expression of social relationships: it is recuperated like the image in a mirror, in inverse perspective. In the totalising perspective in which it conditions the whole of everyone's life, and in which its real and its mythic power can no longer be distinguished (both being both real and mythical), the process of privative appropriation has made it impossible to express life any way except negatively. Life in its entirety is suspended in a negativity that corrodes it and formally defines it. To talk of life today is like talking of rope in the house of a hanged man. Since the key of will-to-live has been lost we have been wandering in the corridors of an endless mausoleum. The dialogue of chance and the throw of the dice no longer suffices to justify our lassitude; those who still accept living in well-furnished weariness picture themselves as leading an indolent existence while failing to notice in each of their daily gestures a living denial of their despair, a denial that should rather make them despair only of the poverty of their imagination. Forgetting life, one can identify with a range of

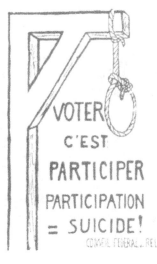

VOTER C'EST PARTICIPER
PARTICIPATION = SUICIDE!
CONSEIL FEDERAL...REL

images, from the brutish conqueror and brutish slave at one pole to the saint and the pure hero at the other. The air in this shithouse has been unbreathable for a long time. The world and man as representation stink like carrion and there's no longer any god around to turn the charnel houses into beds of lilies. After all the ages men have died while accepting without notable change the explanations of gods, of nature and of biological laws, it wouldn't seem unreasonable to ask if we don't die because so much death enters - and for very specific reasons - into every moment of our lives.

13 Privative appropriation can be defined notably as the appropriation of things by means of the appropriation of people. It is the spring and the troubled water where all reflections mingle and blur. Its field of action and influence, spanning the whole of history, seems to have been characterised until now by a fundamental double behavioural determination: an ontology based on sacrifice and negation of self (its subjective and objective aspects respectively) and a fundamental duality, a division between particular and general, individual and collective, private and public, theoretical and practical, spiritual and material, intellectual and manual, etc. The contradiction between universal appropriation and universal expropriation implies that the master has been seen for what he is and isolated. This mythical image of terror, want and renunciation presents itself to slaves, to servants, to all those who can't stand living as they do; it is the illusory reflection of their participation in property, a natural illusion since they really do participate in it through the daily sacrifice of their energy (what the ancients called pain or torture and we call labour or work) since they themselves produce this property in a way that excludes them. The master can only cling to the notion of work-as-sacrifice, like Christ to his cross and his nails; it is up to him to authenticate sacrifice, to apparently renounce his right to exclusive enjoyment and to cease to expropriate with purely human violence (that is, violence without mediation). The sublimity of the gesture obscures the initial violence, the nobility of the sacrifice absolves the commando, the brutality of the conqueror is bathed in the

light of a transcendence whose reign is internalised, the gods are the intransigent guardians of rights, the irascible shepherds of a peaceful and law-abiding flock of "Being and Wanting-To-Be Owner." The gamble on transcendence and the sacrifice it implies are the masters' greatest conquest, their most accomplished submission to the necessity of conquest. Anyone who intrigues for power while refusing the purification of renunciation (the brigand or the tyrant) will sooner or later be tracked down and killed like a mad dog, or worse: as someone who only pursues his own ends and whose blunt conception of "work" lacks any tact toward others' feelings: Troppmann, Landru, Petiot, murdering people without justifying it in the name of defending the Free World, the Christian West, the State or Human Dignity, were doomed to eventual defeat. By refusing to play the rules of the game, pirates, gangsters and outlaws disturb those with good consciences (whose consciences are a reflection of myth), but the masters, by killing the encroacher or enrolling him as a cop, re-establish the omnipotence of "eternal truth": those who don't sell themselves lose their right to survive and those who do sell themselves lose their right to live. The sacrifice of the master is the matrix of humanism, which is what makes humanism - and let this be understood once and for all the miserable negation of everything human. Humanism is the master taken seriously at his own game, acclaimed by those who see in his apparent sacrifice - that caricatural reflection of their real sacrifice - a reason to hope for salvation. Justice, dignity, nobility, freedom... these words that yap and howl, are they anything other than household pets whose masters have calmly awaited their homecoming since the time when heroic lackeys won the right to walk them on the streets? To use them is to forget that they are the ballast that enables power to rise out of reach. And if we imagine a regime deciding that the mythical sacrifice of the masters should not be promoted in such universal forms, and setting about tracking down these word-concepts and wiping them out, we could well expect the Left to be incapable of combating it with anything more than a plaintive battle of words whose every phrase, invoking the "sacrifice" of a previous master, calls for an

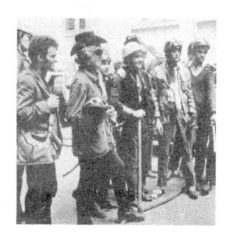

equally mythical sacrifice of a new one (a leftist master, a power mowing down workers in the name of the proletariat). Bound to the notion of sacrifice, humanism is born of the common fear of masters and slaves: it is nothing but the solidarity of a shit-scared humanity. But those who reject all hierarchical power can use any word as a weapon to punctuate their action. Lautréamont and the illegalist anarchists were already aware of this; so were the dadaists.

The appropriator thus becomes an owner from the moment he puts the ownership of people and things in the hands of God or of some universal transcendence whose omnipotence is reflected back on him as a grace sanctifying his slightest gesture; to oppose an owner thus consecrated is to oppose God, nature, the fatherland, the people. In short, to exclude oneself from the physical and spiritual world. "We must neither govern nor be governed," writes Marcel Havrenne so neatly. For those who add an appropriate violence to his humour, there is no longer any salvation or damnation, no place in the universal order, neither with Satan, the great recuperator of the faithful, nor in any form of myth since they are the living proof of the uselessness of all that. They were born for a life yet to be invented; insofar as they lived, it was on this hope that they finally came to grief.

Two corollaries of singularisation in transcendence:

a) If ontology implies transcendence, it is clear that any ontology automatically justifies the being of the master and the hierarchical power wherein the master is reflected in degraded, more or less faithful images.

b) Over the distinction between manual and intellectual work, between practice and theory, is superimposed the distinction between work-as-real-sacrifice and the organisation of work in the form of apparent sacrifice.

It would be tempting to explain fascism - among other reasons for it - as an act of faith, the auto-da-fé of a bourgeoisie haunted by the murder of God and the destruction of the great sacred spectacle, dedicating itself to the devil, to an inverted mysticism, a black mysticism with its rituals and its holocausts. Mysticism and high finance.

It should not be forgotten that hierarchical power is inconceivable without transcendence, without ideologies, without myths. Demystification itself can always be turned into a myth: it suffices to "omit," most philosophically, demystification by acts. Any demystification so neutralised, with the sting taken out of it, becomes painless, euthanasic, in a word, humanitarian. Except that the movement of demystification will ultimately demystify the demystifiers.

14 By directly attacking the mythical organisation of appearance, the bourgeois revolutions, in spite of themselves, attacked the weak point not only of unitary power but of any hierarchical power whatsoever. Does this unavoidable mistake explain the guilt complex that is one of the dominant traits of bourgeois mentality? In any case, the mistake was undoubtedly inevitable.

It was a mistake because once the cloud of lies dissimulating privative appropriation was pierced, myth was shattered, leaving a vacuum that could be filled only by a delirious freedom and a splendid poetry. Orgiastic poetry, to be sure, has not yet destroyed power. Its failure is easily explained and its ambiguous signs reveal the blows struck at the same time as they heal the wounds. And yet - let us leave the historians and aesthetes to their collections - one has only to pick at the scab of memory and the cries, words and gestures of the past make the whole body of power bleed again. The whole organisation of the survival of memories will not prevent them from dissolving into oblivion as they come to life; just as our survival will dissolve in the construction of our everyday life.

And it was an inevitable process: as Marx showed, the appearance of exchange-value and its symbolic representation by money opened a profound latent crisis in the heart of the unitary world. The commodity introduced into human relationships a universality (a 1000-franc note represents anything I can obtain for that sum) and an egalitarianism (equal things are exchanged). This "egalitarian universality" partially escapes both the exploiter and the exploited, but they recognise each other through it.

They find themselves face to face confronting each other no longer within the mystery of divine birth and ancestry, as was the case with the nobility, but within an intelligible transcendence, the Logos, a body of laws that can be understood by everyone, even if such understanding remains cloaked in mystery.

A mystery with its initiates: first of all priests struggling to maintain the Logos in the limbo of divine mysticism, but soon yielding to philosophers and then to technicians both their positions and the dignity of their sacred mission. From Plato's Republic to the Cybernetic State. Thus, under the pressure of exchange-value and technology (generally available mediation), myth was gradually secularised. Two facts should be noted, however:

a) As the Logos frees itself from mystical unity, it affirms itself both within it and against it. Upon magical and analogical structures of behaviour are superimposed rational and logical ones which negate the former while preserving them (mathematics, poetics, economics, aesthetics, psychology, etc.).

b) Each time the Logos, the "organisation of intelligible appearance, becomes more autonomous, it tends to break away from the sacred and become fragmented. In this way it presents a double danger for unitary power. We have already seen that the sacred expresses power's seizure of the totality, and that anyone wanting to accede to the totality must do so through the mediation of power: the interdict against mystics, alchemists and gnostics is sufficient proof of this. This also explains why present-day power "protects" specialists (though without completely trusting them): it vaguely senses that they are the missionaries of a resacralised Logos. There are historical signs that testify to the attempts made within mystical unitary power to found a rival power asserting its unity in the name of the Logos - Christian syncretism (which makes God psychologically explainable), the Renaissance, the Reformation and the Enlightenment.

The masters who strove to maintain the unity of the Logos were well aware that only unity can stabilise power. Examined more closely, their efforts can be seen not to have been as vain as the fragmentation of the Logos in the nineteenth and twentieth centuries would seem to prove. In the general movement of atomisation the Logos has been broken down into specialised techniques (physics, biology, sociology, papyrology, etc.), but at the same time the need to re-establish the totality has become more imperative. It should not be forgotten that all it would take would be an all-powerful technocratic power in order for there to be a totalitarian domination of the totality, for the Logos to succeed myth as the seizure of the totality by a future unitary (cybernetic) power. In such an event the vision of the Encyclopédistes (strictly rationalised progress stretching indefinitely into the future) would have known only a two-century postponement before being realised. This is the direction in which the Stalino-cyberneticians are preparing the future. In this perspective, peaceful coexistence should be seen as a preliminary step toward a totalitarian unity. It is time everyone realised that they are already resisting it.

15 We know the battlefield. The problem now is to prepare for battle before the pataphysician, armed with his totality without technique, and the cybernetician, armed with his technique without totality, consummate their political coitus.

From the standpoint of hierarchical power, myth could be desacralised only if the Logos, or at least its desacralising elements, were resacralised. To attack the sacred was at the same time supposed to liberate the totality and thus destroy power (we've heard that one before!). But the power of the bourgeoisie - fragmented, impoverished, constantly contested-maintains a relative stability by relying on this ambiguity: Technology, which objectively desacralises, subjectively appears as an instrument of liberation. Not a real liberation, which could be attained only by desacralisation - that

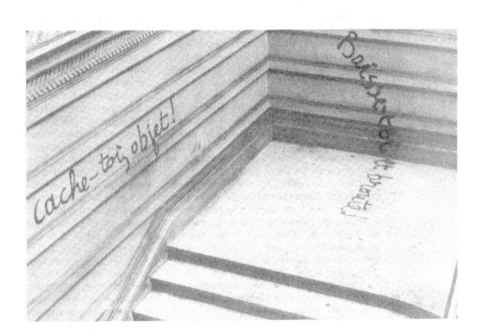

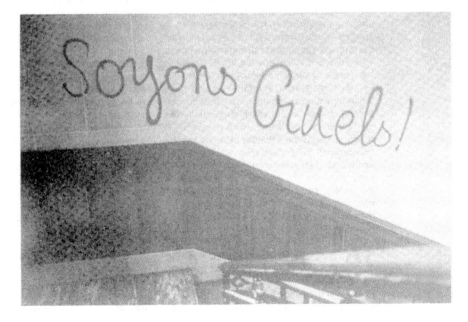

is, by the end of the spectacle - but a caricature, an imitation, an induced hallucination. What the unitary vision of the world transferred into the beyond (above) fragmentary power pro-jects ('throws forward') into a state of future well-being, of brighter tomorrows proclaimed from atop the dunghill of today-tomorrows that are nothing more than the present multiplied by the number of gadgets to be produced. From the slogan "Live in God" we have gone on to the humanistic motto "Survive until you are old," euphemistically expressed as: "Stay young at heart and you'll live a long time."

Once desacralised and fragmented, myth loses its grandeur and its spirituality. It becomes an impoverished form, retaining its former characteristics but revealing them in a concrete, harsh, tangible fashion. God doesn't run the show anymore, and until the day the Logos takes over with its arms of technology and science, the phantoms of alienation will continue to materialise and sow disorder everywhere. Watch for them: they are the first symptoms of a future order. We must start to play right now if the future is not to become impossible (the hypothesis of humanity destroying itself-and with it obviously the whole experiment of constructing everyday life). The vital objectives of a struggle for the construction of everyday life are the sensitive key points of all hierarchical power. To build one is to destroy the other. Caught in the vortex of desacralisation and resacralisation, we stand essentially for the negation of the following elements the organisation of appearance as a spectacle in which everyone denies himself, the separation on which private life is based, since it is there that the objective separation between owners and dispossessed is lived and reflected on every level and sacrifice These three elements are obviously interdependent, just as are their opposites: participation, communication, realisation. The same applies to their context nontotality (a bankrupt world, a controlled totality) and totality.

16 The human relationships that were formerly dissolved in divine transcendence (the totality crowned by the sacred) settled out and solidified as soon as the sacred stopped acting as a catalyst. Their materiality

was revealed and, as the capricious laws of the economy succeed those of Providence, the power of men began to appear behind the power of gods. Today a multitude of roles corresponds to the mythical role everyone once played under the divine spotlight. Though their masks are now human faces, these roles still require both actors and extras to deny their real lives in accordance with the dialectic of real and mythical sacrifice. The spectacle is nothing but desacralised and fragmented myth. It forms the armour of a power (which could also be called essential mediation) that becomes vulnerable to every blow once it no longer succeeds in dissimulating (in the cacophony where all cries drown out each other and form an overall harmony) its nature as privative appropriation, and the greater or lesser dose of misery it allots to everyone.

Roles have become impoverished within the context of a fragmentary power eaten away by desacralisation, just as the spectacle represents an impoverishment in comparison with myth. They betray its mechanisms and artifices so clumsily that power, to defend itself against popular denunciation of the spectacle, has no other alternative than to itself take the initiative in this denunciation by even more clumsily changing actors or ministers, or by organising pogroms of supposed or prefabricated scape-goat agents (agents of Moscow, Wall Street, the Judeocracy or the Two Hundred Families). Which also means that the whole cast has been forced to become hams, that style has been replaced by manner.

Myth, as an immobile totality, encompassed all movement (consider pilgrimage, for example, as fulfilment and adventure within immobility). On the one hand, the spectacle can seize the totality only by reducing it to a fragment and to a series of fragments (psychological, sociological, biological, philological and mythological world-views), while on the other hand, it is situated at the point where the movement of desacralisation converges with the efforts at resacralisation. Thus it can succeed in imposing immobility only within the real movement, the movement that changes it despite its resistance. In the era of fragmentation the organisation of appearance makes movement a linear succes-

sion of immobile instants (this notch-to-notch progression is perfectly exemplified by Stalinist "Dialectical Materialism"). Under what we have called "the colonisation of everyday life," the only possible changes are changes of fragmentary roles. In terms of more or less inflexible conventions, one is successively citizen, head of family, sexual partner, politician, specialist, professional, producer, consumer. Yet what boss doesn't himself feel bossed? The proverb applies to everyone: You sometimes get a fuck, but you always get fucked!

The era of fragmentation has at least eliminated all doubt on one point: everyday life is the battlefield where the war between power and the totality takes place, with power using all its strength to control the totality.

What do we demand in backing the power of everyday life against hierarchical power? We demand everything. We are taking our stand in the generalised conflict stretching from domestic squabbles to revolutionary war, and we have gambled on the will to live. This means that we must survive as antisurvivors. Fundamentally we are concerned only with the moments when life breaks through the glaciation of survival (whether these moments are unconscious or theorised, historical-like revolution-or personal). But we must recognise that we are also prevented from freely following the course of such moments (except for the moment of revolution itself) not only by the general repression exerted by power, but also by the exigencies of our own struggle, our own tactics, etc. It is also important to find the means of compensating for this additional "margin of error" by widening the scope of these moments and demonstrating their qualitative significance. What prevents what we say on the construction of everyday life from being recuperated by the cultural establishment (Arguments, academic thinkers with paid vacations) is the fact that all situationist ideas are nothing other than faithful developments of acts attempted constantly by thousands of people to try and prevent another day from being no more than twenty-four hours of wasted time. Are we an avant-garde? If so, to be avant-garde means to move in step with reality.

17 It's not the monopoly of intelligence that we hold, but that of its use. Our position is strategic, we are at the heart of every conflict. The qualitative is our striking force. People who half understand this journal ask us for an explanatory monograph thanks to which they will be able to convince themselves that they are intelligent and cultured - that is to say, idiots. Someone who gets exasperated and chucks it in the gutter is making a more meaningful gesture. Sooner or later it will have to be understood that the words and phrases we use are still lagging behind reality. The distortion and clumsiness in the way we express ourselves (which a man of taste called, not inaccurately, "a rather irritating kind of hermetic terrorism") comes from our central position, our position on the ill-defined and shifting frontier where language captured by power (conditioning) and free language (poetry) fight out their infinitely complex war. To those who follow behind us we prefer those who reject us impatiently because our language is not yet authentic poetry-the free construction of everyday life.

Everything related to thought is related to the spectacle. Almost everyone lives in a state of terror at the possibility that they might awake to themselves, and their fear is deliberately fostered by power. Conditioning, the special poetry of power, has extended its dominion so far (all material equipment belongs to it: press, television, stereotypes, magic, tradition, economy, technology - what we call captured language) that it has almost succeeded in dissolving what Marx called the undominated sector, replacing it with another dominated one (see below our composite portrait of "the survivor"). But lived experience cannot so easily be reduced to a succession of empty configurations Resistance to the external organisation of life to the organisation of life as survival contains more poetry than any volume of verse or prose and the poet in the literary sense of the word is one who has at least understood or felt this But such poetry is in a most dangerous situation Certainly poetry in the situationist sense of the word is irreducible and cannot be recuperated by power (as soon as an act is recuperated it becomes a stereotype, conditioning, language of power). But it is encircled by power. Power encircles the irreducible and

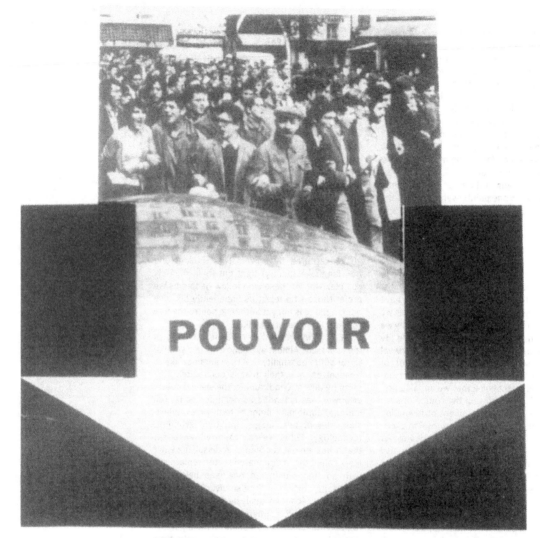

POUVOIR

POPULAIRE
OUI

holds it by isolating it; yet such isolation is impracticable. The two pincers are, first, the threat of disintegration (insanity, illness, destitution, suicide), and second, remote-controlled therapeutics. The first grants death, the second grants no more than survival (empty communication, the company of family or friendship, psychoanalysis in the service of alienation, medical care, ergotherapy). Sooner or later the SI must define itself as a therapy: we are ready to defend the poetry made by all against the false poetry rigged up by power (conditioning). Doctors and psychoanalysts better get it straight too, or they may one day, along with architects and other apostles of survival, have to take the consequences for what they have done.

18 All unresolved, unsuperseded antagonisms weaken. Such antagonisms can evolve only by remaining imprisoned in previous unsuperseded forms (anticultural art in the cultural spectacle, for example). Any radical opposition that fails or is partially successful (which amounts to the same thing) gradually degenerates into reformist opposition. Fragmentary oppositions are like the teeth on cogwheels, they mesh with each other and make the machine go round, the machine of the spectacle, the machine of power.

Myth maintained all antagonisms within the archetype of Manicheanism. But what can function as an archetype in a fragmented society? In fact, the memory of previous antagonisms, presented in their obviously devalued and unaggressive form, appears today as the last attempt to bring some coherence into the organisation of appearance, so great is the extent to which the spectacle has become a spectacle of confusion and equivalences. We are ready to wipe out all trace of these memories by harnessing all the energy contained in previous antagonisms for a radical struggle soon to come. All the springs blocked by power will one day burst through to form a torrent that will change the face of the world.

In a caricature of antagonisms, power urges everyone to be for or against Brigitte Bardot, the nouveau roman, the 4-horse Citroën, spaghetti, mescal, miniskirts, the UN, the classics, nationalisation, thermonuclear war and hitchhiking.

Everyone is asked their opinion about every detail in order to prevent them from having one about the totality. However clumsy this maneouvre may be, it might have worked if the salesmen in charge of peddling it from door to door were not themselves waking up to their own alienation. To the passivity imposed on the dispossessed masses is added the growing passivity of the directors and actors subjected to the abstract laws of the market and the spectacle and exercising less and less real power over the world. Already signs of revolt are appearing among the actors - stars who try to escape publicity or rulers who criticise their own power; Brigitte Bardot or Fidel Castro. The tools of power are wearing out; their desire for their own freedom should be taken into account.

19 At the very moment when slave revolt threatened to overthrow the structure of power and to reveal the relationship between transcendence and the mechanism of privative appropriation, Christianity appeared with its grandiose reformism, whose central democratic demand was for the slaves to accede not to the reality of a human life - which would have been impossible without denouncing the exclusionary aspect of privative appropriation - but rather to the unreality of an existence whose source of happiness is mythical (the imitation of Christ as the price of the hereafter). What has changed? Anticipation of the hereafter has become anticipation of a brighter tomorrow; the sacrifice of real, immediate life is the price paid for the illusory freedom of an apparent life. The spectacle is the sphere where forced labour is transformed into voluntary sacrifice. Nothing is more suspect than the formula "To each according to his work" in a world where work is the blackmail of survival; to say nothing of the formula "To each according to his needs" in a world where needs are determined by power Any construction that attempts to define itself autonomously and thus partially, and does not take into account that it is in fact defined by the negativity in which everything is suspended enters into the reformist project. It is trying to build on quicksand as though it were rock. Contempt and misunderstanding of the context fixed by hierarchical power can only end up reinforcing that context.

On the other hand, the spontaneous acts we can see everywhere forming against power and its spectacle must be warned of all the obstacles in their path and must find a tactic taking into account the strength of the enemy and its means of recuperation. This tactic, which we are going to popularise, is detournement.

20 Sacrifice must be rewarded. In exchange for their real sacrifice the workers receive the instruments of their liberation (comforts gadgets) but this liberation is purely fictitious since power controls the ways in which all the material equipment can be used; since power uses to its own ends both the instruments and those who use them. The Christian and bourgeois revolutions democratised mythical sacrifice, the "sacrifice of the master." Today there are countless initiates who receive crumbs of power for putting to public service the totality of their partial knowledge. They are no longer called "initiates" and not yet "priests of the Logos"; they are simply known as specialists.

On the level of the spectacle their power is undeniable: the contestant on "Double Your Money" and the postal clerk running on all day about all the mechanical details of his car both identify with the specialist, and we know how production managers use such identification to bring unskilled workers to heel. Essentially the true mission of the technocrats would be to unify the Logos; if only - because of one of the contradictions of fragmentary power - they weren't so absurdly compartmentalised and isolated. Each one is alienated in being out of phase with the others; he knows the whole of one fragment and knows no realisation. What real control can the atomic technician, the strategist or the political specialist exercise over a nuclear weapon? What ultimate control can power hope to impose on all the gestures developing against it? The stage is so crowded that only chaos reigns as master. "Order reigns and doesn't govern" (IS #6).

To the extent that the specialist takes part in the development of the instruments that condition and transform the world, he is preparing the way for the revolt of the privileged. Until now such revolt has been called fascism. It is essentially an operatic revolt - didn't Nietzsche see Wagner as a precursor? - in which actors who have been pushed aside for a long time and see themselves as less and less free suddenly demand to play the leading roles. Clinically speaking, fascism is the hysteria of the spectacular world pushed to the point of paroxysm. In this paroxysm the spectacle momentarily ensures its unity while at the same time revealing its radical inhumanity. Through fascism and Stalinism, which constitute its romantic crises, the spectacle reveals its true nature: it is a disease.

We are poisoned by the spectacle. All the elements necessary for a detoxification (that is, for the construction of our everyday lives) are in the hands of specialists. We are thus highly interested in all these specialists, but in different ways. Some are hopeless cases: we are not, for example, going to try and show the specialists of power, the rulers, the extent of their delirium. On the other hand, we are ready to take into account the bitterness of specialists imprisoned in roles that are constricted, absurd or ignominious. We must confess, however, that our indulgence has its limits. If in spite of all our efforts, they persist in putting their guilty conscience and their bitterness in the service of power by fabricating the conditioning that colonises their own everyday lives; if they prefer an illusory representation in the hierarchy to true realisation; if they persist in ostentatiously brandishing their specialisations (their painting, their novels, their equations, their sociometry, their psychoanalysis, their ballistics); finally, if, knowing perfectly well - and soon ignorance of this fact will be no excuse - that only power and the SI hold the key to using their specialisation, they nevertheless still choose to serve power because power, battening on their inertia, has chosen them to serve it, then fuck them! No one could be more generous. They should understand all this and above all the fact that henceforth the revolt of nonruling actors is linked to the revolt against the spectacle (see below the thesis on the SI and power).

21 The generalised anathematisation of the lumpenproletariat stems from the use to which it was put by the bourgeoisie,

which it served both as a regulating mechanism for power and as a source of recruits for the more dubious forces of order: cops, informers, hired thugs, artists... Nevertheless, the lumpenproletariat embodies a remarkably radical implicit critique of the society of work. Its open contempt for both lackeys and bosses contains a good critique of work as alienation, a critique that has not been taken into consideration until now because the lumpenproletariat was the sector of ambiguities, but also because during the nineteenth century and the beginning of the twentieth the struggle against natural alienation and the production of well-being still appeared as valid justifications for work.

Once it became known that the abundance of consumer goods was nothing but the flip side of alienation in production, the lumpenproletariat acquired a new dimension: it liberated a contempt for organised work which, in the age of the Welfare State, is gradually taking on the proportions of a demand that only the rulers still refuse to acknowledge. In spite of the constant attempts of power to recuperate it, every experiment carried out on everyday life, that is, every attempt to construct it (an illegal activity since the destruction of feudal power, where it was limited and restricted to a minority), is concretised today through the critique of alienating work and the refusal to submit to forced labour. So much so that the new proletariat tends to define itself negatively as a "Front Against Forced Labour" bringing together all those who resist recuperation by power. This defines our field of action; it is here that we are gambling on the ruse of history against the ruse of power; it is here that we back the worker (whether steelworker or artist) who - consciously or not - rejects organised work and life, against the worker who - consciously or not - accepts working at the dictates of power. In this perspective, it is not unreasonable to foresee a transitional period during which automation and the will of the new proletariat leave work solely to specialists, reducing managers and bureaucrats to the rank of temporary slaves. In a generalised automation the "workers," instead of supervising machines, could devote their attention to watching over the cybernetic specialists, whose sole task would be to increase a production which, through a reversal of perspective, will have ceased to be the priority sector, in order to serve the priority of life over survival.

22 Unitary power strove to dissolve individual existence in a collective consciousness so that each social unit subjectively defined itself as a particle with a clearly determined weight suspended as though in oil. Everyone had to feel overwhelmed by the omnipresent evidence that everything was merely raw material in the hands of God, who used it for his own purposes, which were naturally beyond individual human comprehension. All phenomena were seen as emanations of a supreme will; any abnormal divergence signified some hidden meaning (any perturbation was merely an ascending or descending path toward harmony: the Four Reigns, the Wheel of Fortune, trials sent by the gods). One can speak of a collective consciousness in the sense that it was simultaneously for each individual and for everyone: consciousness of myth and consciousness of particular-existence-within-myth. The power of the illusion was such that authentically lived life drew its meaning from what was not authentically lived; from this stems that priestly condemnation of life, the reduction of life to pure contingency, to sordid materiality, to vain appearance and to the lowest state of a transcendence that became increasingly degraded as it escaped mythical organisation.

God was the guarantor of space and time, whose coordinates defined unitary society. He was the common reference point for all men; space and time came together in him just as in him all beings became one with their destiny. In the era of fragmentation, man is torn between a time and a space that no transcendence can unify through the mediation of any centralised power. We are living in a space and time that are out of joint, deprived of any reference point or coordinate, as though we were never going to be able to come into contact with ourselves, although everything invites us to.

There is a place where you create yourself and a time in which you play yourself. The space of everyday life, that of one's true realisation, is encircled by every form of conditioning. The narrow space of our true realisation defines us, yet

we define ourselves in the time of the spectacle. Or put another way: our consciousness is no longer consciousness of myth and of particular-being-in-myth, but rather consciousness of the spectacle and of particular-role-in-the-spectacle. (I pointed out above the relationship between all ontology and unitary power; it should be recalled here that the crisis of ontology appears with the movement toward fragmentation.) Or to put it still another way: in the space-time relation in which everyone and everything is situated, time has become the imaginary (the field of identifications); space defines us, although we define ourselves in the imaginary and although the imaginary defines us qua subjectivities.

Our freedom is that of an abstract temporality in which we are named in the language of power (these names are the roles assigned to us), with a choice left to us to find officially recognised synonyms for ourselves. In contrast, the space of our authentic realisation (the space of our everyday life) is under the dominion of silence. There is no name to name the space of lived experience except in poetry, in language liberating itself from the domination of power.

23 By desacralising and fragmenting myth, the bourgeoisie was led to demand first of all independence of consciousness (demands for freedom of thought, freedom of the press, freedom of research, rejection of dogma). Consciousness thus ceased being more or less consciousness- reflecting-myth. It became consciousness of successive roles played within the spectacle. What the bourgeoisie demanded above all was the freedom of actors and extras in a spectacle no longer organised by God, his cops and his priests, but by natural and economic laws, "capricious and inexorable laws" defended by a new team of cops and specialists.

God has been torn off like a useless bandage and the wound has stayed raw. The bandage may have prevented the wound from healing, but it justified suffering, it gave it a meaning well worth a few shots of morphine. Now suffering has no justification whatsoever and morphine is far from cheap. Separation has become concrete. Anyone at all can put their finger on it, and the only answer cybernetic society has to offer

us is to become spectators of the gangrene and decay, spectators of survival.

The drama of consciousness to which Hegel referred is actually the consciousness of drama. Romanticism resounds like the cry of the soul torn from the body, a suffering all the more acute as each of us finds himself alone in facing the fall of the sacred totality and of all the Houses of Usher.

24 The totality is objective reality, in the movement of which subjectivity can participate only in the form of realisation. Anything separate from the realisation of everyday life rejoins the spectacle where survival is frozen (hibernation) and served out in slices. There can be no authentic realisation except in objective reality, in the totality. All the rest is caricature. The objective realisation that functions in the mechanism of the spectacle is nothing but the success of power-manipulated objects (the "objective realisation in subjectivity" of famous artists, stars, celebrities of Who's Who). On the level of the organisation of appearance, every success - and every failure - is inflated until it becomes a stereotype, and is broadcast as though it were the only possible success or failure. So far power has been the only judge, though its judgment has been subjected to various pressures. Its criteria are the only valid ones for those who accept the spectacle and are satisfied to play a role in it. But there are no more artists on that stage, there are only extras.

25 The space-time of private life was harmonised in the space-time of myth. Fourier's harmony responds to this perverted harmony. As soon as myth no longer encompasses the individual and the partial in a totality dominated by the sacred, each fragment sets itself up as a totality. The fragment set up as a totality is, in fact, the totalitarian. In the dissociated space-time that constitutes private life, time - made absolute in the form of abstract freedom, the freedom of the spectacle - consolidates by its very dissociation the spatial absolute of private life, its isolation and constriction. The mechanism of the alienating spectacle wields such force that private life reaches the point of being defined as that which is

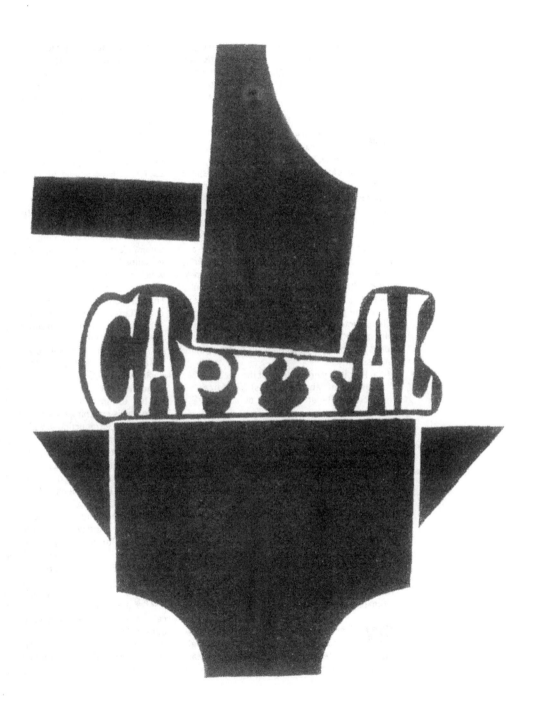

deprived of spectacle; the fact that one escapes roles and spectacular categories is experienced as an additional privation, as a malaise which power uses as a pretext to reduce everyday life to insignificant gestures (sitting down, washing, opening a door).

26 The spectacle that imposes its norms on lived experience itself arises out of lived experience. The time of the spectacle, lived in the form of successive roles, makes the space of authentic experience the area of objective impotence, while at the same time the objective impotence that stems from the conditioning of privative appropriation makes the spectacle the ultimate of potential freedom.

Elements born of lived experience are acknowledged only on the level of the spectacle, where they are expressed in the form of stereotypes, although such expression is constantly contested and refuted in and by lived experience. The composite portrait of the survivors - whom Nietzsche referred to as the "little people" or the "last men" - can be conceived only in terms of the following dialectic of possibility impossibility:

a) Possibility on the level of the spectacle (variety of abstract roles) reinforces impossibility on the level of authentic experience;
b) Impossibility (that is, limits imposed on real experience by privative appropriation) determines the field of abstract possibilities.

Survival is two-dimensional. Against such a reduction, what forces can bring out what constitutes the daily problem of all human beings: the dialectic of survival and life? Either the specific forces the SI has counted on will make possible the supersession of these contraries, reuniting space and time in the construction of everyday life; or life and survival will become locked in an antagonism growing weaker and weaker until the point of ultimate confusion and ultimate poverty is reached.

27 Lived reality is spectacularly fragmented and labelled in biological, sociological or other categories which, while being related to the communicable, never communicate anything but facts emptied of their authentically lived content. It is in this sense that hierarchical power, imprisoning everyone in the objective mechanism of privative appropriation (admission/exclusion, see section 3), is also a dictatorship over subjectivity. It is as a dictator over subjectivity that it strives, with limited chances of success, to force each individual subjectivity to become objectivised, that is, to become an object it can manipulate. This extremely interesting dialectic should be analysed in greater detail (objective realisation in subjectivity - the realisation of power - and objective realisation in objectivity - which enters into the praxis of constructing everyday life and destroying power).

Facts are deprived of content in the name of the communicable, in the name of an abstract universality, in the name of a perverted harmony in which everyone realises himself in an inverted perspective. In this context the SI is in the line of contestation that runs through Sade, Fourier, Lewis Carroll, Lautréamont, surrealism, lettrism - at least in its least known currents, which were the most extreme.

Within a fragment set up as a totality, each further fragment is itself totalitarian. Sensitivity, desire, will, intelligence, good taste, the subconscious and all the categories of the ego were treated as absolutes by individualism. Today sociology is enriching the categories of psychology, but the introduction of variety into the roles merely accentuates the monotony of the identification reflex. The freedom of the "survivor" will be to assume the abstract constituent to which he has "chosen" to reduce himself. Once any real realisation has been put out of the picture, all that remains is a psychosociological dramaturgy in which interiority functions as a safety-valve, as an overflow to drain off the effects one has worn for the daily exhibition. Survival becomes the ultimate stage of life organised as the mechanical reproduction of memory.

28 Until now the approach to the totality has been falsified. Power has parasitically interposed itself as an indispensable mediation between man and nature. But the relation between man and nature is based only on praxis. It is praxis which constantly breaks through the coherent veneer of lies that myth and its

substitutes try to maintain. It is praxis, even alienated praxis, which maintains contact with the totality. By revealing its own fragmentary character, praxis at the same time reveals the real totality (reality): it is the totality being realised by way of its opposite, the fragment.

In the perspective of praxis, every fragment is totality. In the perspective of power, which alienates praxis, every fragment is totalitarian. This should be enough to wreck the attempts cybernetic power will make to envelop praxis in a mystique, although the seriousness of these attempts should not be underestimated.

All praxis enters into our project; it enters with its share of alienation, with the impurities of power: but we are capable of filtering them out. We will elucidate the force and purity of acts of refusal as well as the manipulative maneouvres of power, not in a Manichean perspective, but as a means of developing, through our own strategy, this combat in which everywhere, at every moment, the adversaries are seeking one another but only clashing accidentally, lost in irremediable darkness and uncertainty.

29 Everyday life has always been drained to the advantage of apparent life, but appearance, in its mythical cohesion, was powerful enough to repress any mention of everyday life. The poverty and emptiness of the spectacle, revealed by all the varieties of capitalism and all the varieties of bourgeoisie, has revealed both the existence of everyday life (a shelter life, but a shelter for what and from what?) and the poverty of everyday life. As reification and bureaucratisation grow stronger, the debility of the spectacle and of everyday life is the only thing that remains clear. The conflict between the human and the inhuman has also been transferred to the plane of appearance. As soon as Marxism became an ideology, Marx's struggle against ideology in the name of the richness of life was transformed into an ideological anti-ideology, an antispectacle spectacle (just as in avant-garde culture the antispectacular spectacle is restricted to actors alone, antiartistic art being created and understood only by artists, so the relationship between this ideological anti-ideology and the function of the professional revolutionary in Leninism should be examined).

Thus Manicheanism has found itself momentarily revived. Why did St. Augustine attack the Manicheans so relentlessly? It was because he recognised the danger of a myth offering only one solution, the victory of good over evil; he saw that this impossibility threatened to provoke the collapse of all mythical structures and bring into the open the contradiction between mythical and authentic life. Christianity offered the third way, the way of sacred confusion. What Christianity accomplished through the force of myth is accomplished today through the force of things. There can no longer be any antagonism between Soviet workers and capitalist workers or between the bomb of the Stalinist bureaucrats and the bomb of the non-Stalinist bureaucrats; there is no longer anything but unity in the chaos of reified beings.

Who is responsible? Who should be shot? We are dominated by a system, by an abstract form. Degrees of humanity and inhumanity are measured by purely quantitative variations of passivity. The quality is the same everywhere: we are all proletarianised or well on the way to becoming so. What are the traditional "revolutionaries" doing? They are eliminating certain distinctions, making sure that no proletarians are any more proletarian than all the others. But what party is working for the end of the proletariat?

The perspective of survival has become intolerable. What is weighing us down is the weight of things in a vacuum. That's what reification is: everyone and everything falling at an equal speed, everyone and everything stigmatised with their equal value. The reign of equal values has realised the Christian project, but it has realised it outside Christianity (as Pascal had supposed) and, above all, it has realised it over God's dead body, contrary to Pascal's expectations.

The spectacle and everyday life coexist in the reign of equal values. People and things are interchangeable. The world of reification is a world without a centre, like the new prefabricated cities that are its decor. The present fades away before the promise of an eternal future that is nothing but a mechanical extension of the past. Time itself is deprived of a centre. In this concentration-camp world, victims and torturers

wear the same mask and only the torture is real. No new ideology can soothe the pain, neither the ideology of the totality (Logos) nor that of nihilism - which will be the two crutches of the cybernetic society. The tortures condemn all hierarchical power, however organised or dissimulated it may be. The antagonism the SI is going to revive is the oldest of all, it is radical antagonism and that is why it is taking up again and assimilating all that has been left by the insurrectionary movements and great individuals in the course of history.

30 So many other banalities could be taken up and reversed. The best things never come to an end. Before rereading the above - which even the most mediocre intelligence will be able to understand by the third attempt - the reader would be well-advised to concentrate carefully on the following text, for these notes, as fragmentary as the preceding ones, must be discussed in detail and implemented. It concerns a central question: the SI and revolutionary power.

Being aware of the crises of both mass parties and "elites," the SI must embody the supersession of both the Bolshevik Central Committee (supersession of the mass party) and of the Nietzschean project (supersession of the intelligentsia).

a) Every time a power has presented itself as directing a revolutionary upsurge, it has automatically undermined the power of the revolution. The Bolshevik C.C. defined itself simultaneously as concentration and as representation. Concentration of a power antagonistic to bourgeois power and representation of the will of the masses. This duality led it rapidly to become no more than an empty power, a power of empty representation, and consequently to rejoin, in a common form (bureaucracy), a bourgeois power that was being forced (in response to the very existence of the Bolshevik power) to follow a similar evolution. The conditions for a concentrated power and mass representation exist potentially in the SI when it states that it holds the qualitative and that its ideas are in everyone's mind.

Nevertheless we refuse both concentrated power and the right of representation, conscious that we are now taking the only public attitude (for we cannot avoid being known to some extent in a spectacular manner) enabling those who find that they share our theoretical and practical positions to accede to revolutionary power: power without mediation, power entailing the direct action of everyone. Our guiding image could be the Durruti Column, moving from town to village, liquidating the bourgeois elements and leaving the workers to see to their own self-organisation.

b) The intelligentsia is power's hall of mirrors. Contesting power, it never offers anything but passive cathartic identification to those whose every gesture gropingly expresses real contestation. The radicalism - not of theory, obviously, but of gesture - that could be glimpsed in the "Declaration of the 121," however, suggests some different possibilities. We are capable of precipitating this crisis, but we can do so only by entering the intelligentsia as a power against the intelligentsia. This phase - which must precede and be contained within the phase described in point a) - will put us in the perspective of the Nietzschean project. We will form a small, almost alchemical, experimental group within which the realisation of the total man can be started. Nietzsche could conceive of such an undertaking only within the framework of the hierarchical principle. It is, in fact, within such a framework that we find ourselves. It is therefore of the utmost importance that we present ourselves without the slightest ambiguity (on the level of the group, the purification of the nucleus and the elimination of residues now seems to be completed). We accept the hierarchical framework in which we are placed only while impatiently working to abolish our domination over those whom we cannot avoid dominating on the basis of our criteria for mutual recognition.

c) Tactically our communication should

be a diffusion emanating from a more or less hidden centre. We will establish non-materialised networks (direct relationships, episodic ones, contacts without ties, development of embryonic relations based on sympathy and understanding, in the manner of the red agitators before the arrival of the revolutionary armies). We will claim radical gestures (actions, writings, political attitudes, works) as our own by analysing them, and we will consider that our own acts and analyses are supported by the majority of people.

Just as God constituted the reference point of past unitary society, we are preparing to create the central reference point for a unitary society now possible. But this point cannot be fixed. As opposed to the ever-renewed confusion that cybernetic power draws from the past of inhumanity, it stands for the game that everyone will play, "the moving order of the future."

Raoul Vaneigem, Internationale Situationniste 7 & 8, 1962 - 63

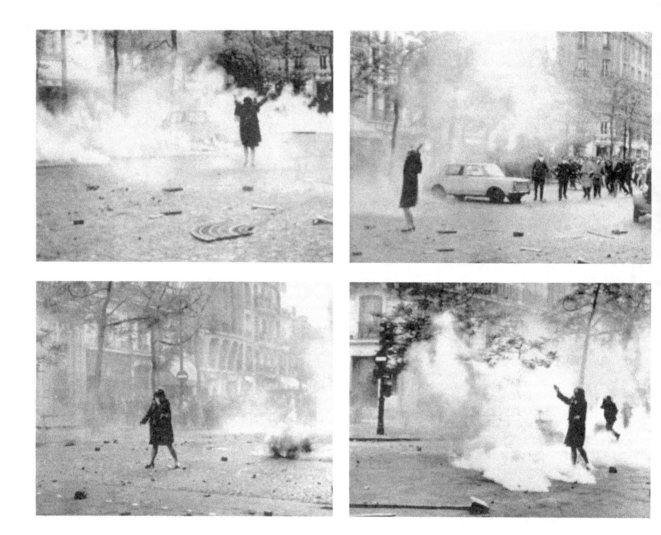

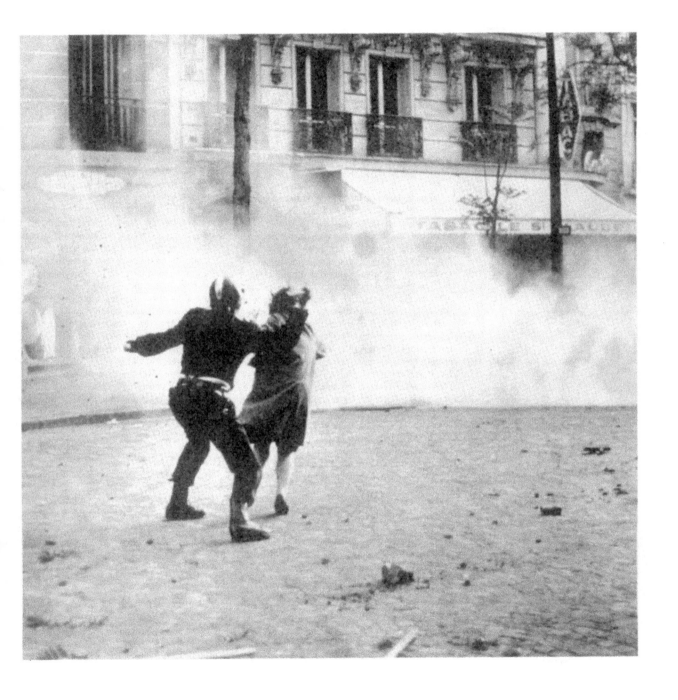

Paris: May 1968

Introduction

(Written for the original edition, published by Solidarity in June 1968)

This is an eye-witness account of two weeks spent in Paris during May 1968. It is what one person saw, heard or discovered during that short period. The account has no pretence at comprehensiveness. It has been written and produced in haste, its purpose being to inform rather than to analyse - and to inform quickly.

The French events have a significance that extends far beyond the frontiers of modern France. They will leave their mark on the history of the second half of the 20th century. French bourgeois society has just been shaken to its foundations. Whatever the outcome of the present struggle, we must calmly take note of the fact that the political map of Western capitalist society will never be the same again. A whole epoch has just come to an end: the epoch during which people couldn't say, with a semblance of verisimilitude, that 'it couldn't happen here'. Another epoch is starting: that in which people *know* that revolution is possible under the conditions of modern bureaucratic capitalism.

For Stalinism too, a whole period is ending: the period during which Communist Parties in Western Europe could claim (admittedly with dwindling credibility) that they remained revolutionary organisations, but that revolutionary opportunities had never really presented themselves. This notion has now irrevocably been swept into the proverbial 'dustbin of history'. When the chips were down, the French Communist Party and those workers under its influence proved to be the final and most effective 'brake' on the development of the revolutionary self-activity of the working class.

A full analysis of the French events will eventually have to be attempted, for, without an understanding of modern society, it will never be possible consciously to change it. But this analysis will have to wait for a while until some of the dust has settled. What can be said now is that, if honestly carried out, such an analysis will compel many 'orthodox' revolutionaries to discard a mass of outdated ideas, slogans and myths to re-assess contemporary reality; particularly the reality of modern bureaucratic capitalism, its dynamic, its methods of control and manipulation, the reasons for both its resilience and its brittleness and - most important of all - the nature of its crises. Concepts and organisations that have been found wanting will have to be discarded. The new phenomena (new in themselves or new to traditional revolutionary theory) will have to be recognised for what they are and interpreted in all their implications. The *real* events of 1968 will then have to be integrated into a new framework of ideas, for without this *development* of revolutionary theory, there can be no *development* of revolutionary practice - and in the long run no transformation of society through the *conscious* actions of men.

Rue Gay Lussac

Sunday 12 May

The rue Gay-Lussac still carries the scars of the 'night of the barricades'. Burnt out cars line the pavement, their carcasses a dirty grey under the missing paint. The cobbles, cleared from the middle of the road, lie in huge mounds on either side. A vague smell of tear gas still lingers in the air.

At the junction with the rue des Ursulines lies a building site, its wire mesh fence breached in several places. From here came material for at least a dozen barricades: planks, wheelbarrows, metal drums, steel girders, cement mixers,

blocks of stone. The site also yielded a pneumatic drill. The students couldn't use it, of course - not until a passing building worker showed them how, perhaps the first worker actively to support the student revolt. Once broken, the road surface provided cobbles, soon put to a variety of uses.

All that is already history.

People are walking up and down the street, as if trying to convince themselves that it really happened. They aren't students. The students themselves know what happened and why it happened. They aren't local inhabitants either. The local inhabitants saw what happened, the viciousness of the CRS charges, the assaults on the wounded, the attacks on innocent bystanders, the unleashed fury of the state machine against those who had challenged it. The people in the streets are the ordinary people of Paris, people from neighbouring districts, horrified at what they have heard over the radio or read in their papers and who have come for a walk on a fine Sunday morning to see for themselves. They are talking in small clusters with the inhabitants of the rue Gay-Lussac. The Revolution, having for a week held the university and the streets of the Latin Quarter, is beginning to take hold of the minds of men.

On Friday 3 May the CRS had paid their historic visit to the Sorbonne. They had been invited in by Paul Roche, Rector of Paris University. The Rector had almost certainly acted in connivance with Alain Peyrefitte, Minister of Education, if not with the Elysee itself. Many students had been arrested, beaten up, and several were summarily convicted.

The unbelievable - yet thoroughly predictable - ineptitude of this bureaucratic 'solution' to the 'problem' of student discontent triggered off a chain reaction. It provided the pent-up anger, resentment and frustration of tens of thousands of young people with both a reason for further action and with an attainable objective. The students, evicted from the university, took to the street, demanding the liberation of their comrades, the reopening of their faculties, the withdrawal of the cops.

Layers upon layers of new people were soon drawn into the struggle. The student union (UNEF) and the union representing university teaching staff (SNESup) called for an unlimited strike. For a week the students held their ground, in ever bigger and more militant street demonstrations. On Tuesday 7 May 50,000 students and teachers marched through the streets behind a single banner: 'Vive La Commune', and sang the Internationale at the Tomb of the Unknown Soldier, at the Arc de Triomphe. On Friday 10 May students and teachers decided to occupy the Latin Quarter en masse. They felt they had more right to be there than the police, for whom barracks were provided elsewhere. The cohesion and sense of purpose of the demonstrators terrified the Establishment. Power couldn't be allowed to lie with this rabble, who had even had the audacity to erect barricades.

Another inept gesture was needed. Another administrative reflex duly materialised. Fouchet (Minister of the Interior) and Joxe (Deputy Prime Minister) ordered Grimaud (Superintendent of the Paris police) to clear the streets. The order was confirmed in writing, doubtless to be preserved for posterity as an example of what not to do in certain situations. The CRS charged... clearing the rue Gay-Lussac and opening the doors to the second phase of the Revolution.

In the rue Gay-Lussac and in adjoining streets, the battle-scarred walls carry a dual message. They bear testimony to the incredible courage of those who held the area for several hours against a deluge of tear gas, phosphorous grenades and repeated charges of club-swinging CRS. But they also show something of what the defenders were striving for...

Mural propaganda is an integral part of the revolutionary Paris of May 1968. It has become a mass activity, part and parcel of the Revolution's method of self-expression. The walls of the Latin Quarter are the depository of a new rationality, no longer confined to books, but democratically displayed at street level and made available to all. The trivial and the profound, the traditional and the esoteric, rub shoulders in this new fraternity, rapidly breaking down the rigid barriers and compartments in people's minds.

'Desobeir d'abord: alors ecris sur les murs (Loi du 10 Mai 1968)' reads an obviously recent inscription, clearly setting the tone. 'Si tout le peuple faisait comme nous' (if everybody acted

like us...) wistfully dreams another in joyful anticipation, I think, rather than in any spirit of self-satisfied substitutionism. Most of the slogans are straightforward, correct and fairly orthodox: 'Liberez nos camarades'; 'Fouchet, Grimaud, demission'; 'A bas l'Etat policier'; 'Greve Generale Lundi'; 'Travailleurs, etudiants, soldaires'; 'Vive les Conseils Ouvriers'. Other slogans reflect the new concerns: 'La publicite te manipule'; 'Examens = hierarchie'; 'L'art est mort, ne consommez pas son cadavre'; 'A bas la societe de consommation'; 'Debout les damnes de Nanterre'. The slogan 'Baisses-toi et broute' (Bend your head and chew the cud) is obviously aimed at those whose minds are still full of traditional preoccupations.

'Contre la fermentation groupusculaire' moans a large scarlet inscription. This one is really out of touch. For everywhere there is a profusion of pasted up posters and journals: *Voix Ouvriere*, *Avant-Garde* and *Revoltes* (for the Trotskyists), *Servir le Peuple* and *Humanite Nouvelle* (for the devotees of Chairman Mao), *Le Libertaire* (for the Anarchists), *Tribune Socialiste* (for the PSU). Even odd copies of *l' Humanite* are pasted up. It is difficult to read them, so covered are they with critical comments.

On a hoarding, I see a large advertisement for a new brand of cheese: a child biting into an enormous sandwich. 'C'est bon le fromage So-and-So' runs the patter. Someone has covered the last few words with red paint. The poster reads 'C'est bon la Revolution'. People pass by, look, and smile.

I talk to my companion, a man of about 45, an 'old' revolutionary. We discuss the tremendous possibilities now opening up. He suddenly turns towards me and comes out with a memorable phrase: "To think one had to have kids and wait 20 years to see all this...".

We talk to others in the street, to young and old, to the 'political' and the 'unpolitical', to people at all levels of understanding and commitment. Everyone is prepared to talk - in fact everyone wants to. They all seem remarkably articulate. We find no-one prepared to defend the actions of the administration. The 'critics' fall into two main groups:

The 'progressive' university teachers, the Communists, and a number of students see the main root of the student 'crisis' in the backwardness of the university in relation to society's current needs, in the quantitative inadequacy of the tuition provided, in the semi-feudal attitudes of some professors, and in the general insufficiency of job opportunities. They see the University as unadapted to the modern world. The remedy for them is adaptation: a modernising reform which would sweep away the cobwebs, provide more teachers, better lecture theatres, a bigger educational budget, perhaps a more liberal attitude on the campus and, at the end of it all, an assured job.

The rebels (which include some but by no means all of the 'old' revolutionaries) see this concern with adapting the university to modern society as something of a diversion. For it is modern society itself which they reject. They consider bourgeois life trivial and mediocre, repressive and repressed. They have no yearning (but only contempt) for the administrative and managerial careers it holds out for them. They are not seeking integration into adult society. On the contrary, they are seeking a chance radically to contest its adulteration. The driving force of their revolt is their own alienation, the meaninglessness of life under modern bureaucratic capitalism. It is certainly not a purely economic deterioration in their standard of living.

It is no accident that the 'revolution' started in the Nanterre faculties of Sociology and Psychology. The students saw that the sociology they were being taught was a means of controlling and manipulating society, not a means of understanding it in order to change it. In the process they discovered revolutionary sociology. They rejected the niche allocated to them in the great bureaucratic pyramid, that of 'experts' in the service of a technocratic Establishment, specialists of the 'human factor' in the modern industrial equation. In the process they discovered the importance of the working class. The amazing thing is that, at least among the active layers of the students, these 'sectarians' suddenly seem to have become the majority: surely the best definition of any revolution.

The two types of 'criticism' of the modern French educational system do not neutralise one another. On the contrary, each creates its own kind of problems for the University authorities

and for the officials at the Ministry of Education. The real point is that one kind of criticism - what one might call the quantitative one - could in time be coped with by modern bourgeois society. The other - the qualitative one - never. This is what gives it its revolutionary potential. The 'trouble with the University', for the powers that be, isn't that money can't be found for more teachers. It can. The 'trouble' is that the University is full of students - and that the heads of the students are full of revolutionary ideas.

Among those we speak to there is a deep awareness that the problem cannot be solved in the Latin Quarter, that isolation of the revolt in a student 'ghetto' (even an 'autonomous' one) would spell defeat. They realise that the salvation of the movement lies in its extension to other sectors of the population. But here wide differences appear. When some talk of the importance of the working class it is as a substitute for getting on with any kind of struggle themselves, an excuse for denigrating the students' struggle as 'adventurist'. Yet it is precisely because of its unparalleled militancy that the students' action has established that direct action works, has begun to influence the younger workers and to rattle the established organisations. Other students realise the relationship of these struggles more clearly. We will find them later at Censier, animating the 'worker-student' action committees.

But enough, for the time being, about the Latin Quarter. The movement has already spread beyond its narrow confines.

May 13: From Renault to the streets of Paris

Monday 13 May

6:15am, Avenue Yves Kermen. A clear, cloudless day. Crowds begin to gather outside the gates of the giant Renault works at Boulogne Billancourt. The main trade union 'centrales' (CGT, CFDT and FO) have called a one day general strike. They are protesting against police violence in the Latin Quarter and in support of long-neglected claims concerning wages, hours, the age of retirement and trade union rights in the plants.

The factory gates are wide open. Not a cop or supervisor in sight. The workers stream in. A loudhailer tells them to proceed to their respective shops, to refuse to start work and to proceed, at 8am, to their traditional meeting place, an enormous shed-like structure in the middle of the Ile Seguin (an island in the Seine entirely covered by parts of the Renault plant).

As each worker goes through the gates, the pickets give him a leaflet, jointly produced by the three unions. Leaflets in Spanish are also distributed (over 2000 Spanish workers are employed at Renault). French and Spanish orators succeed one another, in short spells, at the microphone. Although all the unions are supporting the one-day strike, all the orators seem to belong to the CGT. It's their loudspeaker...

6:45am. Hundreds of workers are now streaming in. Many look as if they had come to work rather than to participate in mass meetings at the plant. The decision to call the strike was only taken on the Saturday afternoon, after many of the men had already dispersed for the weekend. Many seem unaware of what it's all about. I am struck by the number of Algerian and black workers.

There are only a few posters at the gate, again mainly those of the CGT. Some pickets carry CFDT posters. There isn't an FO poster in sight. The road and walls outside the factory have been well covered with slogans: 'One day strike on Monday'; 'Unity in defence of our claims'; 'No to the monopolies'.

The little cafe near the gates is packed. People seem unusually wide awake and communicative for so early an hour. A newspaper kiosk is selling about three copies of *l' Humanite* for every copy of anything else. The local branch of the Communist Party is distributing a leaflet calling for 'resolution, calm, vigilance and unity' and warning against 'provocateurs'.

The pickets make no attempt to argue with those pouring in. No-one seems to know whether they will obey the strike call or not. Less than 25% of Renault workers belong to any union at all. This is the biggest car factory in Europe.

The loudhailer hammers home its message: "The CRS have recently assaulted peasants at Quimper, and workers at Caen, Rhodiaceta (Lyon) and Dassault. Now they are turning on the

students. The regime will not tolerate opposition. It will not modernise the country. It will not grant us our basic wage demands. Our one day strike will show both Government and employers our determination. We must compel them to retreat." The message is repeated again and again, like a gramophone record. I wonder whether the speaker believes what he says, whether he even senses what lies ahead.

At 7am a dozen Trotskyists of the FER (Federation des Etudiants Revolutionaires) turn up to sell their paper *Revoltes*. They wear large red and white buttons proclaiming their identity. A little later another group arrives to sell *Voix Ouvriere*. The loudspeaker immediately switches from an attack on the Gaullist government and its CRS to an attack on "provocateurs" and "disruptive elements, alien to the working class". The Stalinist speaker hints that the sellers are in the pay of the government. As they are here, "the police must be lurking in the neighbourhood". Heated arguments break out between sellers and CGT officials. The CFDT pickets are refused the use of the loudhailer. They shout "democratie ouvriere" and defend the right of the 'disruptive elements' to sell their stuff. A rather abstract right, as not a sheet is sold. The front page of *Revoltes* carries an esoteric article on Eastern Europe.

Much invective (but no blows) are exchanged. In the course of an argument I hear Bro. Trigon (delegate to the second electoral 'college' at Renault) describe Danny Cohn-Bendit as "un agent du pouvoir" (an agent of the authorities). A student takes him up on this point. The Trots don't. Shortly before 8am they walk off, their 'act of presence' accomplished and duly recorded for history.

At about the same time, hundreds of workers who had entered the factory leave their shops and assemble in the sunshine in an open space a few hundred yards inside the main gate. From there they amble towards Ile Seguin, crossing one arm of the river Seine on the way. Other processions leave other points of the factory and converge on the same area. The metallic ceiling is nearly 200 feet above our heads. Enormous stocks of components are piled up high right and left. Far away to the right an assembly line is still working, lifting what looks like rear car seats, complete with attached springs, from the ground to first floor level.

Some 10,000 workers are soon assembled in the shed. The orators address them through a loudspeaker from a narrow platform some 40 feet up. The platform runs in front of what looks like an elevated inspection post but which I am told is a union office inside the factory.

The CGT speaker deals with various sectional wage claims. He denounces the resistance of the government "in the hands of the monopolies". He produces facts and figures dealing with the wage structure. Many highly skilled men are not getting enough. A CFDT speaker follows him. He deals with the steady speed-up, with the worsening of working conditions, with accidents and with the fate of man in production. "What kind of life is this? Are we always to remain puppets, carrying out every whim of the management?" He advocates uniform wage increases for all ('augmentations non-hierarchisees'). An FO speaker follows. He is technically the most competent, but says the least. In flowery rhetoric he talks of 1936, but omits all reference to Leon Blum. The record of FO is bad in the factory and the speaker is heckled from time to time.

The CGT speakers then ask the workers to participate *en masse* in the big rally planned for that afternoon. As the last speaker finishes, the crowd spontaneously breaks out into a rousing 'Internationale'. The older men seem to know most of the words. The younger workers only know the chorus. A friend nearby assures me that in 20 years this is the first time he has heard the song sung inside Renault (he has attended dozens of mass meetings in the Ile Seguin). There is an atmosphere of excitement, particularly among the younger workers.

The crowd then breaks up into several sections. Some walk back over the bridge and out of the factory. Others proceed systematically through the shops where a few hundred blokes are still at work. Some of these men argue but most seem only too glad for an excuse to stop and join in the procession. Gangs weave their way, joking and singing, amid the giant presses and tanks. Those remaining at work are ironically cheered, clapped or exhorted to "step on it", or "work harder". Occasional foremen look on helplessly, as one assembly line after another is

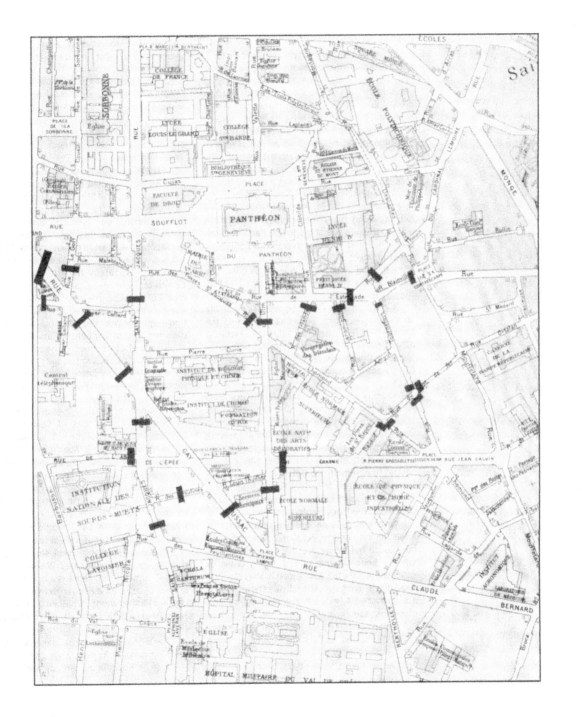

brought to a halt.

Many of the lathes have coloured pictures plastered over them: pin-ups and green fields, sex and sunshine. Anyone still working is exhorted to get out into the daylight, not just to dream about it. In the main plant, over half a mile long, hardly 12 men remain in their overalls. Not an angry voice can be heard. There is much good humoured banter. By 11am thousands of workers have poured out into the warmth of a morning in May. An open-air beer and sandwich stall, outside the gate, is doing a roaring trade.

1.15 pm. The streets are crowded. The response to the call for a 24-hour general strike has exceeded the wildest hopes of the trade unions. Despite the short notice Paris is paralysed. The strike was only decided 48 hours ago, after the 'night of the barricades'. It is moreover 'illegal'. The law of the land demands a five-day notice before an 'official' strike can be called. Too bad for legality.

A solid phalanx of young people is walking up the Boulevard de Sebastopol, towards the Gare de l'Est. They are proceeding to the student rallying point for the giant demonstration called jointly by the unions, the students' organisation (UNEF) and the teachers' associations (FEN and SNESup).

There is not a bus or car in sight. The streets of Paris today belong to the demonstrators. Thousands of them are already in the square in front of the station. Thousands more are moving in from every direction. The plan agreed by the sponsoring organisations is for the different categories to assemble separately and then to converge on the Place de la Republique, from where the march will proceed across Paris, via the Latin Quarter, to the Place Denfert-Rochereau.

We are already packed like sardines for as far as the eye can see, yet there is more than an hour to go before we are due to proceed. The sun has been shining all day. The girls are in summer dresses, the young men in shirt sleeves. A red flag is flying over the railway station. There are many red flags in the crowd and several black ones too.

A man suddenly appears carrying a suitcase full of duplicated leaflets. He belongs to some left 'groupuscule' or other. He opens his suitcase and distributes perhaps a dozen leaflets. But he doesn't have to continue alone. There is an unquenchable thirst for information, ideas, literature, argument, polemic. The man just stands there as people surround him and press forward to get the leaflets. Dozens of demonstrators, without even reading the leaflet, help him distribute them. Some 6000 copies get out in a few minutes. All seem to be assiduously read. People argue, laugh, joke. I witnessed such scenes again and again.

Sellers of revolutionary literature are doing well. An edict, signed by the organisers of the demonstration, that "the only literature allowed would be that of the organisations sponsoring the demonstration" (see l' Humanite, 13 May 1968) is being enthusiastically flouted. This bureaucratic restriction (much criticised the previous evening when announced at Censier by the student delegates to the Co-ordinating Committee) obviously cannot be enforced in a crowd of this size. The revolution is bigger than any organisation, more tolerant than any institution 'representing' the masses, more realistic than any edict of any Central Committee.

Demonstrators have climbed onto walls, onto the roofs of bus stops, onto the railings in front of the station. Some have loudhailers and make short speeches. All the 'politicos' seem to be in one part or other of this crowd. I can see the banner of the Jeunesse Communiste Revolutionaire, portraits of Castro and Che Guevara, the banner of the FER, several banners of 'Servir le Peuple' (a Maoist group) and the banner of the UJCML (Union de la Jeunesse Communiste Marxiste-Leniniste), another Maoist tendency. There are also banners from many educational establishments now occupied by those who work there. Large groups of lyceens (high school kids) mingle with the students as do many thousands of teachers.

At about 2pm the student section sets off, singing the 'Internationale'. We march 20-30 abreast, arms linked. There is a row of red flags in front of us, then a banner 50 feet wide carrying four simple words: 'Etudiants, Enseignants, Travailleurs, Solidaires'. It is an impressive sight.

The whole Boulevard de Magenta is a solid seething mass of humanity. We can't enter the Place de la Republique, already packed full of

je vote
tu votes
il vote
nous votons
vous votez
ils profitent
GREVE du VOTE

CONSEIL FEDERAL du REL

demonstrators. One can't even move along the pavements or through adjacent streets. Nothing but people, as far as the eye can see.

As we proceed slowly down the Boulevard de Magenta, we notice on a third floor balcony, high on our right, an SFIO (Socialist Party) head-quarters. The balcony is bedecked with a few decrepit-looking red flags and a banner proclaiming 'Solidarity with the students'. A few elderly characters wave at us, somewhat self-consciously. Someone in the crowd starts chanting "O-pur-tu-nistes". The slogan is taken up, rhythmically roared by thousands, to the discomfiture of those on the balcony who beat a hasty retreat. The people have not forgotten the use of the CRS against the striking miners in 1958 by 'socialist' Minister of the Interior Jules Moch. They remember the 'socialist' Prime Minister Guy Mollet and his role during the Algerian War. Mercilessly, the crowd shows its contempt for the discredited politicians now seeking to jump on the bandwagon. "Guy Mollet, au musee", they shout, amid laughter. It is truly the end of an epoch.

At about 3pm we at last reach the Place de la Republique, our point of departure. The crowd here is so dense that several people faint and have to be carried into neighbouring cafes. Here people are packed almost as tight as in the street, but can at least avoid being injured. The window of one cafe gives way under the pressure of the crowd outside. There is a genuine fear, in several parts of the crowd, of being crushed to death. The first union contingents fortunately begin to leave the square. There isn't a policeman in sight.

Although the demonstration has been announced as a joint one, the CGT leaders are still striving desperately to avoid a mixing-up, on the streets, of students and workers. In this they are moderately successful. By about 4.30pm the students' and teachers' contingent, perhaps 80,000 strong, finally leaves the Place de la Republique. Hundreds of thousands of demonstrators have preceded it, hundreds of thousands follow it, but the 'left' contingent has been well and truly 'bottled-in'. Several groups, understanding at last the CGT's manoeuvre, break loose once we are out of the square. They take short cuts via various side streets, at the double, and succeed in infiltrating groups of 100 or so into parts of the march ahead of them, or behind them. The Stalinist stewards walking hand in hand and hemming the march in on either side are powerless to prevent these sudden influxes. The student demonstrators scatter like fish in water as soon as they have entered a given contingent. The CGT marchers themselves are quite friendly and readily assimilate the newcomers, not quite sure what it's all about. The students' appearance, dress and speech does not enable them to be identified as readily as they would be in Britain.

The main student contingent proceeds as a compact body. Now that we are past the bottleneck of the Place de la Republique the pace is quite rapid. The student group nevertheless takes at least half an hour to pass a given point. The slogans of the students contrast strikingly with those of the CGT. The students shout "Le Pouvoir aux Ouvriers" (All Power to the Workers); "Le Pouvoir est dans la rue" (Power lies in the street); "Liberez nos camarades". CGT members shout "Pompidou, demission" (Pompidou, resign). The students chant "de Gaulle, assassin", or "CRS-SS". The CGT: "Des sous, pas de matraques" (money, not police clubs) or "Defence du pouvoir d'achat" (Defend our purchasing power). The students say "Non a l'Universite de classe". The CGT and the Stalinist students, grouped around the banner of their paper *Clarte* reply "Universite Democratique". Deep political differences lie behind the differences of emphasis. Some slogans are taken up by everyone, slogans such as "Dix ans, c'est assez", "A bas l'Etat policier", or "Bon anniversaire, mon General". Whole groups mournfully entone a well-known refrain: "Adieu, de Gaulle". They wave their handkerchieves, to the great merriment of the bystanders.

As the main student contingent crosses the Pont St Michel to enter the Latin Quarter it suddenly stops, in silent tribute to its wounded. All thoughts are for a moment switched to those lying in hospital, their sight in danger through too much tear gas or their skulls or ribs fractured by the truncheons of the CRS. The sudden, angry silence of this noisiest part of the demonstration conveys a deep impression of strength and resolution. One senses massive accounts yet to be

settled.

At the top of the Boulevard St Michel I drop out of the march, climb onto a parapet lining the Luxembourg Gardens, and just watch. I remain there for two hours as row after row of demonstrators marches past, 30 or more abreast, a human tidal wave of fantastic, inconceivable size. How many are they? 600,000? 800,000? A million? 1,500,000? No-one can really number them. The first of the demonstrators reached the final dispersal point hours before the last ranks had left the Place de la Republique, at 7pm.

There were banners of every kind: union banners, student banners, political banners, non-political banners, reformist banners, revolutionary banners, banners of the 'Mouvement contre l'Armement Atomique', banners of various Conseils de Parents d'Eleves, banners of every conceivable size and shape, proclaiming a common abhorrence at what had happened and a common will to struggle on. Some banners were loudly applauded, such as the one saying 'Liberons l'information' (Let's have a free news service) carried by a group of employees from the ORTF. Some banners indulged in vivid symbolism, such as the gruesome one carried by a group of artists, depicting human hands, heads and eyes, each with its price tag, on display on the hooks and trays of a butcher's shop.

Endlessly they filed past. There were whole sections of hospital personnel, in white coats, some carrying posters saying 'Ou sont les disparus des hopitaux?' (where are the missing injured?). Every factory, every major workplace seemed to be represented. There were numerous groups of railwaymen, postmen, printers, Metro personnel, metal workers, airport workers, market men, electricians, lawyers, sewermen, bank employees, building workers, glass and chemical workers, waiters, municipal employees, painters and decorators, gas workers, shop girls, insurance clerks, road sweepers, film studio operators, busmen, teachers, workers from the new plastic industries, row upon row upon row of them, the flesh and blood of modern capitalist society, an unending mass, a power that could sweep *everything* before it, if it but decided to do so.

My thoughts went to those who say that the workers are only interested in football, in the 'tierce' (horse-betting), in watching the telly, in their annual 'conges' (holidays), and that the working class cannot see beyond the problems of its everyday life. It was so palpably untrue. I also thought of those who say that only a narrow and rotten leadership lies between the masses and the total transformation of society. It was equally untrue. Today the working class is becoming conscious of its strength. Will it decide, tomorrow, to use it?

I rejoin the march and we proceed towards Denfert Rochereau. We pass several statues, sedate gentlemen now bedecked with red flags or carrying slogans such as 'Liberez nos camarades'. As we pass a hospital silence again descends on the endless crowd. Someone starts whistling the 'Internationale'. Others take it up. Like a breeze rustling over an enormous field of corn, the whistled tune ripples out in all directions. From the windows of the hospital some nurses wave at us.

At various intersections we pass traffic lights which by some strange inertia still seem to be working. Red and green alternate, at fixed intervals, meaning as little as bourgeois education, as work in modern society, as the lives of those walking past. The reality of today, for a few hours, has submerged all of yesterday's patterns.

The part of the march in which I find myself is now rapidly approaching what the organisers have decided should be the dispersal point. The CGT is desperately keen that its hundreds of thousands of supporters should disperse quietly. It fears them, when they are together. It wants them nameless atoms again, scattered to the four corners of Paris, powerless in the context of their individual preoccupations. The CGT sees itself as the only possible link between them, as the divinely ordained vehicle for the expression of their collective will. The 'Mouvement du 22 Mars', on the other hand, had issued a call to the students and workers, asking them to stick together and to proceed to the lawns of the Champ de Mars (at the foot of the Eiffel Tower) for a massive collective discussion on the experiences of the day and on the problems that lie ahead.

At this stage I sample for the first time what a 'service d'ordre' composed of Stalinist stew-

ards really means. All day, the stewards have obviously been anticipating this particular moment. They are very tense, clearly expecting 'trouble'. Above all else they fear what they call 'debordement', ie being outflanked on the left. For the last half-mile of the march five or six solid rows of them line up on either side of the demonstrators. Arms linked, they form a massive sheath around the marchers. CGT officials address the bottled-up demonstrators through two powerful loudspeakers mounted on vans, instructing them to disperse quietly via the Boulevard Arago, ie to proceed in precisely the opposite direction to the one leading to the Champ de Mars. Other exits from the Place Denfert Rochereau are blocked by lines of stewards linking arms.

On occasions like this, I am told, the Communist Party calls up thousands of its members from the Paris area. It also summons members from miles around, bringing them up by the coachload from places as far away as Rennes, Orleans, Sens, Lille and Limoges. The municipalities under Communist Party control provide further hundreds of these 'stewards' not necessarily Party members, but people dependent on the goodwill of the Party for their jobs and future. Ever since its heyday of participation in the government (1945-47) the Party has had this kind of mass base in the Paris suburbs. It has invariably used it in circumstances like today. On this demonstration there must be at least 10,000 such stewards, possibly twice that number.

The exhortations of the stewards meet with a variable response. Whether they are successful in getting particular groups to disperse via the Boulevard Arago depends of course on the composition of the groups. Most of those which the students have not succeeded in infiltrating obey, although even here some of the younger militants protest: "We are a million in the streets. Why should we go home?" Other groups hesitate, vacillate, start arguing. Student speakers climb on walls and shout: "All those who want to return to the telly, turn down the Boulevard Arago. Those who are for joint worker-student discussions and for developing the struggle, turn down the Boulevard Raspail and proceed to the Champ de Mars".

Those protesting against the dispersion orders are immediately jumped on by the stewards, denounced as 'provocateurs' and often man-handled. I saw several comrades of the 'Mouvement du 22 Mars' physically assaulted, their portable loudhailers snatched from their hands and their leaflets torn from them and thrown to the ground. In some sections there seemed to be dozens, in others hundreds, in others thousands of 'provocateurs'. A number of minor punch-ups take place as the stewards are swept aside by these particular contingents. Heated arguments break out, the demonstrators denouncing the Stalinists as 'cops' and as 'the last rampart of the bourgeoisie'.

A respect for facts compels me to admit that most contingents followed the orders of the trade union bureaucrats. The repeated slanders by the CGT and Communist Party leaders had had their effect. The students were "troublemakers", "adventurers", "dubious elements". Their proposed action would "only lead to a massive intervention by the CRS" (who had kept well out of sight throughout the whole of the afternoon). "This was just a demonstration, not a prelude to Revolution." Playing ruthlessly on the most backward sections of the crowd, and physically assaulting the more advanced sections, the apparatchiks of the CGT succeeded in getting the bulk of the demonstrators to disperse, often under protest. Thousands went to the Champ de Mars. But hundreds of thousands went home. The Stalinists won the day, but the arguments started will surely reverberate down the months to come.

At about 8pm an episode took place which changed the temper of the last sections of the march, now approaching the dispersal point. A police van suddenly came up one of the streets leading into the Place Denfert Rochereau. It must have strayed from its intended route, or perhaps its driver had assumed that the demonstrators had already dispersed. Seeing the crowd ahead the two uniformed gendarmes in the front seat panicked. Unable to reverse in time in order to retreat, the driver decided that his life hinged on forcing a passage through the thinnest section of the crowd. The vehicle accelerated, hurling itself into the demonstrators at about 50 miles an hour. People scattered wildly in all directions. Several people were knocked

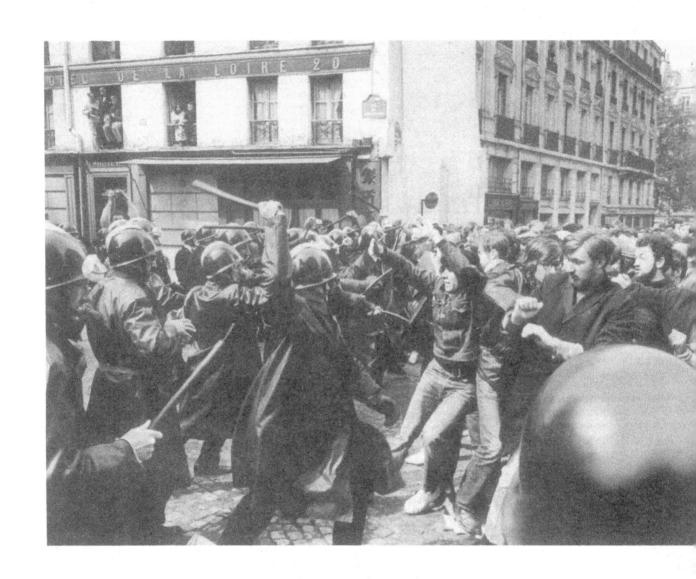

down and two were seriously injured. Many more narrowly escaped. The van was finally surrounded. One of the policemen in the front seat was dragged out and repeatedly punched by the infuriated crowd, determined to lynch him. He was finally rescued, in the nick of time, by the stewards. They more or less carried him, semiconscious, down a side street where he was passed horizontally, like a battered blood sausage, through an open ground floor window.

To do this, the stewards had had to engage in a running fight with several hundred very angry marchers. The crowd then started rocking the stranded police van. The remaining policeman drew his revolver and fired. People ducked. By a miracle no-one was hit. A hundred yards away the bullet made a hole, about three feet above ground level, in a window of 'Le Belfort', a big cafe at 297 Boulevard Raspail. The stewards again rushed to the rescue, forming a barrier between the crowd and the police van, which was allowed to escape down a side street, driven by the policeman who had fired at the crowd.

Hundreds of demonstrators then thronged round the hole in the window of the cafe. Press photographers were summoned, arrived, duly took their close-ups - none of which, of course, were ever published. (Two days later *l' Humanite* carried a few lines about the episode, at the bottom of a column on page 5.) One effect of the episode is that several thousand more demonstrators decided not to disperse. They turned and marched down towards the Champ de Mars, shouting "Ils ont tire a Denfert" (they've shot at us at Denfert). If the incident had taken place an hour earlier, the evening of 13 May might have had a very different complexion.

The Sorbonne 'Soviet'

On Saturday 11 May, shortly before midnight, Mr Pompidou, Prime Minister of France, overruled his Minister of the Interior, his Minister of Education, and issued orders to his 'independent' Judiciary. He announced that the police would be withdrawn from the Latin Quarter, that the faculties would re-open on Monday 13 May, and that the law would 'reconsider' the question of the students arrested the previous week. It was the biggest political climb-down of his

career. For the students, and for many others, it was the living proof that direct action worked. Concessions had been won through struggle which had been unobtainable by other means.

Early on the Monday morning the CRS platoons guarding the entrance to the Sorbonne were discreetly withdrawn. The students moved in, first in small groups, then in hundreds, later in thousands. By midday the occupation was complete. Every 'tricolore' was promptly hauled down, every lecture theatre occupied. Red flags were hoisted from the official flagpoles and from improvised ones at many windows, some overlooking the streets, others the big internal courtyard. Hundreds of feet above the milling students, enormous red and black flags fluttered side by side from the Chapel dome.

What happened over the next few days will leave a permanent mark on the French educational system, on the structure of French society and - most important of all - on the minds of those who lived and made history during that hectic first fortnight. The Sorbonne was suddenly transformed from the fusty precinct where French capitalism selected and moulded its hierarchs, its technocrats and its administrative bureaucracy into a revolutionary volcano in full eruption whose lava was to spread far and wide, searing the social structure of modern France.

The physical occupation of the Sorbonne was followed by an intellectual explosion of unprecedented violence. Everything, literally everything, was suddenly and simultaneously up for discussion, for question, for challenge. There were no taboos. It is easy to criticise the chaotic upsurge of thoughts, ideas and proposals unleashed in such circumstances. 'Professional revolutionaries' and petty bourgeois philistines criticised to their heart's content. But in so doing they only revealed how they themselves were trapped in the ideology of a previous epoch and were incapable of transcending it. They failed to recognise the tremendous significance of the new, of all that could not be apprehended within their own pre-established intellectual categories. The phenomenon was witnessed again and again, as it doubtless has been in every really great upheaval in history.

Day and night, every lecture theatre was

packed out, the seat of continuous, passionate debate on every subject that ever preoccupied thinking humanity. No formal lecturer ever enjoyed so massive an audience, was ever listened to with such rapt attention - or given such short shrift if he talked nonsense.

A kind of order rapidly prevailed. By the second day a noticeboard had appeared near the front entrance announcing what was being talked about, and where. I noted: 'Organisation of the struggle'; 'Political and trade union rights in the University'; 'University crisis or social crisis?'; 'Dossier of police repression'; 'Self-management'; 'Non-selection' (or how to open the doors of the University to everyone); 'Methods of teaching'; 'Exams', etc. Other lecture theatres were given over to the students-workers liaison committees, soon to assume great importance. In yet other halls, discussions were under way on 'sexual repression', on 'the colonial question', on 'ideology and mystification'. Any group of people wishing to discuss anything under the sun would just take over one of the lecture theatres or smaller rooms. Fortunately there were dozens of these.

The first impression was of a gigantic lid suddenly lifted, of pent-up thoughts and aspirations suddenly exploding, on being released from the realm of dreams into the realm of the real and the possible. In changing their environment people themselves were changed. Those who had never dared say anything suddenly felt their thoughts to be the most important thing in the world - and said so. The shy became communicative. The helpless and isolated suddenly discovered that collective power lay in their hands. The traditionally apathetic suddenly realised the intensity of their involvement. A tremendous surge of community and cohesion gripped those who had previously seen themselves as isolated and impotent puppets, dominated by institutions that they could neither control nor understand. People just went up and talked to one another without a trace of self-consciousness. This state of euphoria lasted throughout the whole fortnight I was there. An inscription scrawled on a wall sums it up perfectly: 'Deja dix jours de bonheur' (ten days of happiness already).

In the yard of the Sorbonne, politics (frowned on for a generation) took over with a vengeance. Literature stalls sprouted up along the whole inner perimeter. Enormous portraits appeared on the internal walls: Marx, Lenin, Trotsky, Mao, Castro, Guevara, a revolutionary resurrection breaking the bounds of time and place. Even Stalin put in a transient appearance (above a Maoist stall) until it was tactfully suggested to the comrades that he wasn't really at home in such company.

On the stalls themselves every kind of literature suddenly blossomed forth in the summer sunshine: leaflets and pamphlets by anarchists, Stalinists, Maoists, Trotskyists (three varieties), the PSU and the non-committed. The yard of the Sorbonne had become a gigantic revolutionary drug-store, in which the most esoteric products no longer had to be kept beneath the counter but could now be prominently displayed. Old issues of journals, yellowed by the years, were unearthed and often sold as well as more recent material. Everywhere there were groups of 10 or 20 people, in heated discussion, people talking about the barricades, about the CRS, about their own experiences, but also about the commune of 1871, about 1905 and 1917, about the Italian left in 1921 and about France in 1936. A fusion was taking place between the consciousness of the revolutionary minorities and the consciousness of whole new layers of people, dragged day by day into the maelstrom of political controversy. The students were learning within days what it had taken others a lifetime to learn. Many lyceens came to see what it was all about. They too got sucked into the vortex. I remember a boy of 14 explaining to an incredulous man of 60 why students should have the right to depose professors.

Other things also happened. A large piano suddenly appeared in the great central yard and remained there for several days. People would come and play on it, surrounded by enthusiastic supporters. As people talked in the lecture theatres of neo-capitalism and of its techniques of manipulation, strands of Chopin and bars of jazz, bits of La Carmagnole and atonal compositions wafted through the air. One evening there was a drum recital, then some clarinet players took over. These 'diversions' may have infuriated some of the more single-minded revolutionaries,

but they were as much part and parcel of the total transformation of the Sorbonne as were the revolutionary doctrines being proclaimed in the lecture halls.

An exhibition of huge photographs of the 'night of the barricades' (in beautiful half-tones) appeared one morning, mounted on stands. No-one knew who had put it up. Everyone agreed that it succinctly summarised the horror and glamour, the anger and promise of that fateful night. Even the doors of the Chapel giving on to the yard were soon covered with inscriptions: 'Open this door - Finis, les tabernacles'. 'Religion is the last mystification'. Or more prosaically: 'We want somewhere to piss, not somewhere to pray'.

The massive outer walls of the Sorbonne were likewise soon plastered with posters - posters announcing the first sit-in strikes, posters describing the wage rates of whole sections of Paris workers, posters announcing the next demonstrations, posters describing the solidarity marches in Peking, posters denouncing the police repression and the use of CS gas (as well as of ordinary tear-gas) against the demonstrators. There were posters, dozens of them, warning students against the Communist Party's band-wagon jumping tactics, telling them how it had attacked their movement and how it was now seeking to assume its leadership. Political posters in plenty. But also others, proclaiming the new ethos. A big one for instance near the main entrance, boldly proclaimed 'Defence d'interdire' (Forbidding forbidden). And others, equally to the point: 'Only the truth is revolutionary', 'Our revolution is greater than ourselves', 'We refuse the role assigned to us, we will not be trained as police dogs'. People's concerns varied but converged. The posters reflected the deeply libertarian prevailing philosophy: 'Humanity will only be happy when the last capitalist has been strangled with the guts of the last bureaucrat'; 'Culture is disintegrating. Create!'; 'I take my wishes for reality for I believe in the reality of my wishes'; or more simply, 'Creativity, spontaneity, life'.

In the street outside, hundreds of passers-by would stop to read these improvised wall-newspapers. Some gaped. Some sniggered. Some nodded assent. Some argued. Some, summoning their courage, actually entered the erstwhile sacrosanct premises, as they were being exhorted to by numerous posters proclaiming that the Sorbonne was now open to all. Young workers who 'wouldn't have been seen in that place' a month ago now walked in in groups, at first rather self-consciously, later as if they owned the place, which of course they did.

As the days went by, another kind of invasion took place - the invasion by the cynical and the unbelieving, or - more charitably - by those who 'had only come to see'. It gradually gained momentum. At certain stages it threatened to paralyse the serious work being done, part of which had to be hived off to the Faculty of Letters, at Censier, also occupied by the students. It was felt necessary, however, for the doors to be kept open, 24 hours a day. The message certainly spread. Deputations came first from other universities, then from high schools, later from factories and offices, to look, to question, to argue, to study.

The most telling sign, however, of the new and heady climate was to be found on the walls of the Sorbonne corridors. Around the main lecture theatres there is a maze of such corridors: dark, dusty, depressing, and hitherto unnoticed passageways leading from nowhere in particular to nowhere else. Suddenly these corridors sprang to life in a firework of luminous mural wisdom - much of it of Situationist inspiration. Hundreds of people suddenly stopped to read such pearls as: 'Do not consume Marx. Live it'; 'The future will only contain what we put into it now'; 'When examined, we will answer with questions'; 'Professors, you make us feel old': 'One doesn't compose with a society in decomposition'; 'We must remain the unadapted ones'; 'Workers of all lands, enjoy yourselves'; 'Those who carry out a revolution only half-way through merely dig themselves a tomb (St Just)'; 'Please leave the PC (Communist Party) as clean on leaving as you would like to find it on entering'; 'The tears of the philistines are the nectar of the gods'; 'Go and die in Naples, with the Club Mediterranee'; 'Long live communication, down with telecommunication'; 'Masochism today dresses up as reformism'; 'We will claim nothing. We will ask for nothing. We will take. We will occupy'; 'The only outrage to the Tomb of the

Unknown Soldier was the outrage that put him there'; 'No, we won't be picked up by the Great Party of the Working Class'. And a big inscription, well displayed: 'Since 1936 I have fought for wage increases. My father, before me, also fought for wage increases. Now I have a telly, a fridge, a Volkswagen. Yet all in all, my life has always been a dog's life. Don't discuss with the bosses. Eliminate them.'

Day after day the courtyard and corridors are crammed, the scene of an incessant bi-directional flow to every conceivable part of the enormous building. It may look like chaos, but it is the chaos of a beehive or of an anthill. A new structure is gradually being evolved. A canteen has been organised in one big hall. People pay what they can afford for glasses of orange juice, 'menthe', or 'grenadine' - and for ham or sausage rolls. I enquire whether costs are covered and am told they more or less break even. In another part of the building a children's creche has been set up, elsewhere a first-aid station, elsewhere a dormitory. Regular sweeping-up rotas are organised. Rooms are allocated to the Occupation Committee, to the Press Committee, to the Propaganda Committee, to the student/worker liaison committees, to the committees dealing with foreign students, to the action committees of Lyceens, to the committees dealing with the allocation of premises, and to the numerous commissions undertaking special projects such as the compiling of a dossier on police atrocities, the study of the implications of autonomy, of the examination system, etc. Anyone seeking work can readily find it.

The composition of the committees was very variable. It often changed from day to day, as the committees gradually found their feet. To those who pressed for instant solutions to every problem it would be answered: "Patience, comrade. Give us a chance to evolve an alternative. The bourgeoisie has controlled this university for nearly two centuries. It has solved nothing. We are building from rock bottom. We need a month or two...".

Confronted with this tremendous explosion which it had neither foreseen nor been able to control the Communist Party tried desperately to salvage what it could of its shattered reputation. Between 3 May and 13 May every issue of *l' Humanite* had carried paragraphs either attacking the students or making slimy innuendoes about them. Now the line suddenly changed.

The Party sent dozens of its best agitators into the Sorbonne to 'explain' its case. The case was a simple one. The Party 'supported the students' - even if there were a few 'dubious elements' in their leadership. It 'always had'. It always would.

Amazing scenes followed. Every Stalinist 'agitator' would immediately be surrounded by a large group of well-informed young people, denouncing the Party's counter-revolutionary role. A wall-paper had been put up by the comrades of *Voix Ouvriere* on which had been posted, day by day, every statement attacking the students to have appeared in *l' Humanite* or in any of a dozen Party leaflets. The 'agitators' couldn't get a word in edgeways. They would be jumped on (non-violently). "The evidence was over there, comrade. Would the Party comrades like to come and read just exactly what the Party had been saying not a week ago? Perhaps *l' Humanite* would like to grant the students space to reply to some of the accusations made against them?" Others in the audience would then bring up the Party's role during the Algerian War, during the miners' strike of 1958, during the years of 'tripartisme' (1945-1947). Wriggle as they tried, the 'agitators' just could not escape this kind of 'instant education'. It was interesting to note that the Party could not entrust this 'salvaging' operation to its younger, student members. Only the 'older comrades' could safely venture into this hornets' nest. So much so that people would say that anyone in the Sorbonne over the age of 40 was either a copper's nark or a stalinist stooge.

The most dramatic periods of the occupation were undoubtedly the 'Assemblees Generales', or plenary sessions, held every night in the giant amphitheatre. This was the soviet, the ultimate source of all decisions, the fount and origin of direct democracy. The amphitheatre could seat up to 5000 people in its enormous hemicycle, surmounted by three balcony tiers. As often as not every seat was taken and the crowd would flow up the aisles and onto the podium. A black flag and a red one hung over the

simple wooden table at which the chairman sat. Having seen meetings of 50 break up in chaos it is an amazing experience to see a meeting of 5000 get down to business. Real events determined the themes and ensured that most of the talk was down to earth.

The topic having been decided, everyone was allowed to speak. Most speeches were made from the podium but some from the body of the hall or from the balconies. The loudspeaker equipment usually worked but sometimes didn't. Some speakers could command immediate attention, without even raising their voices. Others would instantly provoke a hostile response by the stridency of their tone, their insincerity or their more or less obvious attempts at manoeuvring the assembly. Anyone who waffled, or reminisced, or came to recite a set-piece, or talked in terms of slogans, was given short shrift by the audience, politically the most sophisticated I have ever seen. Anyone making practical suggestions was listened to attentively. So were those who sought to interpret the movement in terms of its own experience or to point the way ahead.

Most speakers were granted three minutes. Some were allowed much more by popular acclaim. The crowd itself exerted a tremendous control on the platform and on the speakers. A two-way relationship emerged very quickly. The political maturity of the Assembly was shown most strikingly in its rapid realisation that booing or cheering during speeches slowed down the Assembly's own deliberations. Positive speeches were loudly cheered - at the end. Demagogic or useless ones were impatiently swept aside. Conscious revolutionary minorities played an important catalytic role in these deliberations, but never sought - at least the more intelligent ones - to impose their will on the mass body. Although in the early stages the Assembly had its fair share of exhibitionists, provocateurs and nuts, the overhead costs of direct democracy were not as heavy as one might have expected.

There were moments of excitement and moments of exhalation. On the night of 13 May, after the massive march through the streets of Paris, Daniel Cohn-Bendit confronted J M Catala. General secretary of the Union of Communist Students in front of the packed auditorium. The scene remains printed in my mind.

"Explain to us", Cohn-Bendit said, "why the Communist Party and the CGT told their militants to disperse at Denfert Rochereau, why it prevented them joining up with us for a discussion at the Champ de Mars?".

"Simple, really", sneered Catala. "The agreement concluded between the CGT, the CFDT, the UNEF and the other sponsoring organisations stipulated that dispersal would take place at a predetermined place. The Joint Sponsoring Committee had not sanctioned any further developments..."

"A revealing answer", replied Cohn-Bendit, "the organisations hadn't foreseen that we would be a million in the streets. But life is bigger than the organisations. With a million people almost anything is possible. You say the Committee hadn't sanctioned anything further. On the day of the Revolution, comrade, you will doubtless tell us to forego it 'because it hasn't been sanctioned by the appropriate sponsoring committee'...".

This brought the house down. The only ones who didn't rise to cheer were a few dozen Stalinists. Also, revealingly, those Trotskyists who tacitly accepted the Stalinist conceptions – and whose only quarrel with the CP is that it had excluded them from being one of the 'sponsoring organisations'.

That same night the Assembly took three important decisions. From now on the Sorbonne would constitute itself as a revolutionary headquarters ('Smolny' someone shouted). Those who worked there would devote their main efforts not to a mere re-organisation of the educational system, but to a total subversion of bourgeois society. From now on the University would be open to all those who subscribed to these aims. The proposals having been accepted the audience rose to a man and sang the loudest, most impassioned 'Internationale' I have ever heard. The echoes must have reverberated as far as the Elysee Palace on the other side of the River Seine...

The Censier Revolutionaries

At the same time as the students occupied the

DANS UNE PAREILLE SOCIÉTÉ LA SIMPLE PASSION DU VOL ARRIVE TOUJOURS À DÉCIDER LES PLUS INDÉCIS AUX CHOSES A PRIORI LES PLUS IMPENSABLES LES PLUS IMPOSSIBLES. LA VIE REJOINT LE JEU LE JEU REJOINT LA VIE IL FALLAIT DE TOUTES MANIÈRES ÉTENDRE LEUR TERRAIN D'EXPÉRIMENTATION S'EMPARER DE NOUVEAUX POUVOIRS POUR LUTTER CONTRE CETTE SOCIÉTÉ DU POUVOIR.

Sorbonne, they also took over the 'Centre Censier' (the new Paris University Faculty of Letters).

Censier is an enormous, ultra-modern, steel-concrete-and-glass affair situated at the south-east corner of the Latin Quarter. Its occupation attracted less attention than did that of the Sorbonne. It was to prove, however, just as significant an event. For while the Sorbonne was the shop window of revolutionary Paris – with all that that implies in terms of garish display – Censier was its dynamo, the place where things really got done.

To many, the Paris May Days must have seen an essentially nocturnal affair: nocturnal battles with the CRS, nocturnal barricades, nocturnal debates in the great amphitheatres. But this was but one side of the coin. While some argued late into the Sorbonne night, others went to bed early for in the mornings they would be handing out leaflets at factory gates or in the suburbs, leaflets that had to be drafted, typed, duplicated, and the distribution of which had to be carefully organised. This patient, systematic work was done at Censier. It contributed in no small measure to giving new revolutionary consciousness articulate expression.

Soon after Censier had been occupied a group of activists commandeered a large part of the third floor. This space was to be the headquarters of their proposed 'worker-student action committees'. The general idea was to establish links with groups of workers, however small, who shared the general libertarian-revolutionary outlook of this group of students. Contact having been made, workers and students would co-operate in the joint drafting of leaflets. The leaflets would discuss the immediate problems of particular groups of workers, but in the light of what the students had shown to be possible. A given leaflet would then be jointly distributed by workers and students, outside the particular factory or office to which it referred. In some instances the distribution would have to be undertaken by students alone, in others hardly a single student would be needed.

What brought the Censier comrades together was a deeply-felt sense of the revolutionary potentialities of the situation and the knowledge that they had no time to waste. They all felt the pressing need for direct action propaganda, and that the urgency of the situation required of them that they transcend any doctrinal differences they might have with one another. They were all intensely political people. By and large, their politics were those of the new and increasingly important historical species: the ex-members of one or other revolutionary organisation.

What were their views? Basically they boiled down to a few simple propositions. What was needed just now was a rapid, autonomous development of the working class struggle, the setting up of elected strike committees which would link union and non-union members in all strike-bound plants and enterprises, regular meetings of the strikers so that fundamental decisions remained in the hands of the rank and file, workers' defence committees to defend pickets from police intimidation, a constant dialogue with the revolutionary students aimed at restoring to the working class its own tradition of direct democracy and its own aspiration to self-management (auto-gestion), usurped by the bureaucracies of the trade unions and the political parties.

For a whole week the various Trotskyist and Maoist factions didn't even notice what was going on at Censier. They spent their time in public and often acrimonious debates at the Sorbonne as to who could provide the best leadership. Meanwhile, the comrades at Censier were steadily getting on with the work. The majority of them had 'been through' either Stalinist or Trotskyist organisations. They had left behind them all ideas to the effect that 'intervention' was meaningful only in terms of potential recruitment to their own particular group. All recognised the need for a widely-based and moderately structured revolutionary movement, but none of them saw the building of such a movement as an immediate, all important task, on which propaganda should immediately be centred.

Duplicators belonging to 'subversive elements' were brought in. University duplicators were commandeered. Stocks of paper and ink were obtained from various sources and by various means. Leaflets began to pour out, first in hundreds, then in thousands, then in tens of

thousands as links were established with one group of rank and file workers after another. On the first day alone, Renault, Citroen, Air France, Boussac, the Nouvelles Messagerires de Presse, Rhone-Poulenc and the RATP (Metro) were contacted. The movement then snowballed.

Every evening at Censier, the action committees reported back to an 'Assemblee Generale' devoted exclusively to this kind of work. The reactions to the distribution were assessed, the content of future leaflets discussed. These discussions would usually be led off by the worker contact who would describe the impact of the leaflet on his workmates. The most heated discussion centred on whether direct attacks should be made on the leaders of the CGT or whether mere suggestions as to what was needed to win would be sufficient to expose everything the union leaders had (or hadn't) done and everything they stood for. The second viewpoint prevailed.

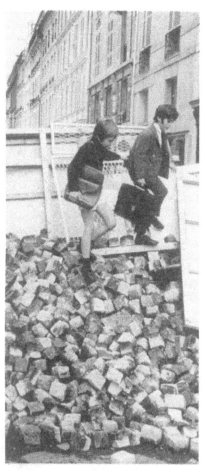

The leaflets were usually very short, never more than 200 or 300 words. They nearly all started by listing the workers grievances – or just by describing their conditions of work. They would end by inviting workers to call at Censier or at the Sorbonne. "These places are now yours. Come there to discuss your problems with others. Take a hand yourselves in making known your problems and demands to those around you". Between this kind of opening and this kind of conclusion, most leaflets contained one or two key political points.

The response was instantaneous. More and more workers dropped in to draft joint leaflets with the students. Soon there was no lecture room big enough for the daily 'Assemblee Generale'. The students learned a great deal from the workers' self-discipline and from the systematic way in which they presented their reports. It was all so different from the 'in-fighting' of the political sects. There was agreement that these were the finest lectures held at Censier!

Among the more telling lines of these leaflets, I noted the following:

Air France leaflet "We refuse to accept a degrading 'modernisation' which means we are constantly watched and have to submit to conditions which are harmful to our health, to our nervous system and an insult to our status of human beings... We refuse to entrust our demands any longer to professional trade union leaders. Like the students, we must take the control of our affairs into our own hands".

Renault leaflet "If we want our wage increases and our claims concerning conditions of work to be secure, if we don't want them constantly threatened, we must now struggle for a fundamental change in society... As workers we should ourselves seek to control the operation of our enterprises. Our objectives are similar to those of the students. The management (gestion) of industry and the management of the university should be democratically ensured by those who work there..."

Rhone-Poulenc leaflet "Up till now we tried to solve our problems through petitions, partial struggles, the election of better leaders. This has led us nowhere. The action of the students has shown us that only rank and file action could compel the authorities to retreat...the students are challenging the whole purpose of bourgeois education. They want to take the fundamental decisions themselves. So should we. *We* should decide the purpose of production, and at whose cost production will be carried out".

District leaflet (distributed in the streets at Boulogne Billancourt) "The government fears the extension of the movement. It fears the developing unity between workers and students. Pompidou has announced that 'the government will defend the Republic'. The Army and police are being prepared. De Gaulle will speak on the 24th. Will he send the CRS to clear pickets out of strikebound plants? Be prepared. In workshops and faculties, think in terms of self-defence..."

Every day dozens of such leaflets were discussed, typed, duplicated, distributed. Every evening we heard of the response: "The blokes think it's tremendous. It's just what they are thinking. The union officials never talk like this".

"The blokes liked the leaflet. They are sceptical about the 12%. They say prices will go up and that we'll lose it all in a few months. Some say let's push all together now and take on the lot". "The leaflet certainly started the lads talking. They've never had so much to say. The officials had to wait their turn to speak..."

I vividly remember a young printing worker who said one night that these meetings were the most exciting thing that had ever happened to him. All his life he had dreamed of meeting people who thought and spoke like this. But every time he thought he had met one all they were interested in was what they could get out of him. This was the first time he had been offered disinterested help.

I don't know what has happened at Censier since the end of May. When I left, sundry Trots were beginning to move in, "to politicise the leaflets" (by which I presume they meant that the leaflets should now talk about "the need to build the revolutionary Party"). If they succeed – which I doubt, knowing the calibre of the Censier comrades – it will be a tragedy.

The leaflets were in fact political. During the whole of my short stay in France I saw nothing more intensely and relevantly political (in the best sense of the term) than the sustained campaign emanating from Censier, a campaign for constant control of the struggle from below, for self-defence, for workers' management of production, for popularising the concept of workers' councils, for explaining to one and all the tremendous relevance, in a revolutionary situation, of revolutionary demands, of organised self-activity, of collective self-reliance.

As I left Censier I could not help thinking how the place epitomised the crisis of modern bureaucratic capitalism. Censier is no educational slum. It is an ultra-modern building, one of the showpieces of Gaullist 'grandeur'. It has closed circuit television in the lecture theatres, modern plumbing, and slot machines distributing 24 different kinds of food – in sterilised containers – and 10 different kinds of drink. Over 90% of the students there are of petty bourgeois or bourgeois backgrounds. Yet such is their rejection of the society that nurtured them that they were working duplicators 24 hours a day, turning out a flood of revolutionary literature of a kind no modern city has ever had pushed into it before. This kind of activity had transformed these students and had contributed to transforming the environment around them. They were simultaneously disrupting the social structure and having the time of their lives. In the words of a slogan scrawled on the wall: 'On n'est pas la pour s'emmerder' (you'll have to look this one up in the dictionary).

Getting Together

When the news of the first factory occupation (that of the Sud Aviation plant at Nantes) reached the Sorbonne - late during the night of Tuesday 14 May - there were scenes of indescribable enthusiasm. Sessions were interrupted for the announcement. Everyone seemed to sense the significance of what had just happened. After a full minute of continuous, delirious cheering, the audience broke into a synchronous, rhythmical clapping, apparently reserved for great occasions.

On Thursday 16 May the Renault factories at Cleon (near Rouen) and at Flins (North West of Paris) were occupied. Excited groups in the Sorbonne yard remained glued to their transistors as hour by hour news came over of further occupations. Enormous posters were put up, both inside and outside the Sorbonne, with the most up-to-date information of which factories had been occupied: the Nouvelles Messageries de Presse in Paris, Kleber Colombes at Caudebec, Dresser-Dujardin at Le Havre, the naval shipyard at Le Trait...and finally the Renault works at Boulogne Billancourt. Within 48 hours the task had to be abandoned. No noticeboard – or panel of noticeboards – was large enough. At last the students felt that the battle had really been joined.

Early on Friday afternoon an emergency 'General Assembly' was held. The meeting decided to send a big student deputation to the occupied Renault works. Its aim was to establish contact, express student solidarity and, if possible, discuss common problems. The march was scheduled to leave the Place de la Sorbonne at 6pm.

At about 5pm thousands of leaflets were suddenly distributed in the amphitheatres, in

the Sorbonne yard and in the streets around. They were signed by the Renault Bureau of the CGT. The Communist Party had been working... fast. The leaflets read:

"We have just heard that students and teachers are proposing to set out this afternoon in the direction of Renault. This decision was taken without consulting the appropriate trade union sections of the CGT, CFDT and FO.

"We greatly appreciate the solidarity of the students and teachers in the common struggle against the 'pouvoir personnel' (ie de Gaulle) and the employers, but are opposed to any ill-judged initiative which might threaten our developing movement and facilitate a provocation which would lead to a diversion by the government.

"We strongly advise the organisers of this demonstration against proceeding with their plans.

"We intend, together with the workers now struggling for their claims, to lead our own strike. We refuse any external intervention, in conformity with the declaration jointly signed by the CGT, CFDT and FO union, and approved this morning by 23,000 workers belonging to the factory".

The distortion and dishonesty of this leaflet defy description. No-one intended to instruct the workers how to run the strike and no student would have the presumption to seek to assume its leadership. All the students wanted was to express solidarity with the workers in what was now a common struggle against the state and the employing class.

The CGT leaflet came like any icy shower to the less political students and to all those who still had illusions about Stalinism. "They won't let us get through". "The workers don't want to talk with us". The identification of workers with 'their' organisation is very hard to break down. Several hundred who had intended to march to Billancourt were probably put off. The UNEF vacillated, reluctant to lead the march in direct violation of the wishes of the CGT.

Finally some 1500 people set out, under a single banner, hastily prepared by some Maoist students. The banner proclaimed: 'The strong hands of the working class must now take over the torch from the fragile hands of the students'.

Many joined the march who were not Maoists and who didn't necessarily agree with this particular formulation of its objectives.

Although small when compared to other marches, this was certainly a most political one. Practically everyone on it belonged to one or other of the 'groupuscules': a spontaneous united front of Maoists, Trotskyists, anarchists, the comrades of the Mouvement du 22 Mars and various others. Everyone knew exactly what he was doing. It was this that infuriated the Communist Party.

The march set off noisily, crosses the Boulevard St Michel, and passes in front of the occupied Odeon Theatre (where several hundred more joyfully join it). It then proceeds at a very brisk pace down the rue de Vaugirard, the longest street in Paris, towards the working class districts to the South West of the city, growing steadily in size and militancy as it advances. It is important to reach the factory before the Stalinists have time to mobilise their big battalions....

Slogans such as "Avec nous, chez Renault" (come with us to Renault), "Le pouvoir est dans la rue" (power lies in the street), "Le pouvoir aux ouvriers" (power to the workers) are shouted lustily, again and again. The Maoists shout "A bas le gouvernement gaulliste anti-populaire de chomage et de misere" – a long and politically equivocal slogan, but one eminently suited to collective shouting. The Internationale bursts out repeatedly, sung this time by people who seem to know the words – even the second verse!

By the time we have marched the five miles to Issy-les-Moulineaux it is already dark. Way behind us now are the bright lights of the Latin Quarter and of the fashionable Paris known to tourists. We go through small, poorly-lit streets, the uncollected rubbish piled high in places. Dozens of young people join us en route, attracted by the noise and the singing of revolutionary songs such as 'La Jeune Garde', 'Zimmerwald' and the songs of the Parisians. "Chez Renault, chez Renault" the marchers shout. People congregate in the doors of the bistros, or peer out of the windows of crowded flats to watch us pass. Some look on in amazement but many – possibly a majority – now clap or wave encouragement. In

some streets many Algerians line the pavement. Some join in the shouting of "CRS – SS"; "Charonne"; "A bas l'Etat police". They have not forgotten. Most look on shyly or smile in an embarrassed way. Very few join the march.

On we go, a few miles more. There isn't a gendarme in sight. We cross the Seine and eventually slow down as we approach a square beyond which lie the Renault works. The streets here are very badly-lit. There is a sense of intense excitement in the air.

We suddenly come up against a lorry, parked across most of the road, and fitted with loudspeaker equipment. The march stops. On the lorry stands a CGT official. He speaks for five minutes. In somewhat chilly tones he says how pleased he is to see us. "Thank you for coming, comrades. We appreciate your solidarity. But please no provocations. Don't go too near the gates as the management would use it an excuse to call the police. And go home soon. It's cold and you'll need all your strength in the days to come".

The students have brought their own loud-hailers. One or two speak, briefly. They take note of the comments of the comrade from the CGT. They have no intention of provoking anyone, no wish to usurp anyone's functions. We then slowly but quite deliberately move forwards into the square, on each side of the lorry, drowning the protests of about a hundred Stalinists in a powerful 'Internationale'. Workers in neighbouring cafes come out and join us. This time the Party had not had time to mobilise its militants. It could not physically isolate us.

Part of the factory now looms up right ahead of us, three storeys high on our left, two storeys high on our right. In front of us, there is a giant metal gate, closed and bolted. A large first floor window to our right is crowded with workers. The front row sit with their legs dangling over the sill. Several seem in their teens, one of them waves a big red flag. There are no 'tricolores' in sight – no 'dual allegiance' as in other occupied places I had seen. Several dozen more workers are on the roofs of the two buildings.

We wave. They wave back. We sing the 'Internationale'. They join in. We give the clenched fist salute. They do likewise. Everybody cheers. Contact has been made.

An interesting exchange takes place. A group of demonstrators starts shouting "Les usines aux ouvriers" (the factories to the workers). The slogan spreads like wildfire through the crowd. The Maoists, now in a definite minority, are rather annoyed. (According to Chairman Mao, workers' control is a petty-bourgeois, anarcho-syndicalist deviation). "Les usines aux ouvriers"...10, 20 times the slogan reverberates round the Place Nationale, taken up by a crowd now some 3000 strong.

As the shouting subsides, a lone voice from one of the Renault roofs shouts back: "La Sorbonne aux Etudiants". Other workers on the same roof take it up. Then those on the other roof. By the volume of their voices there must be at least 100 of them, on top of each building. There is then a moment of silence. Everyone thinks that the exchange has come to an end. But one of the demonstrators starts chanting: "La Sorbonne aux ouvriers". Amidst general laughter, everyone joins in.

We start talking. A rope is quickly passed down from the window, a bucket at the end of it. Bottles of beer and packets of fags are passed up. Also revolutionary leaflets. Also bundles of papers (mainly copies of *Servir Le Peuple* – a Maoist journal carrying a big title 'Vive la CGT'). At street level there are a number of gaps in the metal façade of the building. Groups of students cluster at these half dozen openings and talk to groups of workers on the other side. They discuss wages, conditions, the CRS, what the lads inside need most, how the students can help. The men talk freely. They are not Party members. They think the constant talk of provocateurs a bit far fetched. But the machines must be protected. We point out that two or three students inside the factory, escorted by the strike committee, couldn't possibly damage the machines. They agree. We contrast the widely open doors of the Sorbonne with the heavy locks and bolts on the Renault gates – closed by the CGT officials to prevent the ideological contamination of 'their militants'. How silly, we say, to have to talk through these stupid little slits in the wall. Again they agree. They will put it to their 'dirigieants' (leaders). No-one seems, as yet, to think beyond this.

There is then a diversion. A hundred yards

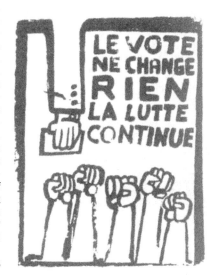

away a member of the FER gets up on a parked car and starts making a speech through a loud-hailer. The intervention is completely out of tune with the dialogue that is just starting. It's the same gramophone record that we have been hearing all week at the Sorbonne. "Call on the union leaders to organise the election of strike committees in every factory. Force the union leaders to federate the strike committees. Force the union leaders to set up a national strike committee. Force them to call a general strike throughout the whole of the country" (this at a time when millions of workers are already on strike without any call whatsoever!). The tone is strident, almost hysterical, the misjudging of the mood monumental. The demonstrators themselves drown the speaker in a loud 'Internationale'. As the last bar fades the Trotskyist tries again. Again the demonstrators drown him.

Groups stroll up the Avenue Yves Kermen, to the other entrances to the factory. Real contact is here more difficult to establish. There is a crowd outside the gate but most of them are Party members. Some won't talk at all. Other just talk slogans.

We walk back to the square. It is now well past midnight. The crowd thins. Groups drop into a couple of cafes which are still open. Here we meet a whole group of young workers, aged about 18. They had been in the factory earlier in the day.

They tell us that at any given time, just over 1000 workers are engaged in the occupation. The strike started on the Thursday afternoon, at about 2pm, when the group of youngsters from shop 70 decided to down tools and spread into all parts of the factory asking their mates to do likewise. That same morning they had heard of the occupation of Cleon and that the red flag was floating over the factory at Flins. There had been a lot of talk about what to do. At a midday meeting the CGT had spoken vaguely of a series of rotating strikes, shop by shop, to be initiated the following day.

The movement spread at an incredible pace. The youngsters went round shouting "Occupation! Occupation!". Half the factory had stopped working before the union officials realised what was happening. At about 4pm,

Sylvain, a CGT secretary, had arrived with loud-speaker equipment to tell them "they weren't numerous enough, to start work again, that they would see tomorrow about a one day strike". He is absolutely by-passed. At 5pm Halbeher, general secretary of the Renault CGT, announces, pale as a sheet, that the "CGT has called for the occupation of the factory". "Tell your friends", the lads say. "*We started it*. But will we be able to keep it in our hands? Ca, c'est un autre prob-leme..."

Students? Well, hats off to anyone who can thump the cops that hard! The lads tell us two of their mates had disappeared from the factory altogether 10 days ago "to help the Revolution". Left family, jobs, everything. And good luck to them. "A chance like this comes once in a life-time". We discuss plans, how to develop the movement. The occupied factory could be a ghetto, 'isolant les durs' (isolating the most militant). We talk about camping, the cinema, the Sorbonne, the future. Almost, until sunrise...

'Attention Aux Provocateurs'

Social upheavals, such as the one France has just been through, leave behind them a trail of shattered reputations. The image of Gaullism as a meaningful way of life, 'accepted' by the French people, has taken a tremendous knock. But so has the image of the Communist Party as a viable challenge to the French establishment.

As far as the students are concerned the recent actions of the PCF (Parti Communiste Francais) are such that the Party has probably sealed its fate in this milieu for a generation to come. Among the workers the effects are more difficult to assess and it would be premature to attempt this assessment. All that can be said is that the effects are sure to be profound although they will probably take some time to express themselves. The proletarian condition itself was for a moment questioned. Prisoners who have had a glimpse of freedom do not readily resume a life sentence.

The full implications of the role of the PCF and of the CGT have yet to be appreciated by British revolutionaries. They need above all else to be informed. In this section we will document

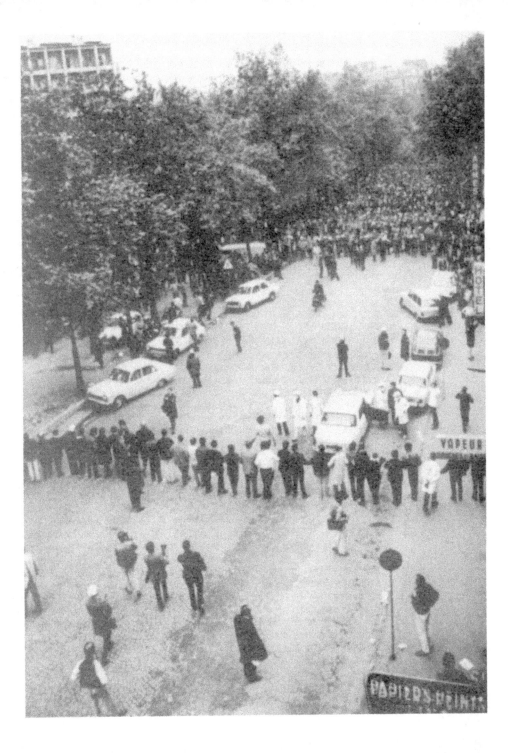

the role of the PCF to be best of our ability. It is important to realise that for every ounce of shit thrown at the students in its official publication, the Party poured tons more over them at meetings or in private conversations. In the nature of things it is more difficult to document this kind of slander.

Friday 3 May

A meeting was called in the yard of the Sorbonne by UNEF, JCR, MAU and FER to protest at the closure of the Nanterre faculty. It was attended by militants of the Mouvement du 22 Mars. The police were called in by Rector Roche and activists from all these groups were arrested.

The UEC (Union des Etudiants Communistes) didn't participate in this campaign. But it distributed a leaflet in the Sorbonne denouncing the activity of the 'groupuscules' (abbreviation for 'groupes miniscules', tiny groups).

"The leaders of the leftist groups are taking advantage of the shortcomings of the government. They are exploiting student discontent and trying to stop the functioning of the faculties. They are seeking to prevent the mass of students from working and from passing their exams. These false revolutionaries are acting objectively as allies of the Gaullist power. They are acting as supporters of its policies, which are harmful to the mass of the students and in particular to those of modest origin".

On the same day l' Humanite had written "Certain small groups (anarchists, Trotskyists, Maoists) composed mainly of the sons of the big bourgeoisie and led by the German anarchist Cohn-Bendit, are taking advantage of the shortcomings of the government ..." etc... (see above). The same issue of l' Humanite had published an article by Marchais, a member of the Party's Central Committee. This article was to be widely distributed, as a leaflet, in factories and offices:

"Not satisfied with the agitation they are conducting in the student milieu - and agitation which is against the interests of the mass of the students and favours fascist provocateurs - these pseudo-revolutionaries now have the nerve to seek to give lessons to the working class movement. We find them in increasing numbers at the gates of factories and in places where immigrant workers live, distributing leaflets and other propaganda. These false revolutionaries must be unmasked, for objectively they are serving the interests of the Gaullist power and of the big capitalist monopolies."

Monday 6 May

The police have been occupying the Latin Quarter over the weekend. There have been big student street demonstrations. At the call of UNEF and SNESup 20,000 students marched from Denfert Rochereau to St Germain des Pres calling for the liberation of the arrested workers and students. Repeated police assaults on the demonstrators: 422 arrested, 800 wounded.

L' Humanite states: "One can clearly see today the outcome of the adventurist actions of the leftist, anarchist, Trotskyist and other groups. Objectively they are playing into the hands of the government... The discredit into which they are bringing the student movement is helping feed the violent campaigns of the reactionary press and of the ORTF, who by identifying the actions of these groups with those of the mass of the students are seeking to isolate the students from the mass of the population...".

Tuesday 7 May

UNEF and SNESup call on their supporters to start an unlimited strike. Before discussions with the authorities begin they insist on:

a) a stop to all legal action against the students and workers who have been questioned, arrested or convicted in the course of the demonstrations of the last few days,

b) the withdrawal of the police from the Latin Quarter and from all University premises,

c) a reopening of the closed faculties.

In a statement showing how comparatively out of touch they were with the deep motives of the student revolt, the 'Elected Communist Representatives of the Paris Region' declared (in l' Humanite):

"The shortage of credits, of premises, of equipment, of teachers...prevent three students

out of four from completing their studies, without mentioning all those who never have access to higher education.... This situation has caused profound and legitimate discontent among both students and teachers. It has also favoured the activity of irresponsible groups whose conceptions can offer no solution to the students' problems. It is intolerable that the government should take advantage of the behaviour of an infinitesimal minority to stop the studies of tens of thousands of students a few days from their exams...".

The same issue of *l'Humanite* carried a statement from the 'Sorbonne-Lettres' (teachers) branch of the Communist Party: "The Communist teachers demand the liberation of the arrested students and the reopening of the Sorbonne. Conscious of our responsibilities, we specify that this solidarity does not mean that we agree with or support the slogans emanating from certain student organisations. We disapprove of unrealistic, demagogic and anti-communist slogans and of the unwarranted methods of action advocated by various leftist groups".

On the same day Georges Seguy, general secretary of the CGT, spoke to the Press about the programme of the Festival of Working Class Youth (scheduled for May 17-19, but subsequently cancelled): "The solidarity between students, teachers and the working class is a familiar notion to the militants of the CGT... It is precisely this tradition that compels us not to tolerate any dubious or provocative elements, elements which criticise the working class organisations..."

Wednesday 8 May

A big students demonstration called by the UNEF has taken place in the streets of Paris the previous evening. The front page of *l'Humanite* carries a statement from the Party Secretariat: "The discontent of the students is legitimate. But the situation favours adventurist activities, whose conception offers no perspective to the students and has nothing in common with a really progressive and forward-looking policy..."

In the same issue, J M Catala, general secretary of the UEC (Union des Etudiants Communistes) writes that: "the actions of irresponsible groups are assisting the Establishment in its aims... What we must do is ask for a bigger educational budget which would ensure bigger student grants, the appointment of more and better qualified teachers, the building of new faculties..."

The UJCF (Union des Jeunesses Communistes de France) and the UJFF (Union des Jeunes Filles Francaises) distribute a leaflet in a number of lycees. *L'Humanite* quotes it approvingly: "We protest against police violence unleashed against the students. We demand the reopening of the Nanterre and of the Sorbonne and the liberation of all those arrested. We denounce the Gaullist power as being mainly (!) responsible for this situation. We also denounce the adventurism of certain irresponsible groups and call on the lyceens to fight side by side with the working class and its Communist Party..."

Monday 13 May

Over the weekend Pompidou has climbed down. But the unions, the UNEF and the teachers have decided to maintain their call for a one day general strike.

On its front page *l'Humanite* publishes, in enormous headlines, a call for the 24 hour strike followed by a statement from the Political Bureau:

"The unity of the working class and of the students threatens the regime... This creates an enormous problem. It is essential that no provocation, no diversion should be allowed to divert any of the forces struggling against the regime or should give the government the flimsiest pretext to distort the meaning of this great fight. The Communist Party associates itself without reservation with the just struggle of the students..."

Wednesday 15 May

The enormous Monday demonstrations in Paris and other towns – which incidentally prevented *l'Humanite* as well as other papers from appearing on the Tuesday – were a tremendous success. In a sense they triggered off the 'spontaneous' wave of strikes which followed within a day or two. *L'Humanite* publishes, on its front

page, a statement issued the day before by the Party's Political Bureau. After taking all the credit for May 13, the statement continues:

"The People of Paris marched for hours in the streets of the capital showing a power which made any provocation impossible. The Party organisations worked day and night to ensure that this great demonstration of workers, teachers and students should take place in maximum unity, strength and discipline.... It is now clear that the Establishment confronted with the protests and collective action of all the main sections of the population, will seek to divide us in the hope of beating us. It will resort to all methods, including provocation. The Political Bureau warns workers and students against any adventurist endeavours which might, in the present circumstances, dislocate the broad front of the struggle which is in the process of developing, and provide the Gaullist power with an unexpected weapon with which to consolidate its shaky rule..."

Saturday 18 May

Over the past 48 hours, strikes with factory occupations have spread like a trail of gunpowder, from one corner of the country to the other. The railways are paralysed, civil airports fly the red flag. (Provocateurs have obviously been at work!)

L' Humanite publishes on its front page a declaration from the National Committee of the CGT: "From hour to hour strikes and factory occupations are spreading. This action, started on the initiative of the CGT and of other trade union organisations (sic!), creates a new situation of exceptional importance.... Long-accumulated popular discontent is now finding expression. The questions being asked must be answered seriously and full notice taken of their importance. The evolution of the situation is giving a new dimension to the struggle... While multiplying its efforts to raise the struggle to the needed level, the National Committee warns all CGT militants and local groups against any attempts by outside groups to meddle in the conduct of the struggle, and against all acts of provocation which might assist the forces of repression in their attempts to thwart the devel-

opment of the movement..."

The same issue of the paper devoted a whole page to warning students of the fallacy of any notions of 'student power' – *en passant* – attributing to the 'Mouvement du 22 Mars' a whole series of political positions they never held.

Monday 20 May

The whole country is totally paralysed. The Communist Party is still warning about 'provocations'. The top right hand corner of *l' Humanite* contains a box labelled "WARNING". "Leaflets have been distributed in the Paris area calling for an insurrectionary general strike. It goes without saying that such appeals have not been issued by our democratic trade union organisations. They are the work of provocateurs seeking to provide the government with a pretext for intervention... The workers must be vigilant to defeat all such manoeuvres..."

In the same issue, Etienne Fajon of the Central Committee, continues the warnings: "The Establishment's main preoccupation at the moment is to divide the ranks of the working class and to divide it from other sections of the population... Our political Bureau has warned workers and students, from the very beginning, against adventurist slogans capable of dislocating the broad front of the struggle. Several provocations have thus been prevented. Our political vigilance must clearly be maintained..."

The same issue devoted its central pages to an interview of Mr Georges Seguy, general secretary of the CGT, conducted over the Europe No. 1 radio network. In these live interviews, various listeners phoned questions in directly. The following exchanges are worth recording:

Question "Mr Seguy, the workers on strike are everywhere saying that they will go the whole hog. What do you mean by this? What are your objectives?"

Answer "The strike is so powerful that the workers obviously mean to obtain the maximum concessions at the end of such a movement. The whole hog for us trade unionists, means winning the demands for which we have always fought, but which the government and the employers have always refused to consider. They have

opposed an obtuse intransigence to the proposals for negotiations which we have repeatedly made.

The whole hog means a general rise in wages (no wages less than 600 francs per month), guaranteed employment, an earlier retirement age, reduction of working hours without loss of wages and the defence and extension of trade union rights within the factory. I am not putting these demands in any particular order because we attach the same importance to all of them".

Question "If I am not mistaken the statutes of the CGT declare its aims to be the overthrow of capitalism and its replacement by socialism. In the present circumstances, that you have yourself referred to as 'exceptional' and 'important', why doesn't the CGT seize this unique chance of calling for its fundamental objectives?"

Answer "This is a very interesting question. I like it very much. It is true that the CGT offers the workers a concept of trade unionism that we consider the most revolutionary insofar as its final objective is the end of the employing class and of wage labour. It is true that this is the first of our statutes. It remains fundamentally the CGT's objective. But can the present movement reach this objective? If it became obvious that it could, we would be ready to assume our responsibilities. It remains to be seen whether all the social strata involved in the present movement are ready to go that far".

Question "Since last week's events I have gone everywhere where people are arguing. I went this afternoon to the Odeon Theatre. Masses of people were discussing there. I can assure you that all the classes who suffer from the present regime were represented there. When I asked whether people thought that the movement should go further than the small demands put forwards by the trade unions for the last 10 or 20 years, I brought the house down. I therefore think that it would be criminal to miss the present opportunity. It would be criminal because sooner or later this will have to done. The conditions of today might allow us to do it peacefully and calmly and will perhaps never come back. I think this call must be made by you and the other political organisations.

These political organisations are not your business, of course, but the CGT is a revolutionary organisation. You must bring out your revolutionary flag. The workers are astounded to see you so timid".

Answer "While you were bathing in the Odeon fever, I was in the factories. Amongst workers. I assure you that the answer I am giving you is the answer of a leader of a great trade union, which claims to have assumed all its responsibilities, but which does not confuse its wishes with reality".

A caller "I would like to speak to Mr Seguy. My name is Duvauchel. I am the director of the Sud Aviation factory at Nantes".

Seguy "Good morning, sir".

Duvauchel "Good morning, Mr General Secretary. I would like to know what you think of the fact that for the last four days I have been sequestrated, together with about 20 other managerial staff, inside the Sud Aviation factory at Nantes".

Seguy "Has anyone raised a hand against you?"

Duvauchel "No. But I am prevented from leaving, despite the fact that the general manager of the firm has intimated that the firm was prepared to make positive proposals as soon as free access to its factories could be resumed, and first of all to its managerial staff".

Seguy "Have you asked to leave the factory?"

Duvauchel "Yes!"

Seguy "Was permission refused?"

Duvauchel "Yes!"

Seguy "Then I must refer you to the declaration that I made yesterday at the CGT's press conference. I stated that I disapproved of such activities. We are taking the necessary steps to see that they are not repeated".

But enough is enough. The Revolution itself will doubtless be denounced by the Stalinists as a provocation! By way of an epilogue it is worth recording that at a packed meeting of revolutionary students, held at the Mutualite on Thursday 9 May, a spokesman of the Trotskyist organisation Communiste Internationaliste could think of nothing better to do than call a meeting to pass a resolution calling on Seguy to call a general strike!!!

France, 1968

This has undoubtedly been the greatest revolutionary upheaval in Western Europe since the days of the Paris Commune. Hundreds of thousands of students have fought pitched battles with the police. Nine million workers have been on strike. The red flag of revolt has flown over occupied factories, universities, building sites, shipyards, primary and secondary schools, pit heads, railway stations, department stores, docked transatlantic liners, theatres, hotels. The Paris Opera, the Folies Bergeres and the building of the National Council for Scientific Research were taken over, as were the headquarters of the French Football Federation – whose aim was clearly perceived as being 'to prevent ordinary footballers enjoying football'.

Virtually every layer of French society has been involved to some extent or other. Hundreds of thousands of people of all ages have discussed every aspect of life in packed-out, non-stop meetings in every available schoolroom and lecture hall. Boys of 14 have invaded a primary school for girls shouting "Liberte pour les filles". Even such traditionally reactionary enclaves as the Faculties of Medicine and Law have been shaken from top to bottom, their hallowed procedures and institutions challenged and found wanting. Millions have taken a hand in making history. This is the stuff of revolution.

Under the influence of the revolutionary students, thousands began to query the whole principle of hierarchy. The students had questioned it where it seemed the most 'natural': in the realms of teaching and knowledge. They proclaimed that democratic self-management was possible – and to prove it began to practice it themselves. They denounced the monopoly of information and produced millions of leaflets to break it. They attacked some of the main pillars of contemporary 'civilisation': the barriers between manual workers and intellectuals, the consumer society, the 'sanctity' of the university and of other founts of capitalist culture and wisdom.

Within a matter of days the tremendous creative potentialities of the people suddenly erupted. The boldest and most realistic ideas – and they are usually the same - were advocated,

argued, applied. Language, rendered stale by decades of bureaucratic mumbo-jumbo, eviscerated by those who manipulate it for advertising purposes, suddenly reappeared as something new and fresh. People reappropriated it in all its fullness. Magnificently apposite and poetic slogans emerged from the anonymous crowd. Children explained to their elders what the function of education should be. The educators were educated. Within a few days, young people of 20 attained a level of understanding and a political and tactical sense which many who had been in the revolutionary movement for 30 years or more were still sadly lacking.

The tumultuous development of the students' struggle triggered off the first factory occupations. It transformed both the relation of forces in society and the image, in people's minds, of established institutions and of established leaders. It compelled the State to reveal both its oppressive nature and its fundamental incoherence. It exposed the utter emptiness of Government, Parliament, Administration - and of ALL political parties. Unarmed students had forced the Establishment to drop its mask, to sweat with fear, to resort to the police club and to the gas grenade. Students finally compelled the bureaucratic leaderships of the 'working class organisations' to reveal themselves as the ultimate custodians of the established order.

But the revolutionary movement did still more. It fought its battles in Paris, not in some under-developed country, exploited by imperialism. In a glorious few weeks the actions of students and young workers dispelled the myth of the well-organised, well-oiled modern capitalist society, from which radical conflict had been eliminated and in which only marginal problems remained to be solved. Administrators who had been administering everything were suddenly shown to have had a grasp of nothing. Planners who had planned everything showed themselves incapable of ensuring the endorsement of their plans by those to whom they applied.

This most modern movement should allow real revolutionaries to shed a number of the ideological encumbrances which in the past hampered revolutionary activity. It wasn't hunger which drove the students to revolt. There wasn't an 'economic crisis' even in the loosest sense of

the word. The revolt had nothing to do with 'under-consumption' or with 'over-production'. The 'falling rate of profit' just didn't come into the picture. Moreover, the student movement wasn't based on economic demands. On the contrary, the movement only found its real stature, and only evoked its tremendous response, when it went beyond the economic demands within which official student unionism had for so long sought to contain it (incidentally with the blessing of all the political parties and 'revolutionary' groups of the 'left'). And conversely it was by confining the workers' struggle to purely economic objectives that the trade union bureaucrats have so far succeeded in coming to the assistance of the regime.

The present movement has shown that the fundamental contradiction of modern bureaucratic capitalism isn't the 'anarchy of the market'. It isn't the 'contradiction between the forces of production and the property relations'. The central conflict to which all others are related is the conflict between order-givers (dirigeants) and order-takers (executants). The insoluble contradiction which tears the guts out of modern capitalist society is the one which compels it to exclude people from the management of their own activities and which at the same time compels it to solicit their participation, without which it would collapse. These tendencies find expression on the one hand in the attempt of the bureaucrats to convert men into objects (by violence, mystification, new manipulation techniques – or 'economic carrots') and, on the other hand, in mankind's refusal to allow itself to be treated in this way.

The French events show clearly something that all revolutions have shown, but which apparently has again and again to be learned anew. There is no 'in-built revolutionary perspective', no 'gradual increase of contradictions', no 'progressive development of a revolutionary mass consciousness'. What are given are the contradictions and the conflicts we have described and the fact that modern bureaucratic society more or less inevitably produces periodic 'accidents' which disrupt its functioning. These both provoke popular interventions and provide the people with opportunities for asserting themselves and for changing the social order. The functioning of bureaucratic capitalism creates the conditions within which revolutionary consciousness may appear. These conditions are an integral part of the whole alienating hierarchical and oppressive social structure. Whenever people struggle, sooner or later they are compelled to question the whole of that social structure.

These are the ideas which many of us in *Solidarity* have long subscribed to. They were developed at length in some of Paul Cardan's pamphlets. Writing in *Le Monde* (20 May 1968) E Morin admits that what is happening today in France is "a blinding resurrection: the resurrection of that libertarian strand which seeks conciliation with marxism, in a formula of which *Socialisme ou Barbarie* had provided a first synthesis a few years ago..." As after every verification of basic concepts in the crucible of real events, many will proclaim that these had always been their views. This, of course isn't true.[1] The point however isn't to lay claims to a kind of copyright in the realm of correct revolutionary ideas. We welcome converts, from whatever source and however belated.

We can't deal here at length with what is now an important problem in France, namely the creation of a new kind of revolutionary movement. Things would indeed have been different if such a movement had existed, strong enough to outwit the bureaucratic manoeuvres, alert enough day by day to expose the duplicity of the 'left' leaderships, deeply enough implanted to explain to the workers the real meaning of the students' struggle, to propagate the idea of autonomous strike committees (linking up union and non-union members), of workers' management of production and of workers' councils. Many things which could have been done weren't done because there wasn't such a movement. The way the students' own struggle was unleashed shows that such an organisation could have played a most important catalytic role without automatically becoming a bureaucratic 'leadership'. But such regrets are futile. The non-existence of such a movement is no accident. If it had been formed during the previous period it certainly wouldn't have been the kind of movement of which we are speaking. Even taking the 'best' of the small organisation -

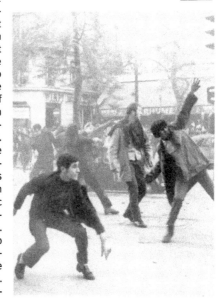

and multiplying its numbers a hundredfold - wouldn't have met the requirements of the current situation. When confronted with the test of events all the 'left' groups just continued playing their old gramophone records. Whatever their merits as depositories of the cold ashes of the revolution – a task they have now carried out for several decades – they proved incapable of snapping out of their old ideas and routines, incapable of learning or forgetting anything.[2]

The new revolutionary movement will have to be built from the new elements (students and workers) who have understood the real significance of current events. The revolution must step into the great political void revealed by the crisis of the old society. It must develop a voice, a face, a paper – and it must do it soon.

We can understand the reluctance of some students to form such an organisation. They feel there is a contradiction between action and thought, between spontaneity and organisation. Their hesitation is fed by the whole of their previous experience. They have seen how thought could become sterilising dogma, organisation become bureaucracy or lifeless ritual, speech become a means of mystification, a revolutionary idea become a rigid and stereotyped programme. Through their actions, their boldness, their reluctance to consider long-term aims, they have broken out of this straight-jacket. But this isn't enough.

Moreover many of them had sampled the traditional 'left' groups. In all their fundamental aspects these groups remain trapped within the ideological and organisational frameworks of bureaucratic capitalism. They have programmes fixed once and for all, leaders who utter fixed speeches, whatever the changing reality around them, organisational form which mirror those of existing society. Such groups reproduce within their own ranks the division between order-takers and order-givers, between those who 'know' and those who don't, the separation between scholastic pseudo-theory and real life. They would even like to impose this division into the working class, whom they aspire to lead, because (and I was told this again and again) "the workers are only capable of developing a trade union consciousness".

But these students are wrong. One doesn't get beyond bureaucratic organisation by denying all organisation. One doesn't challenge the sterile rigidity of finished programmes by refusing to define oneself in terms of aims and methods. One doesn't refute dead dogma by the condemnation of all theoretical reflection. The students and young workers can't just stay where they are. To accept these 'contradictions' as valid and as something which cannot be transcended is to accept the essence of bureaucratic capitalist ideology. It is to accept the prevailing philosophy and the prevailing reality. It is to integrate the revolution into an established historical order.

If the revolution is only an explosion lasting a few days (or weeks), the established order – whether it knows it or not - will be able to cope. What is more - at a deep level – class society even needs such jolts. This kind of 'revolution' permits class society to survive by compelling it to transform and adapt itself. This is the real danger today. Explosions which disrupt the imaginary world in which alienated societies tend to live – and bring them momentarily down to earth – help them eliminate outmoded methods of domination and evolve new and more flexible ones.

Action or thought? For revolutionary socialists the problem is not to make a synthesis of these two preoccupations of the revolutionary students. It is to destroy the social context in which such false alternatives find root.

Solidarity, 1968

1 We recall for instance a long review of *Modern Capitalism and Revolution in International Socialism* (No 22) where, under the heading 'Return to Utopia', Cardan was deemed to have "nothing to say in relation to theory". His prediction that people would eventually reject the emptiness of the consumer society were described as "mere moralising" and as "doing credit to a Christian ascetic". The authors should perhaps visit the new monastery at the Sorbonne.

2 We are not primarily referring to trotskyist groups such as the FER, which on the night of the barricades, despite repeated appeals for help, refused to cancel their mass meeting at the *Mutualite* or to send reinforcements to assist students and workers already engaged in a bitter fight with the CRS on the barricades

of the rue Gay Lussac. We are not referring to their leader Chisseray who claimed it was "necessary above all to preserve the revolutionary vanguard from an unnecessary massacre". Nor are we referring to the repeated maoist criticisms of the students' struggle, uttered as late as 7 May. What we are referring to is the inability of *any* Trotskyist or Maoist group to raise the real issues demanded in a revolutionary situation, ie to call for workers' management of production and the formation of workers' councils. None of these groups even touched on the sort of question the revolutionary students were discussing day and night: the relations of production in the capitalist factory, alienation at work whatever the level of wages, the division between leaders and led within the factory hierarchy or within the 'working class' organisations themselves. All that *Humanite Nouvelle* could counterpose to the constantly demobilising activities of the CGT was the immensely demystifying slogan: "Vive le CGT" ("The CGT isn't *really* what it appears to be, comrade"). All that *Voix Ouvriere* could counterpose to the CGT's demand for a minimum wage of 600 francs was... a minimum wage of 1000 francs. This kind of revolutionary auction (in purely economic demands), after the workers had been occupying the factories for several weeks, shows the utter bankruptcy of revolutionaries who fail to recognise a revolution. *Avant Garde* correctly attacked some of the ambiguities of auto-gestion (self-management) as advocated by the CFDT, but failed to point out the deeply revolutionary implications of the slogan.

Workers Beware!
Text of a CGT poster, placarded all over Boulogne Billancourt:

For some months the most diverse publications have been distributed by elements recruited in a milieu foreign to the working class.

The authors of these articles remain anonymous most of the time, a fact which fully illustrates their dishonesty. They give the most weird and tempting titles to their papers, the better to mislead: *Luttes Ouvrieres; Servir le Peuple; Unite et Travail*; Lutte Communiste; Revoltes; Voix Ourriere; Un Groupe d' Ouvriers.*

The titles may vary but the content has a common objective: to lead the workers away from the CGT and to provoke divisions in their ranks, in order to weaken them.

At night, their commandos tear up our posters. Every time they distribute something at the gates, the police are not far off, ready to protect their distribution, as was the case recently at LMT. Recently they attempted to invade the offices of the Labour Exchange at Boulogne. Their activities are given an exaggerated publicity on the Gaullist radio and in the columns of the bourgeois press.

This warning is no doubt superfluous for the majority of Renault workers, who, in the past, have got to know about this kind of agitation. On the other hand the younger workers must be told that these elements are in the service of the bourgeoisie, who have always made use of these pseudo-revolutionaries whenever the rise of united left forces has presented a threat to its privileges.

It is therefore important not to allow these people to come to the gates of our factory, to sully our trade union organisation and our CGT militants. who are tirelessly exerting themselves in defence of our demands and to bring about unity. These elements always reap a fat reward at the end of the day for their dirty work, and for the loyal services given to the bosses (some now occupy high positions in the management of the factory).

This having been said, the CGT (Renault) Committee calls on the workers to continue the fight for their demands, to intensify their efforts to ensure greater unity of the trade union and democratic forces, and to strengthen the ranks of the CGT struggling for these noble objectives.

The Trade Union Bureau, CGT, Renault

*This is a fascist publication; all the others are 'left' publications. A typical amalgam technique.

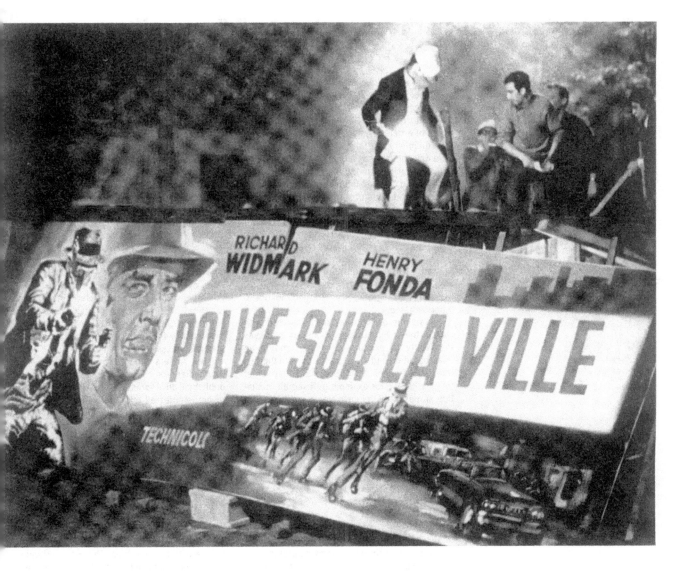

The Decline & Fall of the "Spectacular" Commodity-Economy

From the 13th to the 16th of August, 1965, the blacks of Los Angeles revolted. An incident involving traffic police and pedestrians developed into two days of spontaneous riots. The forces of order, despite repeated reinforcement, were unable to gain control of the streets. By the third day, the negroes had armed themselves by pillaging such arms shops as were accessible, and were so enabled to open fire on police helicopters. Thousands of soldiers - the whole military weight of an infantry division, supported by tanks - had to be thrown into the struggle before the Watts area could be surrounded, after which it took several days and much street fighting for it to be brought under control. The rioters didn't hesitate to plunder and burn the shops of the area. The official figures testify to 32 dead, including 27 negroes, plus 800 wounded and 3,000 arrested.

Reactions on all sides were invested with clarity: the revolutionary act always discloses the reality of existing problems, lending an unaccustomed and unconscious truth to the various postures of its opponents. Police Chief William Parker, for example, refused all mediation proposed by the main Negro organisations, asserting correctly that the rioters had no leader. Evidently, as the blacks were without a leader, this was the moment of truth for both parties. What did Roy Wilkins, general secretary of the NAACP, want at that moment ? He declared that the riots should be put down "with all the force necessary". And the Cardinal of Los Angeles, McIntyre, who protested loudly, had not protested against the violence of the repression, which one would have supposed the subtle thing to do, at the moment of the *aggiornamento* of the Roman church; instead, he protested in the most urgent tones about "a premeditated revolt against the rights of one's neighbour; respect for the law and the maintenance of order", calling upon catholics to oppose the plundering and the apparently unjustified violence. All the theorists and "spokesmen" of the international Left (or, rather of its nothingness) deplored the irresponsibility and disorder, the pillaging and above all the fact that *arms and alcohol* were the first targets for plunder; finally, that 2,000 fires had been started by the Watts gasoline throwers to light up their battle and their ball. But who was there to defend the rioters of Los Angeles in the terms they deserve? Well, we shall. Let us leave the economists to grieve over the 27 million dollars lost, and the town planners over one of their most beautiful supermarkets gone up in smoke, and McIntyre over his slain Deputy Sheriff; let the sociologists weep over the absurdity and the intoxication of this rebellion. The job of a revolutionary journal is not only to justify the Los Angeles insurgents, but to help uncover their just reasons: to explain theoretically the truth for which such practical action expresses the search.

In Algiers in July, 1965, following Boumedienne's *coup d'etat*, the situationists published an *Address* to the Algerians and to revolutionaries all over the world, which interpreted conditions in Algeria and in the rest of the world *as a whole*; among their examples, they evoked the American negroes, who if they could "affirm themselves significantly" would unmask the contradictions of the most advanced of capitalist systems. Five weeks later, this significance found an expression on the street. Theoretical criticism of modern society, in its advanced forms, and criticism in *actions* of the same society, co-exist at this moment: still separated but both advancing towards the same reality, both talking of the same thing. These two critiques are mutually explanatory, each being incomprehensible without the other. Our theory of "survival" and the "spectacle" is illuminated and ver-

ified by these actions so unintelligible to the American false consciousness. One day these actions will in turn be illuminated by this theory.

Up to this time the Negro "Civil Rights" demonstrations had been kept by their leaders within the limits of a legal system which overlooked the most appalling violence on the part of the police and the racists: in Alabama the previous March for instance, at the time of the Montgomery March, and as if this scandal was not sufficient, a discreet agreement between the Federal government, Governor Wallace and Pastor King had led the Selma Marchers of the 10th of March to stand back at the first request, in dignity and prayer. Thus the confrontation expected by the crowd had been reduced to the charade of a merely potential confrontation. In that moment, Non-Violence reached the pitiful limit of its courage: first you expose yourself to the enemies' blows, then force your moral grandeur to the point of sparing him the trouble of using more force. But the basic fact is that the civil rights movement, by remaining within the law, only posed legal problems. It is logical to make an appeal to the law legally. What is not logical is to appeal legally against a patent illegality as if this contradiction would disappear if pointed out. For it is clear that the superficial and outrageously visible illegality - from which the blacks still suffer in many American states - has its roots in a socio-economic contradiction which existing laws simply cannot touch, and which no future juridical law will be able to get rid of in face of more basic cultural laws of the society: and it is against these that the negroes are at last daring to raise their voices and asking the right to live. In reality, the American negro wants the total subversion of that Society - or nothing.

The problem of this necessity for subversion arises of its own accord the moment the blacks start using subversive means: the changeover to such methods happens on the level of their daily life, appearing at one and the same time as the most accidental and the most objectively justified development. This issue is no longer the status of the American negro, but the status of America, even if this happens to find its first expression among the negroes. This was not a *racial* conflict: the rioters left certain whites that were in their path alone, attacking only the white policemen: similarly, black solidarity did not extend to black shopkeepers, not even to black car-drivers. Even Luther King, in Paris last October, had to admit that the limits of his competence had been overshot: "They were not race riots," he said, "but one class."

The Los Angeles rebellion was a rebellion against commodities and of worker consumers *hierarchically* subordinated to commodity values. The negroes of Los Angeles - like the young delinquents of all advanced countries, but more radically because at the level of a class globally deprived of a future, a sector of the proletariat unable to believe in significant chance of integration and promotion - take modern capitalist propaganda *literally*, with its display of affluence. They want to possess *immediately* all the objects shown and made abstractly accessible: they want to *make use* of them. That is why they reject the values of exchange, the *commodity-reality* which is its mold, its purpose and its final goal, which has *preselected* everything. Through theft and gift they retrieve a use which at once gives the lie to the oppressive rationality of commodities, disclosing their relations and invention to be arbitrary and unnecessary. The plunder of the Watts sector was the most simple possible realisation of the hybrid principle: "To each according to his (false) needs" - needs determined and produced by the economic system, which the act of pillaging rejects.

But the fact that the vaunting of abundance is taken at its face value and discovered *in the immediate* instead of being eternally pursued in the course of alienated labour and in the face of increasing but unmet social needs - this fact means that real needs are expressed in carnival, playful affirmation and the *potlatch* of destruction. The man who destroys commodities shows his human superiority over commodities. He frees himself from the arbitrary forms which cloak his real needs. The flames of Watts consumed the system of consumption! The theft of large refrigerators by people with no electricity, or with their electricity cut off, gives the best possible metaphor for the life of affluence transformed into a truth *in play*. Once it is no longer bought, the commodity lies open to criticism and modification, and this under whichever of its

forms it may appear. Only so long as it is paid for with money, as a status symbol of survival, can it be worshiped fetishistically. Pillage is the *natural* response to the affluent society: the affluence, however, is by no means natural or human - it is simply abundance of goods. Pillage, moreover, which instantly destroys commodities as such, discloses the *ultima ratio* of commodities, namely, the army, the police and the other specialised detachments which have the monopoly of armed force within the State. What is a policeman ? He is the active servant of commodities, the man in complete submission to commodities, whose job is to insure that a given product of human labour remains a commodity with the magical property of having to be paid for instead of becoming a mere refrigerator or rifle - a mute, passive insensible thing, itself in submission to the first comer to make use of it. Over and above the indignity of depending on a policeman, the blacks reject the indignity of depending on commodities. The Watts youth, having no future in market terms, grasped another *quality* of the present, and the truth of that present was so irresistible that it drew on the whole population, women, children, and even sociologists who happened to find themselves on the scene. A young negro sociologist of the district, Bobbi Hollon, had this to say to the *Herald Tribune* in October: "Before, people were ashamed to say they came from Watts. They'd mumble it. Now, they say it with pride. Boys who always went around with their shirts open to the waist, and who'd have cut you into strips in half a second, used to apply here every morning. They organised the distribution of food. Of course it's no good pretending the food wasn't plundered... All that Christian blah has been used too long against the negroes. These people could plunder for ten years and they wouldn't get back half the money that has been stolen from them all these years. Myself, I'm just a little black girl." Bobbi Hollon, who has sworn never to wash from her sandals the blood that splashed them during the rioting, adds: "All the world looks to Watts now."

How do men make history, starting from the conditions pre-established to persuade them not to take a hand in it? The Los Angeles negroes are better paid than any others in the U.S., but it is also here that they are furthest behind that high point of affluence which is California. Hollywood, the pole of the worldwide spectacle, is in their immediate vicinity. They are promised that, with patience, they will join in America's prosperity, but they realise that this prosperity is not a static sphere but rather a ladder without end. The higher they climb, the further they get from the top, because they don't have a fair start, because they are less qualified and thus more numerous among the unemployed, and finally because the hierarchy which crushes them is not one based simply on buying power as a pure economic fact: an essential inferiority is imposed on them in every area of daily life by the customs and prejudices of a society in which all human power is based on buying power. So long as the human riches of the American negro are despised and treated as criminal, monetary riches will never make him acceptable to the alienated society of America: individual wealth may make a rich negro but the negroes as a whole *must represent poverty* in a society of hierarchised wealth. Every witness noted this cry which proclaims the fundamental meaning of the rising: 'This is the Black Revolution, and we want the world to know it!' *Freedom now!* is the password of all historical revolutions, but here for the first time it is not poverty but material abundance which must be controlled according to new laws. The control of abundance is not just changing the way it is shared out, but *redefining its every orientation*, superficial and profound alike. This is the first skirmish of an enormous struggle, infinite in its implications.

The blacks are not isolated in their struggle because a *new proletarian consciousness* - the consciousness of not being the master of one's activity, of one's life, in the slightest degree - is taking form in America among strata whose refusal of modern capitalism resembles that of the negroes. Indeed, the first phase of the negro struggle has been the signal to a movement of opposition which is spreading. In December, 1964 the students of Berkeley, frustrated in their participation in the civil rights movement, ended up by calling a strike to oppose the system of California's "multiversity", and by extension the social system of the U.S., in which they are allotted such a passive role. Immediately, drinking

and drug orgies were uncovered among the students - the same supposed activities for which the negroes have long been castigated. This generation of students has since invented a new form of struggle against the dominant spectacle, the teach-in, a form taken up by the Edinburgh students on October 20th apropos of the Rhodesian crisis. This clearly imperfect and primitive type of opposition represents the stage of discussion which refuses to be limited in time (academically), and in this its logical outcome is a progression to practical activity. Also in October, thousands of demonstrators appeared in the streets of Berkeley and New York, their cries echoing those of the Watts rioters: "Get out of our district and out of Vietnam!" The whites, becoming more radical, have stepped outside the law: "courses" are given on how to defraud the recruiting boards, draft cards are burned and the act televised. In the affluent society, disgust for affluence and *for its price* is finding expression. The spectacle is being spat on by an advanced sector whose autonomous activity denies its values. The classical proletariat, to the extent to which it had been provisionally integrated into the capitalist system, had itself failed to *integrate* the negroes (several Los Angeles unions refused negroes until 1959); now, the negroes are the rallying point for all those who refuse the logic of integration into that system - integration into capitalism being of course the *ne plus ultra* of all integration promised. And comfort will never be comfortable enough for those who seek what is not on the market - or rather, that which the market eliminates. The level reached by the technology of the most privileged becomes an insult - and one more easily expressed than that most basic insult, which is reification. The Los Angeles rebellion is the first in history able to justify itself by the argument that there was no air conditioning during a heatwave.

The American negro has his own particular spectacle, his press, magazines, coloured film stars, and if the blacks realise this, if they spew out this spectacle for its phoneyness, as an expression of their unworthiness, it is because they see it to be a *minority* spectacle - nothing but the appendage of a general spectacle. They recognise that this parade of their consumption-to-be-desired is a colony of the white one, and thus they see through the lie of this total economico-cultural spectacle more quickly. By wanting to participate really and immediately in affluence - and this is an official value of every American - they demand the equalitarian *realisation* of the American spectacle of everyday life: they demand that the half-heavenly, half-terrestrial values of this spectacle be put to the test. But it is of the essence of the spectacle that it cannot be made real either immediately or equally; and this, *not even for the whites*. (In fact, the function of the negro in terms of the spectacle is to serve as the perfect prod: in the race for riches, such underprivilege is an incitement to ambition.) In taking the capitalist spectacle at its face value the negroes are already rejecting the spectacle itself. The spectacle is a drug for slaves. It is not supposed to be taken literally, but followed at just a few paces' distance; if it were not for this albeit tiny distance, it would become total mystification. The fact is that in the U.S. today the whites are enslaved to commodities while the negroes negate them. The blacks ask for *more than the whites* - that is the core of an insoluble problem, or rather one only soluble through the dissolution of the white social system. This is why those whites who want to escape their own servitude must needs rally to the negro cause, not in a solidarity based on colour, obviously, but in a global rejection of commodities and, in the last analysis, of the State. The economic and social backwardness of the negroes allows them to see what the white consumer is, and their justified contempt for the white is nothing but contempt for any passive consumer. Whites who cast off their role have no chance unless they link their struggle more and more to the negro's struggle, uncovering his real and coherent reasons and supporting them until the end. If such an accord were to be ruptured at a radical point in the battle, the result would be the formation of a black nationalism and a confrontation between the two splinters exactly after the fashion of the prevailing system. A phase of mutual extermination is the other possible outcome of the present situation, once resignation is overcome.

The attempts to build a black nationalism, separatist and pro-African as they are, are

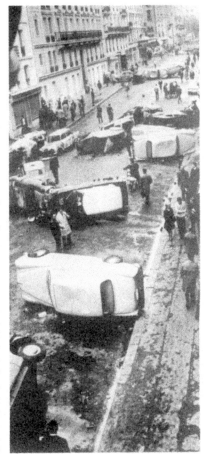

dreams giving no answer to the reality of oppression The American negro has no fatherland. He is in *his own country* and he is *alienated*: so is the rest of the population, but the blacks differ insofar as they are aware of it. In this sense, they are not the most backward sector of their society, but the most advanced. They are the negation at work, "the bad aspect producing the movement which makes history by setting the struggle in motion". (Marx: *The Poverty of Philosophy*). Africa has nothing to do with it.

The American negroes are the product of modern industry, just as are electronics, advertising or the cyclotron. And they carry within them its contradictions. These are the men whom the spectacle-paradise must integrate and repulse simultaneously, so that the antagonism between the spectacle and the real activity of men surrenders completely to their enunciations. The spectacle is *universal* in the same way as the commodities. But as the world of commodities is based in class conflict, commodities are themselves hierarchic. The necessity of commodities - and hence of the spectacle whose job it is to *inform* about commodities - to be at once universal and hierarchic leads to a universal hierarchisation. But as this hierarchisation must remain *unavowed*, it is expressed in the form of unacknowledgeable hierarchic value judgements, in a world of reasonless rationalisation. It is this process which creates *racialisms* everywhere: the English Labour government has just restrained coloured immigration, while the industrially advanced countries of Europe are once again becoming racialist as they import their sub-proletariat from the Mediterranean area, so exerting a colonial exploitation within their borders. And if Russia continues to be antisemitic, it is because she is still a society of hierarchy and commodities, in which labour must be bought and sold as a commodity. Together, commodities and hierarchies are constantly renewing their alliance, which extends its influence by modifying its form: it is seen just as easily in the relations between trade unionist and worker as between two car owners with artificially distinguished models. This is the original sin of commodity rationality, the sickness of bourgeois reason, whose legacy is bureaucracy. But the

repulsive absurdity of certain hierarchies and the fact that the whole world strength of commodities is directed blindly and automatically towards their protection, leads us to see - the moment we engage on a negating praxis - that every hierarchy is absurd.

The rational world produced by the industrial revolution has rationally liberated individuals from their local and national limitations, and related them on a world scale; but denies reason by separating them once more, according to a hidden logic which finds its expression in mad ideas and grotesque value-systems. Man, estranged from his world, is everywhere surrounded by strangers. The barbarian is no longer at the ends of the earth, he is on the spot, made into a barbarian by this very same forced participation in hierarchised consumption. The humanism cloaking all this is opposed to man, and the negation of his activity and his desires; it is the humanism of commodities, expressing the benevolence of the parasite, merchandise, towards the men off whom it feeds. For those who reduce men to objects, objects seem to acquire human qualities, and manifestations of real human activity appear as unconscious animal behaviour. Thus the chief humanist of Los Angeles, William Parker, can say: "They started behaving like a bunch of monkeys in a zoo."

When the state of emergency was declared by the California authorities, the insurance companies recalled that they do not cover risks at that level: they guarantee nothing beyond survival. Overall, the American negroes can rest assured that, if they keep quiet, their *survival* is guaranteed; and capitalism has become sufficiently centralised and entrenched in the State to distribute "welfare" to the poorest. But simply because they are behind in the process of intensification of socially organised survival, the blacks present problems of life and what they demand is not to survive but to live. The blacks have nothing to insure of their own; they have to destroy all the forms of security and private insurance known up to now. They appear as what they really are: the irreconcilable enemies - not of the vast majority of Americans - but of the alienated way of life of all modern society; the most advanced country industrially only shows us the road that will be everywhere fol-

lowed unless the system is overthrown.

Certain black nationalist extremists, in showing why they could never accept less than a separate State, have advanced the argument that American society, even if it someday concedes total civic and economic equality, will never get around to accepting mixed marriages. *It is therefore this American society which must disappear,* not only in America but everywhere in the world. The end of all racial prejudice (like the end of so many other prejudices such as sexual ones related to inhibitions) can only lie beyond "marriage" itself: that is, beyond the bourgeois family (which is questioned by the American negroes). This is the rule as much in Russia as in the United States, as a model of hierarchic relations and of the stability of an *inherited power* (be it money or socio-bureaucratic status). It is now often said that American youth, after thirty years of silence, is rising again as a force of opposition, and that the black revolt is their Spanish Civil War. This time, its "Lincoln Battalions" must understand the full significance of the struggle in which they engage, supporting it up to the end of its universal implications. The "excesses" of Los Angeles are no more a political error in the Black Revolt than the armed resistance of the P.O.U.M in Barcelona, May 1937, was a betrayal of the anti-Franquist war. A rebellion against the spectacle is situated on the level of the totality, because - even were it only to appear in a single district, Watts - it is a protest by men against the inhuman life, because it begins at the level of the *real single individual,* and because community, from which the individual in revolt is separated, is the *true social nature* of man, human nature: the positive transcendence of the spectacle.

Guy Debord
Situationist International, December 1965

Documents

Communique

Comrades,
Considering that the Sud-Aviation factory at Nantes has been occupied for two days by the workers and students of that city, and that today the movement is spreading to several factories (Nouvelles Messageries de la Presse Parisienne in Paris, Renault in Cleon, etc), THE SORBONNE OCCUPATION COMMITTEE calls for the immediate occupation of all the factories in France and the formation of Workers Councils.

Comrades, spread and reproduce this appeal as quickly as possible.

Sorbonne, 16 May 1968, 3.30 pm

Slogans to be spread now by every means

(Leaflets, announcements over microphones, comic strips, songs, graffiti, balloons on paintings in the Sorbonne, announcements in theatres during films or while disrupting them, balloons on subway billboards,before making love, after making love, in elevators, each time you raise your glass in a bar):

OCCUPY THE FACTORIES
POWER TO THE WORKERS COUNCILS
ABOLISH CLASS SOCIETY
DOWN WITH THE SPECTACLE-COMMODITY SOCIETY
ABOLISH ALIENATION
ABOLISH THE UNIVERSITY
HUMANITY WON'T BE HAPPY TILL THE LAST BUREAUCRAT IS HUNG WITH THE GUTS OF THE LAST CAPITALIST
DEATH TO THE COPS
FREE ALSO THE 4 GUYS CONVICTED FOR LOOT-ING DURING THE 6 MAY RIOT

Occupation Committee of the Autonomous and Popular Sorbonne University, 16 May 1968, 7 .00 pm

Minimum definition of revolutionary organisations

Since the only purpose of a revolutionary organisation is the abolition of all existing classes in a way that does not bring about a new division of society, we consider any organisation revolutionary which *consistently and effectively* works toward the international realisation of the absolute power of the workers councils, as prefigured in the experience of the proletarian revolutions of this century.

Such an organisation makes a unitary critique of the world, or is nothing. By unitary critique we mean a comprehensive critique of all geographical areas where various forms of separate socioeconomic powers exist, as well as a comprehensive critique of all aspects of life.

Such an organisation sees the beginning and end of its program in the complete decolonisation of everyday life. It thus aims not at the masses' self-management of the *existing world*, but at its uninterrupted transformation. It embodies the radical critique of *political economy*, the supersession of the commodity and of wage labour.

Such an organisation refuses to reproduce within itself any of the hierarchical conditions of the dominant world. The only limit to participating in its total democracy is that each member must have recognised and appropriated the coherence of its critique. This coherence must be both in the critical theory proper and in the relationship between this theory and practical

activity. The organisation radically criticises every *ideology as separate power* of ideas and as *ideas of separate power*. It is thus at the same time the negation of any remnants of religion, and of the prevailing social spectacle which, from news media to mass culture, monopolizes communication between people around their unilateral reception of images of their alienated activity. The organisation dissolves any 'revolutionary ideology' unmasking it as a sign of the failure of the revolutionary project, as the private property of new specialists of power, as one more fraudulent representation setting itself above real proletarianised life.

Since the ultimate criterion of the modern revolutionary organisation is its totalness, such an organisation is ultimately a critique of politics. It must explicitly aim to dissolve itself as a separate organisation at its moment of victory.

Adopted by the 7th Conference of the SI, July 1966

A gust of wind through the Japanese apple tree

Ladies and Gentlemen,

Henri Lefebvre, one of the most well-known agents of recuperation of this half of the century (it's well-known how the situationists well and truly put him and the whole Arguments gang in their place in their pamphlet *Into the Dustbin of History!*) proposes to add the Zengakuren to his trophies. The CNRS has its emissaries, PRAXIS has its researchers.

The metaphilosopher Lefebvre is less stupid than the pataphilosopher Morin. But the metastalinist ought to have the good grace to shut up when it's a matter of class struggle.

A word to the wise is enough.

The Enrages, Nanterre, March 19, 1968

Gut rage!

Comrades,

In spite of the proven collusion between UEC Stalinists and reactionaries, last Friday's marvel-lous riots show that students, in struggle, are starting to gain a consciousness that they didn't have before: and where violence begins, reformism ends. The University Council which met this morning will have its work cut out: this obsolete form of repression can do nothing to counter the violence in the streets. The banning for Five years of our comrade Gerard Bigorgne from all the universities of France - quietly ignored by the whole of the press, the political groups, and students' associations - and which now menaces our comrade Rene Riesel and six other Nanterre students, is at the same time a way for the university authorities to hand them over to the police.

Faced with repression, the struggle which has begun must retain its method of violent action, which for the time being is its only streugth. But above all it must instigate a consciousness amongst students who will lead the movement forward.

Because there aren't only the cops: there are also the lies of the various political tendencies - Trotskyists (JCR, FER, VO), Maoists (UJCML, CP rank and file), and anarchists-a-la-Cohn-Bendit. Let's settle our business ourselves!

The example shown by the comrades arrested at the Sorbonne on Friday, who escaped from the van they'd been taken to, is an example to follow. When there are only three cops in a police van, we'll know what to do. The case of Sergeant Brunet, done over yesterday, will set a precedent: death to the pigs!

Already violence has shut the mouths of the petty bosses of the political groups; to challenge the bourgeois university alone is trivial when it's the whole of this sociey which is to be destroyed.

LONG LIVE THE ZENGAKUREN!
LONG LIVE THE VANDALIST COMMITTEE OF PUBLIC SAFETY (Bordeaux)!
LONG LIVE THE ENRAGES!
LONG LIVE THE S.I.!
LONG LIVE THE SOCIAL REVOLUTION!

The Enrages, Paris, May 6, 1968

The castle is burning!

Address to the Council of the University of Paris

Relics of the past,
Your crass ignorance of life gives you no authoriy to do anything. Do you want proof? If you can sit today it will only be if you are backed up by a cordon of police.

In fact nobody respects you any more. So cry now over your old Sorbonne.

It just makes me laugh that certain modernising old farts are getting touchy about defending me, supposing - wrongly - that after having spat in their faces, I might once more become presentable enough for them to protect me. Despite their perseverance in such masochism, these opportunists wouldn't even know how to patch up the Universly. Monsieur Lefebvre, I say to you, shit.

There will be more and more of those who take from the education system the best thing it has: the grants. You've refused this to me, so I've had nothing to hide. I've got to bite the bullet.

Today's trial is, of course, a ridiculous fairy tale. The real trial took place on Monday on the streets, and secular justice has already detained about thirty riotes. For my comrades, what matters is the unconditional release of *all the prisoners* (*as well* as the students).

Freedom is the crime which contains all crimes. Woe betide feudal justice when the castle is burning!

Rene Riesel, Paris, May 10, 1968

Vigilance!

Comrades,
The supremacy of the revolutionary assembly can only mean something if it exercises its power.

For the last 48 hours even the capaciy of the general assembly to make decisions has been challenged by a systematic obstruction of all proposals for action.

Up until now no motion could be voted on or even discussed, and bodies elected by the general assembly (Occupation Committee and Coordinating Committee) see their work sabotaged by pseudo-spontaneous groups.

All the debates on organisation, which people wanted to argue about before any action, are pointless if we do nothing.

AT THIS RATE, THE MOVEMENT WILL BE BURIED IN THE SORBONNE!

The prerequisite of direct democracy is the minimum support that revolutionary students can give to revolutionary workers who are occupying their factories.

It is inexcusable that yesterday evening's incidents in the GA should pass without retaliation.

The priests are holding us back when anti-clerical posters are torn up.

The bureaucrats are holding us back when, without even giving their names, they paralyse the revolutionary awareness that can take the movement forward from the barricades.

Once again, it's the future that is sacrificed to the re-establishment of the old unionism.

Parliamentary cretinism wants to take over the rostrum, as it tries to put the old, patched-up system back on its feet again.

Comrades,the reform of the university alone is insignificant, when it is the whole of the old world which is to be destroyed.

The movement is nothing if it is not revolutionary.

Occupation Committee of the Sorbonne, May 16, 1968, 4.30pm.

Watch out!

The Press Committee situated on the second floor, stair C, in the Gaston Azard library, represents only itself. It happens to be a case of a dozen or so student journalists anxious to prove themselves straight away to their future employers and future censors.

This Committee, which is trying to monopolize all contact with the Press, refuses to transmit the communiques of the regularly elected bodies of the general assembly.

THIS PRESS COMMITTEE IS A CENSORSHIP COMMITTEE: don't have anything more to do with it.

Les syndicats viennent de nous démontrer qu'ils ne sont qu'un mécanisme d'intégration à la société capitaliste!

The various working parties can, while waiting for this evening's general assembly where new decisions will be taken, address themselves to the occupation committee and the coordinating committee elected by the GA yesterday evening.

EVERYBODY COME TO THE GENERAL ASSEMBLY THIS EVENING IN ORDER TO THROW OUT THE BUREAUCRATS!

Occupation Committee of the autonomous and popular The Sorbonne, May 16, 5pm

Watch out for manipulators!
Watch out for bureaucrats!

Comrades,

No-one must be unaware of the Importance of the GA this evening (Thursday 16 May). For two days individuals one recognizes from having seen them previously peddling their party lines have succeeded in sowing confusion and in smothering the GAs under a barrage of bureaucratic manipulations whose clumsiness clearly demonstrates the contempt they have for this assembly. *This assembly must learn to make itself respected, or disappear.* Two points must be discussed above all:

WHO IS IN CHARGE OF THE MARSHALS? whose disgusting role is intolerable.

WHY IS THE PRESS COMMITTEE - which *dares to censor the communiques* that it is charged to transmit to the agencies - composed of apprentice journalists who are careful not to disappoint the ORTF bosses or jeopardize their future job possibilities?

Apart from this: as the workers are beginning to occupy several factories in France, FOLLOWING OUR EXAMPLE AND WITH THE SAME RIGHT WE HAVE, the Sorbonne occupation committee issued a statement approving of this movement at 3 pm this afternoon. The central problem of the present GA is therefore to declare itself by a clear vote supporting or disavowing this appeal of its occupation committee. In the case of a disavowal, this assembly will then have taken the responsibility of reserving for the students a right that it refuses to the working class;

and in that case it is clear that it will no longer want to concern itself with anything but a Gaullist reform of the university.

Occupation Committee of the autonomous and popular Sorbonne University, 16 May 1968, 6.30pm

Telegrams

17 MAY 1968 / PROFESSOR IVAN SVITAK PRAGUE CZECHOSLOVAKIA / THE OCCUPATION COMMITTEE OF THE AUTONOMOUS AND POPULAR SORBONNE SENDS FRATERNAL SALUTATIONS TO COMRADE SVITAK AND TO CZECHOSLOVAKIAN REVOLUTIONARIES STOP LONG LIVE THE INTERNATIONAL POWER OF THE WORKERS COUNCILS STOP HUMANITY WON'T BE HAPPY TILL THE LAST CAPITALIST IS HUNG WITH THE GUTS OF THE LAST BUREAUCRAT STOP LONG LIVE REVOLUTIONARY MARXISM

17 MAY 1968 / ZENGAKUREN TOKYO JAPAN / LONG LIVE THE STRUGGLE OF THE JAPANESE COMRADES WHO HAVE OPENED COMBAT SIMULTANEOUSLY ON THE FRONTS OF ANTI-STALINISM AND ANTI-IMPERIALISM STOP LONG LIVE FACTORY OCCUPATIONS STOP LONG LIVE THE GENERAL STRIKE STOP LONG LIVE THE INTERNATIONAL POWER OF THE WORKERS COUNCILS STOP HUMANITY WON'T BE HAPPY TILL THE LAST BUREAUCRAT IS HUNG WITH THE GUTS OF THE LAST CAPITALIST STOP OCCUPATION COMMITTEE OF THE AUTONOMOUS AND POPULAR SORBONNE

17 MAY 1968 / POLITBURO OF THE COMMUNIST PARTY OF THE USSR THE KREMLIN MOSCOW / SHAKE IN YOUR SHOES BUREAUCRATS STOP THE INTERNATIONAL POWER OF THE WORKERS COUNCILS WILL SOON WIPE YOU OUT STOP HUMANITY WON'T BE HAPPY TILL THE LAST BUREAUCRAT IS HUNG WITH THE GUTS OF THE LAST CAPITALIST STOP LONG LIVE THE STRUGGLE OF THE KRONSTADT SAILORS AND OF THE MAKHNOVSHCHINA AGAiNST TROTSKY AND LENIN STOP LONG LIVE THE 1956 COUNCILIST INSURRECTION OF BUDAPEST STOP DOWN WITH THE STATE STOP LONG LIVE REVOLUTION-

ARY MARXISM STOP OCCUPATION COMMITTEE OF THE AUTONOMOUS AND POPULAR SOBONNE

17 MAY 1968 / POLITBURO OF THE CHINESE COMMUNIST PARTY GATE OF CELESTIAL PEACE PEKING / SHAKE IN YOUR SHOES BUREAU-CRATS STOP THE INTERNATIONAL POWER OF THE WORKERS COUNCILS WILL SOON WIPE YOU OUT STOP HUMANITY WON'T BE HAPPY TILL THE LAST BUREAUCRAT IS HUNG WITH THE GUTS OF THE LAST CAPITALIST STOP LONG LIVE FACTORY OCCUPATIONS STOP LONG LIVE THE GREAT CHI-NESE PROLETARIAN REVOLUTION OF 1927 BETRAYED BY THE STALINIST BUREAUCRATS STOP LONG LIVE THE PROLETARIANS OF CAN-TON AND ELSEWHERE WHO HAVE TAKEN UP ARMS AGAINST THE SO-CALLED PEOPLE'S ARMY STOP LONG LIVE THE CHINESE WORKERS AND STUDENTS WHO HAVE ATTACKED THE SO-CALLED CULTURAL REVOLUTION AND THE MAOIST BUREAUCRATIC ORDER STOP LONG LIVE REVOLUTIONARY MARXISM STOP DOWN WITH THE STATE STOP OCCUPATION COMMIT-TEE OF THE AUTONOMOUS AND POPULAR SOR-BONNE

Report on the occupation of the Sorbonne

The occupation of the Sorbonne that began Monday, 13 May, has inaugurated a new period in the crisis of modern society. The events now taking place in France foreshadow the return of the proletarian revolutionary movement in all countries. The movement that had already advanced from theory to struggle in the streets has now advanced to a struggle for power over the means of production. Modernized capitalism thought it had finished with class struggle - it's started up again! The proletariat no longer exist-ed - but here it is again.

In surrendering the Sorbonne, the govern-ment counted on pacifying the student revolt, which had already succeeded in holding a sec-tion of Paris behind its barricades an entire night before being recaptured with great difficulty by the police. The Sorbonne was given over to the students in the hope that they would peacefully discuss their university problems. But the occu-piers immediately decided to open it to the pub-lic to freely discuss the general problems of the society. This was thus a prefiguration of a coun-cil, a council in which even the students broke out of their miserable studenthood and ceased to be students.

To be sure, the occupation has never been total: a chapel and some remnants of adminis-trative offices have been tolerated. The democ-racy has never been complete: future tech-nocrats of the UNEF claimed to be making them-selves useful and other political bureaucrats have also tried their manipulations. Workers' participation has remained very limited and the presence of nonstudents soon began to be questioned. Many students, professors, journal-ists and imbeciles of other occupations have come as spectators.

In spite of all these deficiencies, which are not surprising considering the contradiction between the scope of the project and the nar-rowness of the student milieu, the exemplary nature of the best aspects of this situation immediately took on an explosive sigmficance. Workers could not fail to be inspired by seeing free discussion, the striving for a radical critique and direct democracy in action. Even limited to a Sorbonne liberated from the state, this was a revolutionary program developing its own forms. The day after the occupation of the Sorbonne the Sud-Aviation workers of Nantes occupied their factory. On the third day, Thursday the 16th, the Renault factories at Cleon and Flins were occupied and the movement began at the NMPP and at Boulogne-Billancourt, starting at Shop 70. Now, at the end of the week, 100 factories have been occupied while the wave of strikes, accepted but never initiated by the union bureaucracies, is paralyzing the railroads and developing toward a general strike.

The only power in the Sorbonne was the general assembly of its occupiers. At its first ses-sion, on 14 May, amidst a certain confusion, it had elected an Occupation Committee of 15 members revocable by it each day. Only one of the delegates, belonging to the Nanterre-Paris Enrages group, had set forth a program: defence of direct democracy in the Sorbonne and absolute power of workers' councils as ultimate

goal. The next day's general assembly reelected its entire Occupation Committee, which had not been able to accomplish anything by then. In fact, all the specialised groupings that had set themselves up in the Sorbonne followed the directives of a hidden "Coordination Committee" composed of volunteer and very moderating organizers responsible to no one. An hour after the reelection of the Occupation Committee one of the "coordinators" privately tried to declare it dissolved. A direct appeal to the base in the courtyard of the Sorbonne aroused a movement of protests which obliged the manipulator to retract himself. By the next day, Thursday the 16th, thirteen members of the Occupation Committee had disappeared, leaving two comrades, including the Enrages member, vested with the only delegation of power authorized by the general assembly - and this at a time when the gravity of the moment necessitated immediate decisions: democracy was constantly being flouted in the Sorbonne and factory occupations were spreading. The Occupation Committee, rallying around it as many Sorbonne occupiers as it could who were determined to maintain democracy there, at 3pm launched an appeal for "the occupation of all the factories in France and the formation of workers' councils." To disseminate this appeal, the Occupation Committee had at the same time to restore the democratic functioning of the Sorbonne. It had to take over or recreate from scratch all the services that were supposed to be under its authority: the loudspeaker system, printing facilities, interfaculty liaison, security. It ignored the squawking complaints of the spokesmen of various political groups (JCR, Maoists, etc.), reminding them that it was responsible only to the general assembly. It intended to report to it that very evening, but the Sorbonne occupiers' unanimous decision to march on Renault-Billancourt (whose occupation we had learned of in the meantime) postponed the session of the assembly until 2pm the next day.

During the night, while thousands of comrades were at Billancourt, some unidentified persons improvised a general assembly, which broke up when the Occupation Committee, having learned of its existence, sent back two delegates to call attention to its illegitimacy.

Friday the 17th at 2pm the regular assembly saw its rostrum occupied for a long time by self-appointed marshals belonging to the FER; and in addition had to interrupt the session for the second march on Billancourt at 5 pm.

That evening at 9 pm the Occupation Committee was finally able to present a report of its activities. It was completely unsuccessful, however, in getting its actions discussed and voted on, in particular its appeal for the occupation of the factories, which the assembly did not take the responsibility of either disavowing or approving. Confronted with such indifference and confusion, the Occupation Committee had no choice but to withdraw. The assembly showed itself just as incapable of protesting against a new invasion of the rostrum by the FER troops, whose putsch seemed to be aimed at countering the provisional alliance of JCR and UNEF bureaucrats. The partisans of direct democracy immediately declared that they no longer had anything to do at the Sorbonne.

At the very moment that the example of the occupation is beginning to be taken up in the factories it is collapsing at the Sorbonne. This is all the more serious since the workers have against them a bureaucracy infinitely more entrenched than that of the student or leftist amateurs. In addition, the leftist bureaucrats, echoing the CGT in the hope of being accorded a little marginal role alongside it, abstractly separate the workers from the students, whom "they don't need lessons from." But in fact the students have already given a lesson to the workers precisely by occupying the Sorbonne and briefly initiating a really democratic discussion. All the bureaucrats tell us demogogically that the working class is grown up, in order to hide the fact that it is enchained - first of all by them (now or in their future hopes, depending on which group they're in). They counterpose their lying seriousness to "the festival" in the Sorbonne, but it was precisely this festiveness that bore within itself the only thing that is serious: the radical critique of prevailing conditions.

The student struggle is now left behind. Even more left behind are all the second-string bureaucratic leaderships that think it's a good idea to feign respect for the Stalinists at this very moment when the CGT and the so-called

"Communist" Party are trembling. The outcome of the present crisis is in the hands of the workers themselves if they succeed in accomplishing in the occupation of their factories the goals toward which the university occupation was only able to make a rough gesture.

The comrades who supported the first Sorbonne Occupation Committee - the Enrages-Situationist International Committee, a number of workers and a few students - have formed a Council for Maintaining the Occupations: the maintaining of the occupations obviously being conceivable only through their quantitative and qualitative extension, which must not spare any existing regime.

Council for maintaining the occupations, Paris, 19 May 1968

For the power of the Workers Councils

In the space of ten days workers have occupied hundreds of factories, a spontaneous general strike has totally interrupted the activity of the country, and de facto committees have taken over many buildings belonging to the state. In such a situation - which in any event cannot last but must either extend itself or disappear (through repression or defeatist negotiations) - all the old ideas are swept aside and all the radical hypotheses on the return of the revolutionary, proletarian movement are confirmed. The fact that the whole movement was really triggered five months ago by a half dozen revolutionaries of the "Enrages" group reveals even better how much the objective conditions were already present. At this very moment the French example is having repercussions in other countries and reviving the internationalism which is indissociable from the revolutions of our century.

The fundamental struggle today is between, on the one hand, the mass of workers - who do not have direct means of expressing themselves - and on the other, the leftist political and union bureaucracies that (even if merely on the basis of the 14% of the active population that is unionised) control the factory gates and the right to negotiate in the name of the occupiers. These bureaucracies are not workers' organisations that have degenerated and betrayed the workers, they are a mechanism for integrating the workers into capitalist society. In the present crisis they are the main protection of this shaken capitalism.

The de Gaulle regime may negotiate - essentially (if only indirectly) with the PCF-CGT - for the demobilization of the workers in exchange for some economic advantages; after which the radical currents would be repressed. Or "the left" may come to power and pursue the same policies, though from a weaker position. Or an armed repression may be attempted. Or, finally, the workers may take the upper hand by speaking for themselves and becoming conscious of goals as radical as the forms of struggle they have already put into practice. Such a process would lead to the formation of workers councils making decisions democratically at the rank-and-file level, federating with each other by means of delegates revocable at any moment, and becoming the sole deliberative and executive power over the entire country.

In what way could the prolongation of the present situation lead to such a prospect? Within a few days, perhaps, the necessity of starting certain sectors of the economy back up again under workers'control could lay the bases for this new power, a power which everything is already pushing to burst through the constraints of the unions and parties. The railroads and printshops would have to be put back into operation for the needs of the workers' struggle. New de facto authorities would have to requisition and distribute food. If money becomes devalued it might have to be replaced by vouchers backed by those new authorities. It is through such a practical process that the consciousness of the profound will of the proletariat can impose itself - the class consciousness that lays hold on history and brings about the workers' domination over all aspects of their own lives.

Council for maintaining the occupations, Paris, 22 May 1968

Address to all workers

Comrades,

What we have already done in France is haunting Europe and will soon threaten all the ruling classes of the world, from the bureaucrats of Moscow and Peking to the millionaires of Washington and Tokyo. In the same way we have made Paris dance, the international proletariat will again take up its assault on the capitals of all states, on all the citadels of alienation. The occupation of factories and public buildings throughout the country has not only blocked the functioning of the economy, it has brought about a general questioning of the society. A deep-seated movement is leading almost every sector of the population to seek a real change of life. It is now a revolutionary movement, a movement which lacks nothing but the consciousness of what it has already done in order to triumph.

What forces will try to save capitalism? The regime will fall unless it threatens recourse to arms (accompanied by the promise of new elections, which could only take place after the capitulation of the movement) or even resorts to immediate armed repression. As for the possible coming to power of the left, it too will try to defend the old world through concessions and through force. In this event, the best defender of such a "popular government" would be the so-called "Communist" Party, the party of Stalinist bureaucrats, which has fought the movement from the very beginning and which began to envisage the fall of the de Gaulle regime only when it realised it was no longer capable of being that regime's main guardian. Such a transitional government would really be "Kerenskyist" only if the Stalinists were beaten. All this will depend essentially on the workers' consciousness and capacities for autonomous organisation: those who have already rejected the ridiculous accords that so gratified the union leaders need only discover that they cannot "win" much more within the framework of the existing economy, but that they can take everything by transforming all the bases of the economy on their own behalf. The bosses can hardly pay more; but they can disappear.

The present movement did not become "politicised" by going beyond the miserable union demands regarding wages and pensions, demands which were falsely presented as "social questions." It is beyond politics: it is posing the social question in its simple truth. The revolution that has been in the making for over a century is returning. It can assert itself only in its own forms. It is already too late for a bureaucratic-revolutionary patching up. When a recently de-Stalinized Andre Barjonet calls for the formation of a common organisation that would bring together "all the authentic forces of revolution... whether they march under the banner of Trotsky or Mao, of anarchy or situationism (we have only to recall that those who today follow Trotsky or Mao, to say nothing of the pitiful "Anarchist Federation) have nothing to do with the present revolution. The bureaucrats may now change their minds about what they call "authentically revolutionary"; authentic revolution does not have to change its condemnation of bureaucracy.

At the present moment, with the power they hold and with the parties and unions being what they are, the workers have no other choice but to organise themselves in unitary rank-and-file committees directly seizing all aspects of the reconstruction of social life, asserting their autonomy vis-a-vis any sort of politico-unionist leadership, ensuring their self-defence and federating with each other regionally and nationally. By taking this path they will become the sole real power in the country, the power of the workers councils. Otherwise the proletariat, because it is "either revolutionary or nothing" will again become a passive object. It will go back to watching television.

What defines the power of the councils? Dissolution of all external power; direct and total democracy; practical unification of decision and execution; delegates who can be revoked at any moment by those who have mandated them; abolition of hierarchy and independent specialisations; conscious management and transformation of all the conditions of liberated life; permanent creative participation of the masses; internationalist extension and coordination. The present requirements are nothing less than this. Self-management is nothing less. Beware of the recuperators of every modernist variety - including even priests - who are beginning to talk of

self-management or even of workers councils without acknowledging this minimum, because they in fact want to save their bureaucratic functions, the privileges of their intellectual specialisations or their future as petty bosses!

In reality what is necessary now has been necessary since the beginning of the proletarian revolutionary project. People struggled for the abolition of wage labour, of commodity production, of the state. It was a matter of acceding to conscious history, of suppressing all separations and "everything that exists independently of individuals." Proletarian revolution has spontaneously sketched out its adequate form in the councils, in St. Petersburg in 1905 as in Turin in 1920, in Catalonia in 1936 as in Budapest in 1956. The maintaining of the old society, or the formation of new exploiting classes, has each time been by way of the suppression of the councils. Now the working class knows its enemies and its own appropriate methods of action. "Revolutionary organisation has had to learn that it can no longer fight alienation with alienated forms" (*The Society of the Spectacle*). Workers councils are clearly the only solution, since all the other forms of revolutionary struggle have led to the opposite of what was aimed at.

Enrages-Situationist International Committee

Council for maintaining the occupations, Paris, 30 May 1968

The struggle against alienation has to give the words their real meaning as well as to return to them their initial force

So, don't say anymore	but say
society	racket
professor	
psychologist	
poet	
sociologist	
militants (of all feathers)	cops
conscientious objector	
trade unionist	
priest	
family	
(non-exhaustive list)	
information	deformation (at the level of the world racket and its mystifications)
work	hard labour
art	that's how much?
dialogue	masturbation
culture	shit that is used as a permanent gargle by all the pedantic idiots (see professor)
my sister	my Love
dear professor	croak bastard
good night daddy	croak bastard
excuse me officer	croak bastard
thank you doctor croak	croak bastard
legality	trap for assholes
civilisation	sterilisation
urbanism	preventive police
village 1, 2, 3, 4,	strategic hamlets
structuralism	last chanceof neocapitalism whose glaring failures are covered up by official lies, which are clumsily plastered over the most obvious contradictions.

Students, you are impotent fools (we know that already),
but you will remain it as long as you will not have

-beaten up your professors
-buggered all your priests
-set fire to the university

No the Commune is not dead.

Vandalist's department for Public Welfare - Leaflet issued at Bordeaux (France) in April 1968

Further Reading

Debord, Guy
Society of the Spectacle
Rebel Press/Black and Red
£5.95

Debord, Guy
Society of the Spectacle and Other Films
Rebel Press
0946061068
£5.50

Vaneigem, Raoul
The Revolution of Everyday Life
Rebel Press
0946061017
£7.95

Vaneigem, Raoul
A Cavalier History of Surrealism
AK Press
1873176945
£7.95

Vienet, Rene
Enrages and Situationists in the Occupation Movement, France, May 68
Rebel Press
094606605X
£5.95

Gray, Chris
Leaving the 20th Century: The Incomplete Work of the Situationist International
Rebel Press
0946061157
£9.90

Home, Stewart
The Assault on Culture - Utopian Currents from Lettrisme to Class War
AK Press
1873176309
£5.95

Knabb, Ken
Situationist International Anthology
Bureau of Public Secrets
0939682001
£12.95

King Mob
King Mob Echo - English Section of the Situationist International
Dark Star/Vague 31
1871692075
£6.00

For a comprehensive bibliography of Situationist and Situationist-inspired texts consult:

Ford, Simon
The Realisation and Suppression of the Situationist International - An Annotated Bibliography 1972 - 1992
AK Press
1873176821
£7.95

All of the above titles are currently in print. If you have any difficulty obtaining any of the titles they are all available mail order from:

AK Distribution
P O Box 12766
Edinburgh
Scotland
EH8 9YE
ak@akedin.demon.co.uk
www.akuk.com

Please send a large SAE for a full catalogue

They are also stocked by:
Housman's Bookshop
5 Caledonian Road
London
N1 9DX

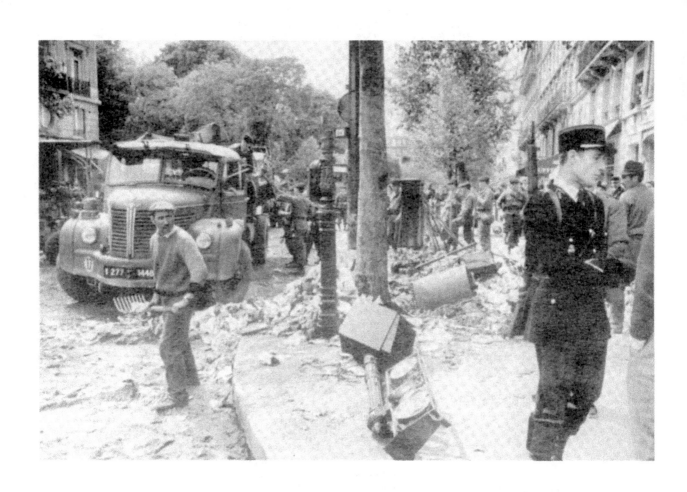

Afterword

There is a tradition of denigrating certain political ideas and actions by describing them as Utopian, unrealistic, naive etc. We have deliberately chosen the title of this Anthology as we feel it sums up important aspects of the events in May. The importance that graffiti, posters, pamphlets etc played both in terms of practical communication and inspirational agitation cannot be denied. Some of the slogans may on one level appear Utopian but a closer analysis shows that they partake of the great Surrealist tradition of the imaginative transformation of the world, a transformation firmly rooted in, not an escape from, reality. As Andre Breton observed, "The Imaginary is that which tends to become real." On one level a slogan on a Parisian wall referring to the beach appears a contradiction. The beach with its connotation of seaside holidays, fun and leisure scrawled on an urban wall in the capital of France. However, although the quality of our illustrations doesn't allow us to show it too clearly, if you look carefully at photographs of Parisian streets which have had their paving stones/cobbles torn up what can you see? Sand, of course.

 For our records and for use in future editions of this book Dark Star would welcome copies of the covers of the pamphlets reprinted in this book to enable us to illustrate the widespread distribution of them both in terms of time and geographical locations.

DARK STAR c/o AK Distribution

Sous les pavés, la plage

Dark Star would like to thank Chris Gray and Ken Knabb, without whose translations this anthology would not have been possible.
As Lautreamont observed, "Words expressing evil are destined to take on a more positive meaning. Ideas improve - the sense of words takes part in this process. Plagiarism is necessary. It is implied in the idea of progress. It clasps an author's sentence tight, uses his expressions, eliminates a false idea, replaces it with the right idea.

To be well wrought, a maxim does not need to be corrected. It needs to be developed."

CPSIA information can be obtained
at www.ICGtesting.com
Printed in the USA
JSHW051236161122
33276JS00001B/1